# THE LAST PHOTOGRAPHIC HEROES

# THE LAST PHOTOGRAPHIC HEROES

## American Photographers of the Sixties and Seventies

### GILLES MORA

Abrams, New York

# CONTENTS

PREFACE

confess: my fascination with photography as a unique, independent means of expression has never wavered. I am among those who, during the 1970s, marveled at the sight of photographers finally believing in the virtues of their wonderfully peculiar art, which was then in full bloom. Today it is a great pleasure for me to relive the adventure of American photography through this book, particularly since our subject is photography of the sixties and seventies, the swan song of a now fragmented medium. Watch out, they'll say, here comes the nostalgia trip!

This book may not be the one I dreamed of writing; that book deserved a broader scope. But nowadays, aside from the weighty catalogues accompanying monumental retrospectives, such a book has difficulty finding a place in publishing houses and on readers' bookshelves. The general public now expects lighter, more direct information, although not necessarily to the exclusion of the essential facts. Meanwhile, art history is sometimes infused with complacency and useless erudition when treating subjects that, by their very nature, should banish the former and moderate the latter. A chapter on the history of American photography as lively and engaging as the one I am treating can be told in an accessible way, in fewer pages, without overlooking the essentials. This is the approach I have tried to adopt.

Why *The Last Photographic Heroes*? If a hero is someone who has devoted body and soul to his cause, then American photography, from the milestone of Robert Frank's *The Americans* in 1958 to the discovery of the Postmodern Cindy Sherman in the early 1980s, abounds in heroic figures, some of whom, like Diane Arbus, border on the tragic. Italian filmmaker Michelangelo Antonioni understood as much when he elevated the photographer—granted, the *fashion* photographer—and his art to the level of contemporary mythology in his 1966 film *Blow-Up*.

Every hero must have his or her quest. For the photographers of the sixties and seventies, and for the critics, curators, gallery owners, and collectors who supported their rise, the quest was for an autonomous photographic language, derived from their belief in a medium with boundless possibilities. These artists devoted themselves to invigorating photography to the point of exhausting it. The era's guiding figures, who founded an authentic community,[1] turned their artistic practice into a joyous cause, a definitive affirmation of the idea of photography as a wholly independent aesthetic that had driven the art form since Alfred Stieglitz and the advent of Modernism. From the first decade of

the twentieth century to the end of the 1970s, American photography charted an ascending curve—with the occasional intriguing bump, notably during the late 1960s—and perfected the notion of aesthetic of the instant perception. Photography triumphed. By 1975, it had won its autonomy in the United States and appeared to have overtaken the other forms of visual expression. This culmination was the fruit of new economic trends in the professional and amateur photography markets; broad-based enthusiasm for the medium on the part of the general public, universities, and museums; editorial and media consensus regarding the mythical figure of the photographer; and a unique artistic and professional environment. The brief twenty-year period that is the focus of this book represents an unprecedented era of artistic effervescence. We are just beginning to understand its effects on our daily use of images and our response to them. Today we are drawn to this period of photography because, for the first time, we can appreciate it in the context of a historical era that we are now beginning to view, retrospectively, in a more profound, complex way. This new, longer historical perspective magnifies the era's photography, which also benefits from our knowledge of its development during the last thirty years. Maybe these really were the last heroes; postmodernism tells us that their cause no longer has a reason to exist. After them, the photographic exploration of the real would no longer be a central concern, giving way to the interpretation—or reinterpretation—of photographic reality, that is to say, of the photograph itself.

Given the breadth of our subject, I have tried to be as clear and direct as possible. I believe that the most innovative American photography of the sixties and seventies—although not the only decisive photography of the period—was created in response to the legacy left by Walker Evans beginning in the late 1930s. Throughout his life—he died in 1975—Evans's thinking and work focused on the essential relationship between the photographic document and its aesthetic ambiguity. The notion of the document and the acceptance of that notion, the subsequent developments it inspired, and, eventually, the effects of its being called into question, occupied the American photo scene in a more or less explicit manner throughout the sixties and seventies. By means of an incredibly varied range of experimentation, many artists explored the tensions between objectivity, subjectivity, neutrality, and realist illusion specific to the photographic medium. They questioned the very nature of what the photograph reveals about the world and what it evades in order to define their positions regarding the possibilities—or limitations—of the photographic document, especially when free of its photojournalistic or strictly commercial ambitions.

Under the dominant impetus of John Szarkowski, the powerhouse MoMA curator, this line of thinking gave rise to the idea of a photographic language with inviolable characteristics. Szarkowski's sacralization of photography was illustrated in concrete terms—his exhibitions and publications having the power of aesthetic manifestoes—instead of the theoretical verbiage then proffered in Europe. It would meet with equally virulent resistance, some of it below the surface, some very much out in the open. The twenty years discussed here should not be seen as a period of consensus about

a predominantly documentary photography, favored by a particularly rich political, sociocultural, and American historical context. On the contrary, these years represent a period of productive tensions. Although frequently underestimated, confrontations constantly arose between the purist vision evoked here and the positive effects of exploding traditional photographic practices contaminated by the broader experiences of the era's impetuous art world. Clearly, the heroism I refer to is also the heroism of a struggle, however questionable that struggle might be. Our hindsight probably amplifies the stakes; we know what survived the period, and for what reasons. During the course of its most decisive decades, American photography closed many doors, but threw a few others wide open.

This introduction to American photography of the sixties and seventies is the fruit of an avowedly personal selection. Some will protest that I have not said enough about the conceptual photography then reaching its apogee on the West Coast. What? Nothing about Pop Art photographers? No room for Andy Warhol? Well, no, not this time: and my choice is deliberate, nearly methodological; it is no oversight due to ignorance or disdain. For the most part, the photographers on whom I have focused, though largely attentive to the artistic currents of their generation, functioned on a different level of photographic experience. While preparing this book, combing the archives of American photographers and looking at the images they produced, I was struck by their extra-ordinary poetry. It is a far cry from the poetry of their European predecessors and contemporaries, particularly because it developed on such a wide scale. The dreamlike quality in the work of Ralph Eugene Meatyard or Ralph Gibson; the irrepressible power of street photography as renewed by Garry Winogrand or Lee Friedlander; the emotional brutality of the urban scenes captured by Tod Papageorge, Charles Traub, or Charles Harbutt; the Rimbaud-inspired adolescent wanderings of Larry Clark; the refined austerity of some of the New Topographers; the uncanny beauty of the snapshot aesthetic; the astounding creations of a few wildly inspired surrealists such as Arthur Tress or Les Krims; the experimental freedom of working with color or the medium itself (Robert Heinecken, an absolute master, yet so underappreciated)—have few equivalents in such a brief time span during any stage in the history of photography, except for European photography between the two world wars. This abundance of creative energy is what makes me so fond of these two decades; and I was lucky enough to experience the 1970s firsthand, often in the field, occasionally alongside some of its key protagonists. My enthusiasm here serves as an excuse for my unabashed subjectivity.

**G. M.**
Tucson, Arizona, 2006

1. A careful study of period archives reveals the friendships and close connections between photographers and among the various members of the American photographic community. Charles Traub used the word community when he stated, "During this period, the noncommercial photography world was about a community, an idiosyncratic group of people experimenting, investigating, and questioning what could be said with the camera." (Charles C. Traub, "Up from the Basement," in *The Collectible Moment: Catalog of Photographs in the Norton Simon Museum* [New Haven, CT: Yale University Press, 2006]).

FROM THE FAMILY OF MAN (1955)
TO ROBERT FRANK

n May 1958, the influential amateur photo magazine *Popular Photography* published a list of the world's ten greatest living photographers, as determined by a diverse jury of 243 "eminent critics, teachers, publishers, art directors, consultants and working photographers."[1] The list encompassed a carefully consensual spectrum of fashion photographers and portraitists (Richard Avedon, Philippe Halsman, Yousuf Karsh, Gjon Mili, Irving Penn); fashionable photojournalists (Henri Cartier-Bresson, Alfred Eisenstaedt, Ernst Haas, W. Eugene Smith); and, inevitably, Ansel Adams. Neither the names of Walker Evans (then working for *Fortune*) nor of Robert Frank (already well-known in the photography world, having published *The Americans* in France earlier that year), nor of photographers Harry Callahan, Aaron Siskind, or Paul Strand, who were still very active, were anywhere to be found.

Though largely shaped by a popular approach aimed at a broad readership of amateur photographers, the picture painted by the list is worth considering, for it sums up the general parameters for the work of an American photographer in the late 1950s. There were two outlets for photography: illustration and information. Beyond that, nothing. Ironically, the ranks of this somewhat reductive Top Ten revealed the limits of photography in a country that had made every effort since the beginning of the twentieth century, and the appearance of Alfred Stieglitz, to free the medium from its utilitarian and commercial restrictions and elevate it to the status of a full-fledged artistic practice.

There was another reality hiding behind these illustrious names, along with a genuine lack. In 1958, only New York's Museum of Modern Art (MoMA) and a handful of other venues offered photography an escape from the curse of the applied arts in the United States. Twenty years later, the situation would be dramatically reversed, with a profusion of platforms for serious photography.[2] What had happened in the intervening years? The story I have chosen to tell is of the unprecedented love affair—taking place in the 1960s and 1970s—between a nation and its photographic art. It is the story of the canonization of the heroes who took the pictures.

The change between 1955 and 1967 can be measured by comparing two shows organized at MoMA in New York by the museum's influential curators. The 1967 exhibition entitled *New Documents* definitively established the reign of curator John Szarkowski. The earlier exhibition, *The Family of Man* (1955), marked the last hurrah of a reductive conception of photography illustrating a type of humanism in support of

debatable ideological positions. Its stunning success, both in the United States and abroad, is remembered to this day. The fruit of photographer-curator Edward Steichen's arduous labor, *The Family of Man* identified the photographer's work with the glorification of sentiments as generous as they were general. The show brought together everything documentary photography could offer to anyone eager to use it for his or her cause, ranging through every permutation of human psychology reduced to the most basic morality. It was a success both from a curatorial and ideological perspective, with more than 9 million visitors eventually seeing its 503 works by photographers from 37 countries. The most unlikely contradictions (the sugary poetry of French photographer Robert Doisneau side by side with the Germanic rigor of August Sander) coexisted in a mix in which the final illustrative effect was all that mattered. To achieve his goal, Steichen pulled off an unrivaled tour de force that emptied every picture and every photographer, whether dead or alive, of substance by incorporating them all in a preconceived collective structure worthy of the most bombastic Hollywood productions.

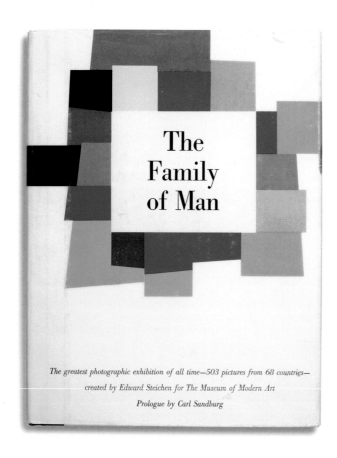

The exhibition was announced—and subtitled— as "the greatest photographic exhibition of all times." In his prologue to the catalogue, Carl Sandburg defined it as a "camera testament, a drama of the grand canyon of humanity, an epic woven of fun, mystery and holiness— here is the Family of Man!"[3] To ensure that the biblical dimension was clear, Edward Steichen placed a quote from Genesis at the beginning of the exhibition as a metaphor for the (photographic) form and its (religious) content: "And God said: Let there be Light." By reducing photography to the role of "mirror of the universal elements and emotions in the everydayness of life,"[4] and intentionally obscuring each photographer's individual approach, Steichen confined the medium to a timeless aesthetic language at the time that the liveliest forces of photographic modernity—for example, Walker Evans,

Cover of the exhibition catalogue *The Family of Man* (1955)

who had chosen not to be in the exhibition, Aaron Siskind, also absent, and Robert Frank, who was generously represented by seven pictures—had been trying for a good twenty years to achieve a personal creative autonomy. This large-scale co-opting of photography by an ideological universalism confronted the medium with its worst demons, reducing it to the most dishonest photojournalism, the kind that destroys history in favor of myth.[5]

In 1958, Robert Frank (b. 1924) published his book *The Americans.*[6] Despite its lack of commercial success, the book encouraged a few independent photographers to explore their medium and their relationship to society in a far more personal or

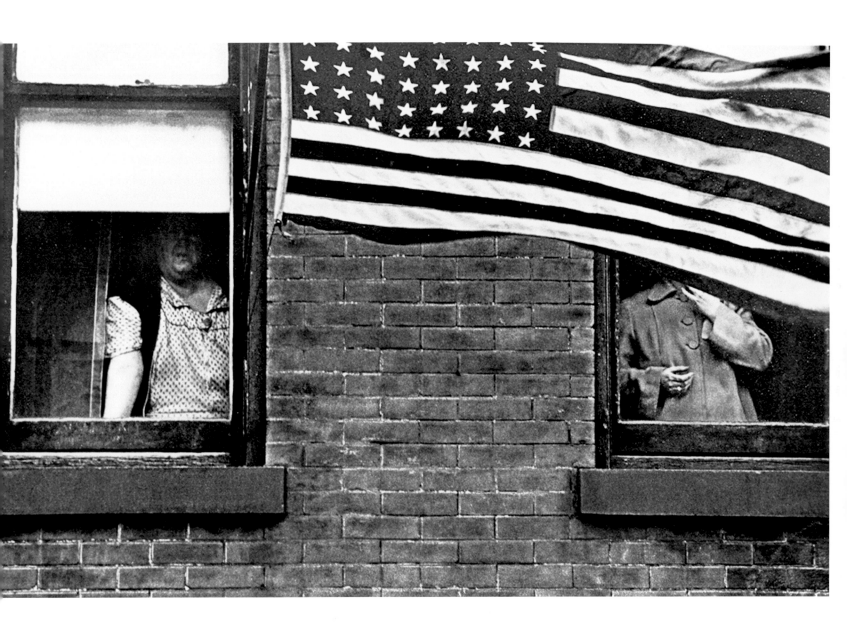

Robert Frank
*Parade—Hoboken, New Jersey,*
1955

experimental way, rejecting the photojournalism of their predecessors. *The Americans* may be considered nearly the exact opposite of Steichen's exhibition. Whereas the curator treated the complex problems of American society with a soothing photographic rendition, Frank formulated an ambiguous personal view, happily turning his back on the clichés of the documentary genre to which Steichen had reduced the work of the photographers in *The Family of Man*. Resistance to *The Americans* sprang up immediately. Although *US Camera* had spoken highly of Frank in September 1954—"he is a genuine poet, . . . a young professional of the highest intelligence"[7]—the photos of his American journey solicited a far different response. In 1960, *Popular Photography*

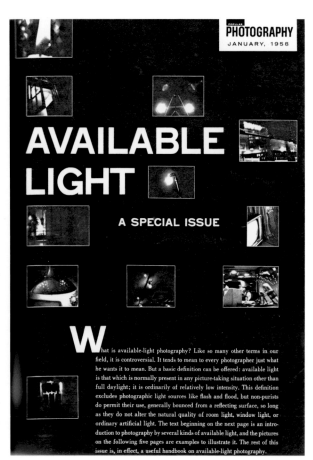

*Popular Photography,*
January 1958

wrote, "These are images of America seen by a joyless man who hates the country of his adoption. . . . If you dig out-of-focus pictures, intense and unnecessary grain, a total absence of normal composition, and a relaxed, snapshot quality, then Robert Frank is for you."[8] Here, form and content were wrapped together in a single condemnation of a photographer using documentary language toward a subjective end, rejecting the conventions of a photojournalism fated to disappear because it could not adequately render the rapidly changing American culture of the 1960s.

To be fair, Frank was not the only postwar photographer to cross the line into a renewed documentary subjectivity. W. Eugene Smith had led the way,[9] and other photographers on the New York scene, whether disciples of the Photo League[10] or solitary explorers of their own experiences, preceded or accompanied Frank. Sid Grossman, Lisette Model, Helen Levitt, Leon Levinstein, and, especially, Louis Faurer drew the contours of a new street photography that redefined the formal characteristics of the photograph through anarchic composition, exacerbated grain, blurry focus, and a more personal relationship to the subject photographed.[11] In 1954, William Klein (b. 1928) took strikingly violent, visually audacious photographs of New York City.

An entire generation would follow in their footsteps. The end of the 1950s and the beginning of the next decade saw the flowering of a crop of photographers sharing a common vision in their exploration of the American social landscape. They laid the groundwork for a decisive turning point in American documentary photography through specific aspects of this vision: the use of ambient light, which had become the new criterion for taking pictures, even among amateur photographers; the spontaneous quality of the photo; and the attention given to the cracks in everyday American life, sometimes even at its margins. Despite being one of its principal innovators, Robert Frank would be the sole artist to abruptly stop believing in this new photographic language and, more generally, in photography. In 1958, he took a series of photos through the window of a New York bus. Then, suddenly, he switched to experimental cinema and abandoned photography, inaugurating photography's era of suspicion.

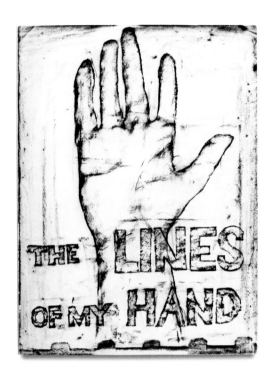

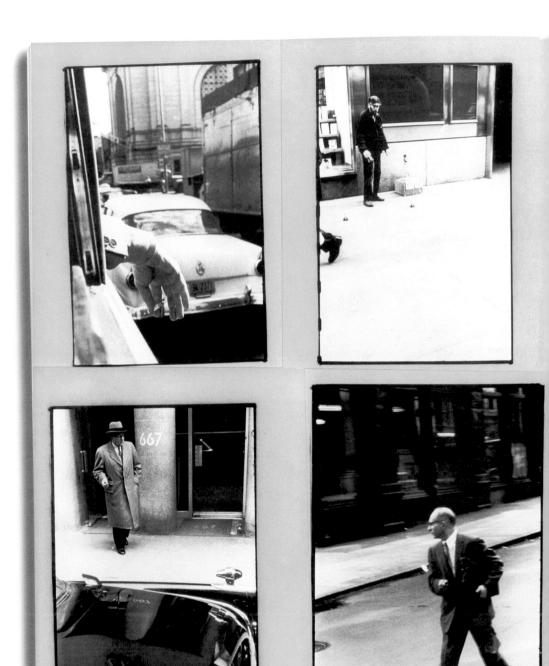

ABOVE LEFT:
Cover of book by Robert Frank,
*The Lines of My Hand* (New York:
Lustrum Press, 1972)

RIGHT:
Reprint of *The Ten Bus
Photographs, New York City*, 1958
From Robert Frank, *The Lines of
My Hand*, n.p.

## WILLIAM GEDNEY (1932—1989)

Though something of a mythical figure in American photography, William Gedney did not have a chance to really affirm his importance. His work was long underappreciated and he died prematurely, of AIDS. Despite a one-man show at MoMA in 1968 and the unflagging support of Lee and Maria Friedlander, Gedney's work received little exposure in the chronicles of sixties and seventies photography. Nonetheless, he left significant archives (nearly 5,000 prints and his diaries), all of which can easily be accessed online,[1] and which attest to his artistic significance and versatility. Though his primary field of action was street photography, he also "covered" fringe communities, such as the Haight-Ashbury hippies in San Francisco (1966–67) and, especially, the gay community to which he belonged. Gedney was one of the first to create a photographic identity for the gay movement. His work as an artist was clearly autobiographical, with his photographic documents illuminated or completed by the texts he wrote. As the author of diurnal and nocturnal images, road journals, and chronicles of the excluded, Gedney may be the most complete—and complex—photographer of the generation born with Robert Frank. This generation would truly find a lineage only in Europe, particularly in the "photobiographic" school best represented by French photographer Bernard Plossu (b. 1945).

1. The Web site dedicated to his archives, which are in the collections of the Duke University library, in Durham, North Carolina, can be found at www.scriptorium.lib.duke.edu/gedney/.

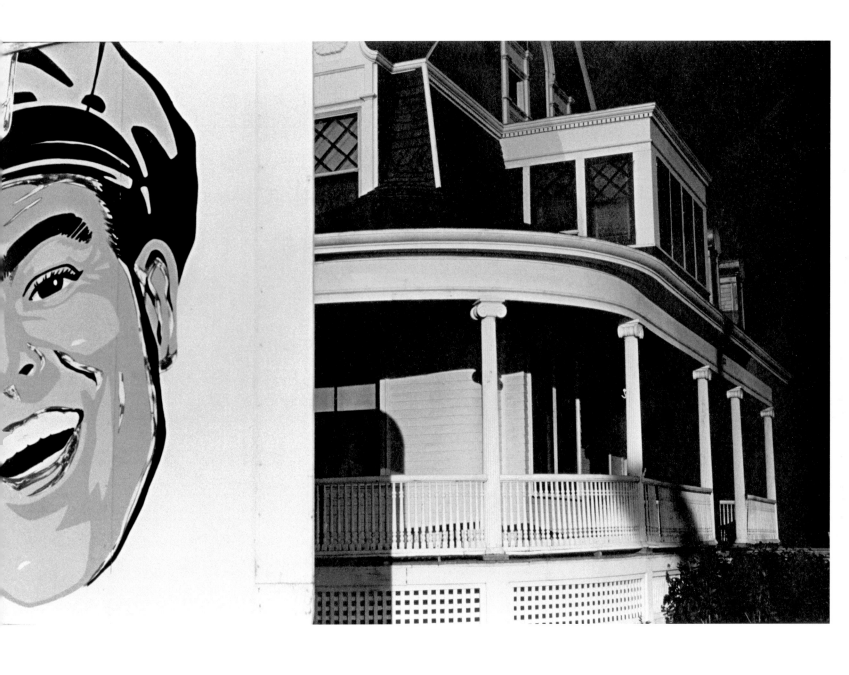

William Gedney
*House with Large Front Porch
and a Billboard in Front at Night,
South Dakota,* 1966

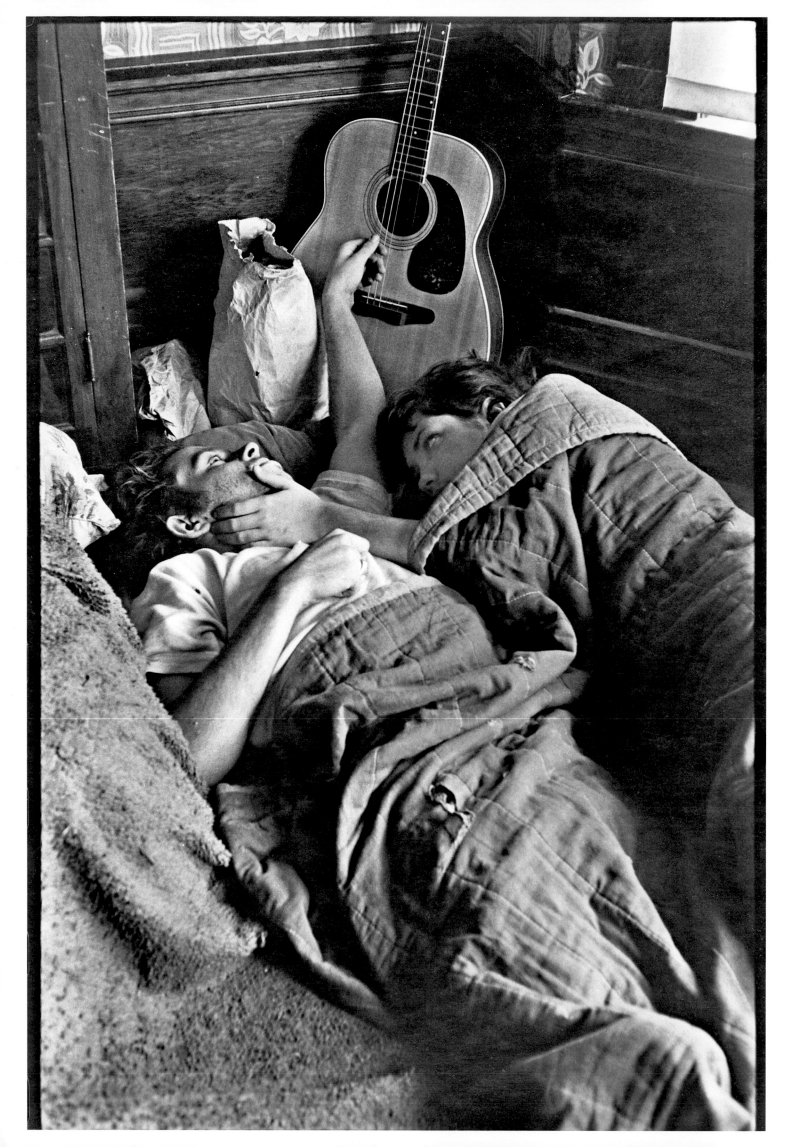

OPPOSITE:
William Gedney
*Hippie Couple in Bed with Guitar in Background, San Francisco,*
1966–1967

ABOVE:
Bruce Davidson
From the series *The Brooklyn Gang,*
*New York City,* 1959

## DON DONAGHY (B. 1936)

Don Donaghy owes his start in photography to Robert Frank. When Donaghy moved from Philadelphia to New York in 1963 as a young devotee of street photography, he showed Frank his first images. Frank responded by helping him to find a place to live, getting him a job at *Harper's Bazaar,* and offering to share his darkroom with him. In his own terms, Donaghy's approach to the photographic act is "nearly religious."[1] He likes to keep things simple technically, particularly by using only a single lens. Bending or altogether ignoring technical rules, he takes delicate images, frequently seized from the momentary nature of a brief encounter, which, despite faulty focus or lighting, are always characterized by a clearly discernible form, occasionally bordering on abstraction. Donaghy insists on the solitary nature of taking pictures, comparing it to a mystical experience. Like Robert Frank, he abruptly stopped taking photographs in 1964 and turned to filmmaking. In her book about the group of photographers she dubbed the New York School (including Diane Arbus, Robert Frank, and William Klein), Jane Livingston writes, "Don Donaghy's photographs of the early 60s are among the most beautiful images made in the history of American photography."[2]

1. Quotation provided by the Yancey Richardson Gallery, New York.
2. Jane Livingston, *The New York School: Photographs 1936–1963* (New York: Stewart, Tabori and Chang, 1992), p. 333.

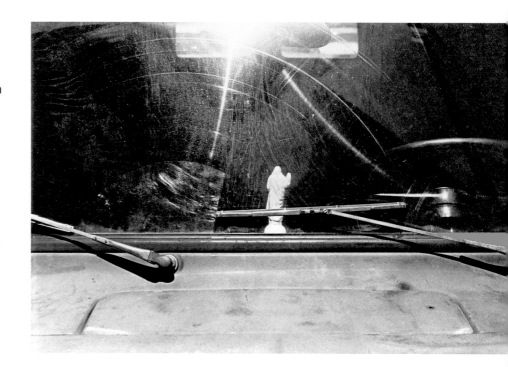

Don Donaghy
*Untitled,* c. 1960

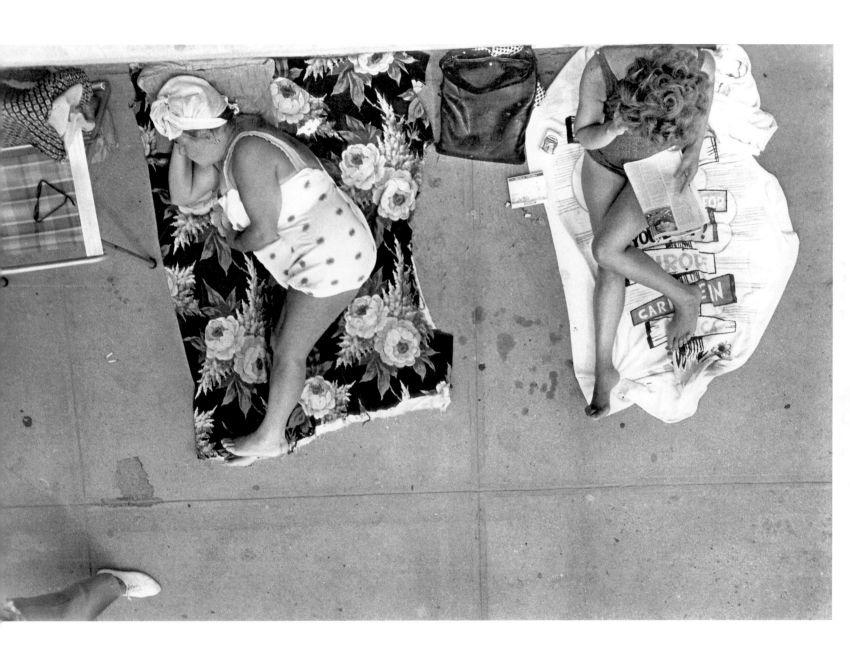

Don Donaghy
*Coney Island, New York City*, 1964

TRANSFORMATIONS OF THE
PHOTOGRAPHIC DOCUMENT

n 1962, The Museum of Modern Art hired unknown curator John Szarkowski
to head its photography department. Szarkowski had little in common with his
illustrious predecessor Edward Steichen except that he was also a photographer
and, like Steichen, had not been formally trained to be a curator. In this
Szarkowski resembled other curators of his generation and those immediately
following it, such as Peter Bunnell, Van Deren Coke, and Nathan Lyons.[12] In a
*New York Times* article published on July 15, 1962, Szarkowski declared that he
was undertaking his new role with a "clear point of view".[13] In a long interview with
*Infinity* magazine in September of that year, Szarkowski made explicit the point of view
that would set him apart from his predecessor, showing his openness to an expanded
notion of photography: "I think that the potential of photography is much larger than
any rationale or theory. It is natural and proper that working photographers should have
strong prejudices about the best use of the medium, trim it to his personal dimensions. . . .
But I know that the accomplishments of photography are more grand than any photo-
graphic creed—whether it's Edward Weston, or Cartier-Bresson, or anyone else's."[14] Most
important, he formulated a position that would become his credo in the years to come,
for an open photographic practice that transcends a reductive pictorial aesthetic: "I don't
feel greatly concerned with the discussion of photography's acceptance as an art form.
Photography is not inevitably an art form, any more than painting is or writing is. Much
of the best photography couldn't possibly have been done if the photographer had been
concerned with trying to prove himself an artist in terms of painters' definitions or
traditions."[15] Szarkowski's statement definitively tolled the bell for the restrictive
photographic elitism forged by Alfred Stieglitz. It opened the door to new directions
and to practitioners more interested in experimenting with the medium's potential than
in deliberately "artistic" attitudes.

The notion Szarkowski cast doubt upon originated in the tradition established
by Alfred Stieglitz, Paul Strand, and Edward Weston. These photographers had gone
beyond—or believed they had gone beyond—pictorialist models to work toward the
modernity of "straight photography." Beginning in 1916–17 (the years when Charles
Sheeler photographed his *Doylestown Houses* series of rural buildings), an entire
segment of the American photo scene, under the influence of Stieglitz, Strand, and
Weston, dedicated itself to elevating photography to the status of a full-fledged art
form.[16] They sought to develop photography into a highly spiritual form of expression

based on the most avant-garde painting, such as Kandinsky's. The limits they imposed were characteristics defined by photographic technique: respect for the descriptive definition; faithful representation of the photographed object without any intrusive mediation; the use of light as a structural element. In summary, Stieglitz, Strand, Weston and their successors—Ansel Adams, of course, as well as the very active Minor White, who had a strong influence on the creative American photography milieu by founding *Aperture* in 1952 and serving as its first editor-in-chief—developed an approach shaped by certain psychological and symbolic assumptions. Stieglitz had set the example with his *Equivalents,* 1922–36, a series of photographs of clouds that served as abstract equivalents of his states of mind.

After World War II, photographic abstraction flowered in the United States under the influence of the New Bauhaus in Chicago, founded and run by the émigré László Moholy-Nagy from 1937 to his death in 1971; it was renamed the Institute of Design in 1944. The proliferation of photographic abstraction drove the medium toward a poetic expressionism and vibrant formal experimentation.

From then on, abstraction and symbolism would be the essential assets of a type of large-format American photography, brilliantly exemplified by Edward Weston's studies of mineral and vegetal forms prior to the early 1950s. Minor White and the "abstract photographers" movement best represented by Aaron Siskind, Walter Chappell, and Paul Caponigro, continued working in this direction throughout the fifties and sixties. With Abstract Expressionism the dominant form of American painting, MoMA organized several exhibitions of photographic abstraction, in which they displayed the most remarkable examples of formal experimentation. The museum's *Abstraction and Photography* made its debut in 1951, was shown again in 1958, and was expanded in 1960 for the exhibition *The Sense of Abstraction.*

This school of abstract metaphysical photography occasionally adopted visual attitudes that could be faulted for sticking too closely to the prevailing trends in painting. Starting in 1972, for instance, Aaron Siskind made a series of photographs as an homage to his friend the painter Franz Kline, who in 1958–59 had helped him select the fifty photos in his first important monograph. Yet, throughout the two decades that concern us, these abstract photographers also produced innovative images of visual poetry that were equally at home in the urban and natural worlds. Nonetheless, many thought they

BELOW:
Ray K. Metzker
*Chicago 15,* c. 1959

OPPOSITE:
Ray K. Metzker
*Car and Streetlamp*
Composed of fourteen
photographs, 1966

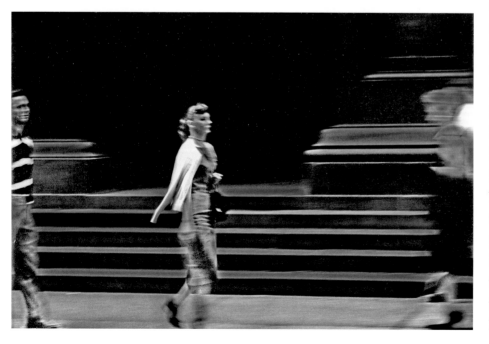

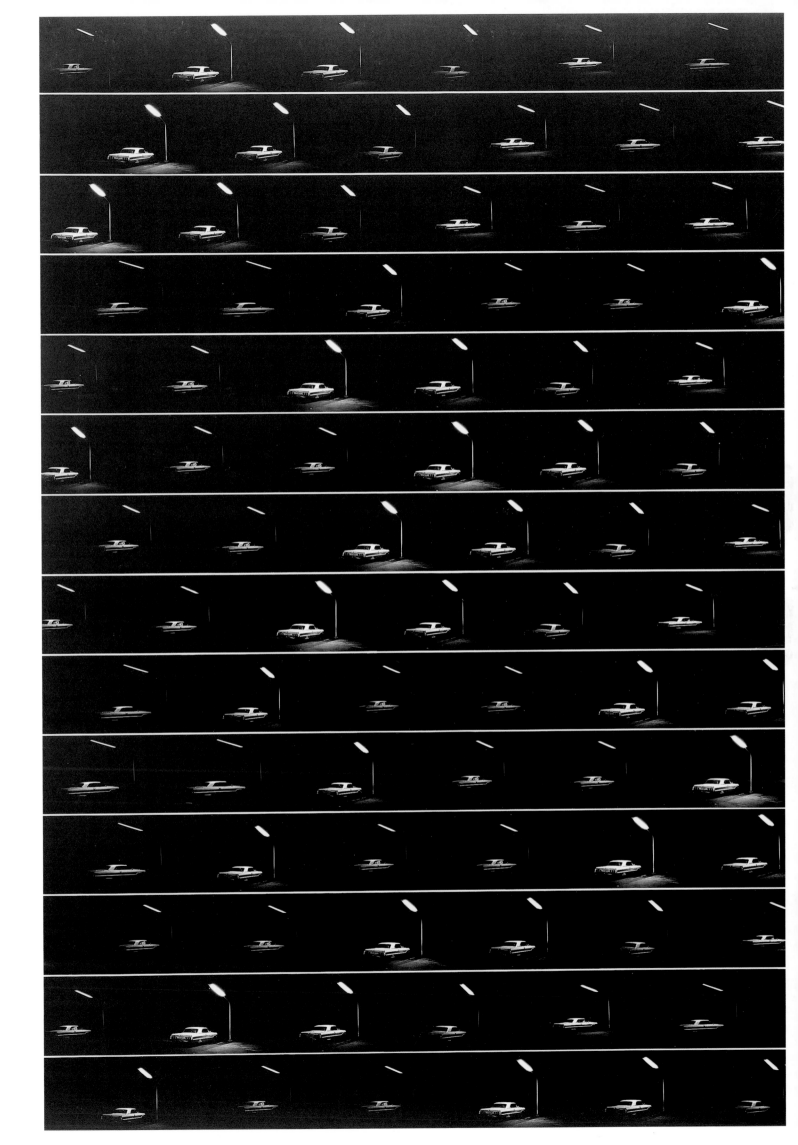

imposed a stifling formal model. In the August 1965 issue of *Popular Photography*, Bruce Downes, one of the magazine's editors, criticized a recent George Eastman House retrospective and catalogue devoted to Aaron Siskind for "canonizing" a "deadening" style of abstraction, what he called "the self-conscious way back to imitating, only now it is Abstract Expressionism rather than nineteenth-century Romanticism. . . . The whole project points up the way in which museums tend to have a devitalizing effect on photography."[17] Downes went on to declare that Siskind, who was celebrated for his abstract work, was providing photographers with an example of a stylistic step backward to a kind of disguised pictorialism.

APERTURE

In fact, the essence of this photography was more closely related to psychological illusions rendered through metaphor, through transformation and transfiguration of the real. For Aaron Siskind, Minor White, Harry Callahan, and their successors, the world could be deciphered as a network of correspondences related to their subjectivity. As Minor White put it, the world allowed for "self-discovery through the camera."[18] White (1908–1976) founded *Aperture* magazine in 1952 with historian Beaumont Newhall and photographers Ansel Adams, Dorothea Lange, and Barbara Morgan. Until his death, through his influence as an editor, teacher, and formally gifted photographer, White embodied the spirit of an artistic photography rooted in the tradition of Stieglitz, Strand, and Weston. In an era of increasingly generalized indifference to culture, with photography consistently moving away from the norms of the beautiful picture, Minor White's artistic stance, along with his open homosexuality and Zen aesthetic, fostered the growth of his mythical status.[19] White's resolutely anti-factual and anti-documentary attitude, with a frank emphasis on aesthetics, placed him in opposition to the photography extolled by Walker Evans. Aside from its exacting compositional standards, this abstract school was identified with carefully controlled photographic technique and well-crafted handmade prints. The Rhode Island School of Design propagated these values during Aaron Siskind's tenure with the photography department from 1971 to 1976. And many artists in the Santa Fe area worked in a similar direction. Paul Caponigro (b. 1932) settled in the region in the 1970s and developed imagery with a mineral theme reminiscent of Weston's. The mystic Walter Chappell (1925–2000), who was heavily influenced by Gurdjieff's philosophical teachings, carried on the work of his master Minor White with a floral series (*Metaflora*) and nudes often inspired by his homosexuality. Occasionally, artists such as Joan Myers (b. 1944), who also settled in Santa Fe, combined this formal approach with a return to old printing techniques such as the palladium print.

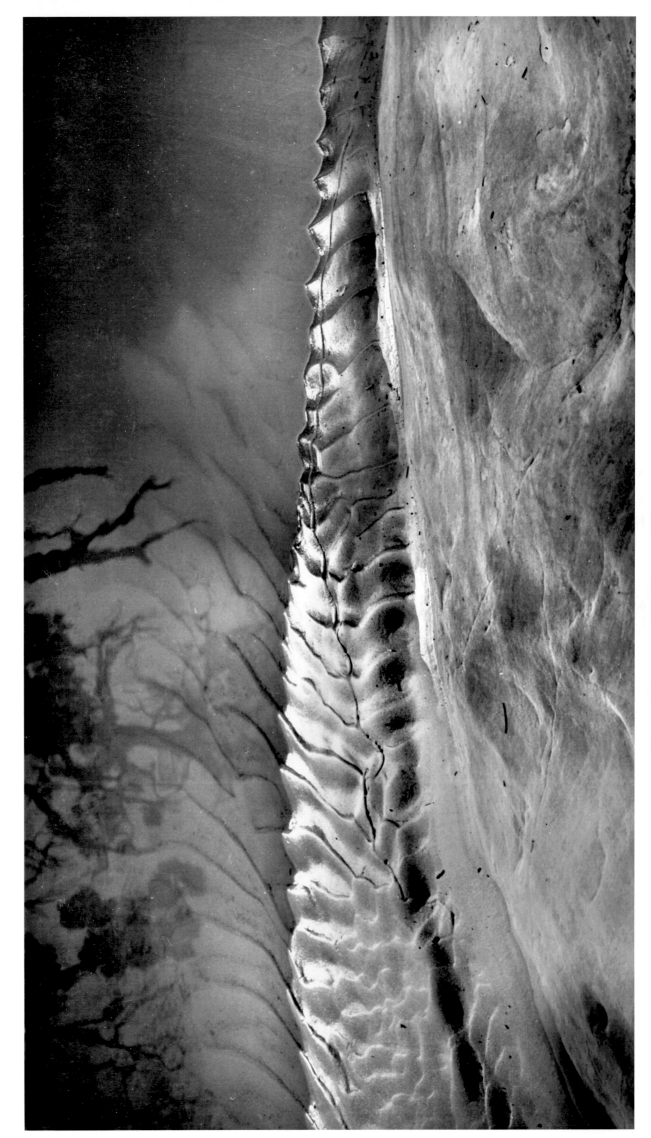

Minor White
*Light Spine, Burr Trail, Utah,*
1966

OPPOSITE:
Walter Chappell
*Bleeding Heart*
From the portfolio *Metaflora*, 1976

ABOVE:
Paul Caponigro
*Landscape, Kalamazoo, Michigan*, 1970

## HARRY CALLAHAN
## (1912—1999)

The crucial encounter of Harry Callahan's career was his meeting with László Moholy-Nagy. Having emigrated from Europe in 1937, the Bauhaus stalwart and founder of European photographic modernism met Callahan in 1946 and hired him as a professor at the Chicago Institute of Design. This was the beginning of Callahan's long career as a teacher who doubled as a photographer hungry for experimentation. His series of snapshots of female passers-by on the streets of Chicago, begun in 1950, was resumed in Providence in 1967. Influenced by abstraction, Callahan's large-format work of the 1950s bordered on minimalism, for example, capturing his wife Eleanor's body or a portion of a landscape in the manner of Japanese calligraphy. His series of beaches on Cape Cod, taken with a 6 x 6 in 1972, displays a visual elegance that anticipates the work of landscape photographers such as Robert Adams. Callahan also dabbled in photographing urban architecture and portraits, and in color. He tried to apply this 1951 definition of his practice to every project: "My work is not storytelling. It's not like documentary pictures. It's the subject matter that counts, but I'm interested in revealing the subject in a new way to intensify it." [1]

1. Harry Callahan, "One in a thousand," notes, 1951, file 48, H. Callahan Archives, Center for Creative Photography (CCP), Tucson, Arizona.

OPPOSITE:
Harry Callahan
*Cape Cod,* 1972

ABOVE:
Harry Callahan
*City Scenes, Cuzco, Mexico,* 1974

## AARON SISKIND (1903—1991)

The astonishing stylistic evolution of Aaron Siskind's photography is rare in the history of the medium. At the beginning of his career, Siskind was a convinced—and convincing—advocate of a rigorous social documentary practice, stunningly embodied in his *Harlem Document* series of 1937–40, and a notable participant in the Photo League. [1] After teaching at Black Mountain College with Harry Callahan in the summer of 1951 and accepting Callahan's subsequent invitation to teach at the Chicago Institute of Design, Siskind radically changed his approach to photography. Starting in the late 1940s, he took up a predominantly abstract, strictly formal photography, shaped by strong symbolic ideas and heavily influenced by the dominant trends in painting, including Abstract Expressionism. Siskind explored the surfaces of walls with his camera, confronting the complex relationships between the forms of objects in an attempt to interpret his personal psychological world. Rejecting any purely factual approach to the subject, he declared: "Walker Evans was essentially interested in recording a fact. I am completely interested in transformation or transfiguration. He was very anti-art, and I am very pro-art. I want you to know it is a work of art." [2] This somewhat elitist attitude was based on a type of symbolism that, at its worst, likened photography to an overly emphatic mode of knowledge. Yet in his best pictures, Siskind rivals painting, in particular the work of Franz Kline. Avoiding imitation and expressing a joyous sensuality, Siskind outdoes Kline's painting by means that are specifically photographic.

1. The Photo League was founded in 1936 to promote politicized documentary photography that recorded the plight of the working class.
2. Quoted in Jonathan Green, *American Photography* (New York: Harry N. Abrams, 1984), p. 55.

Aaron Siskind
*Lima 59*, 1975

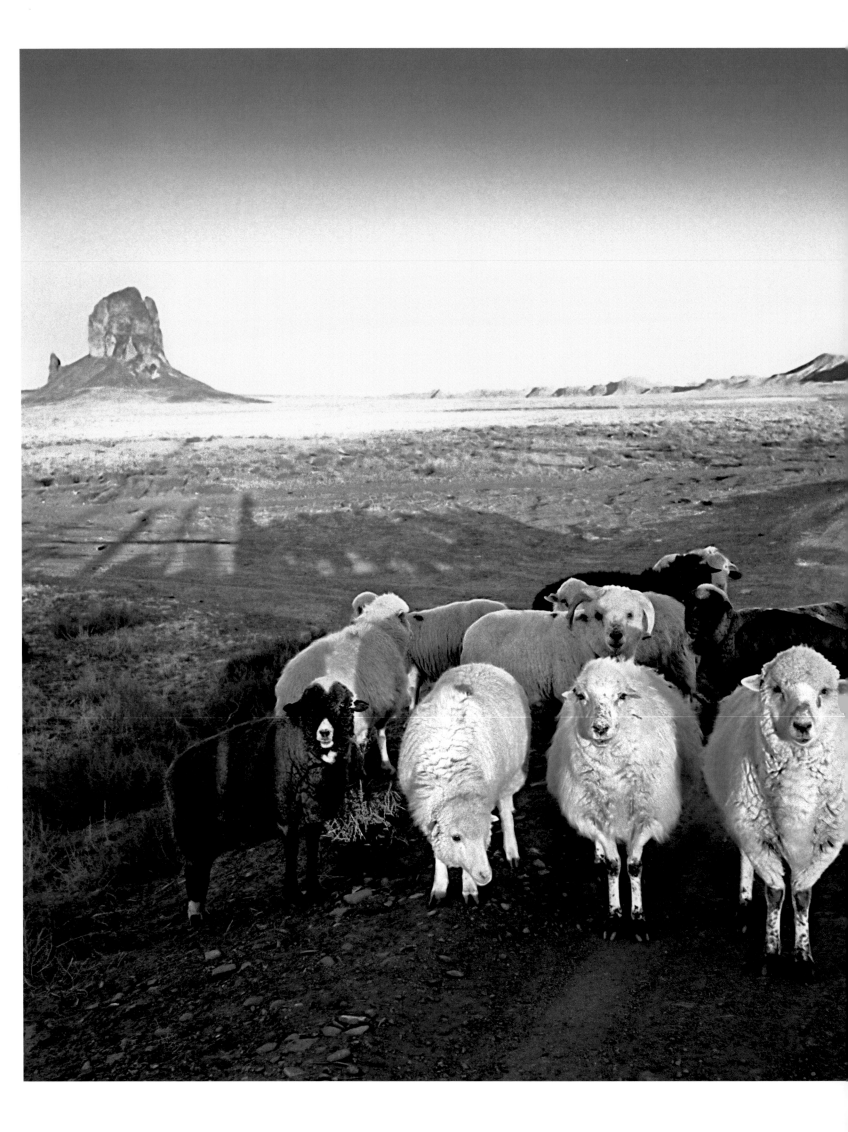

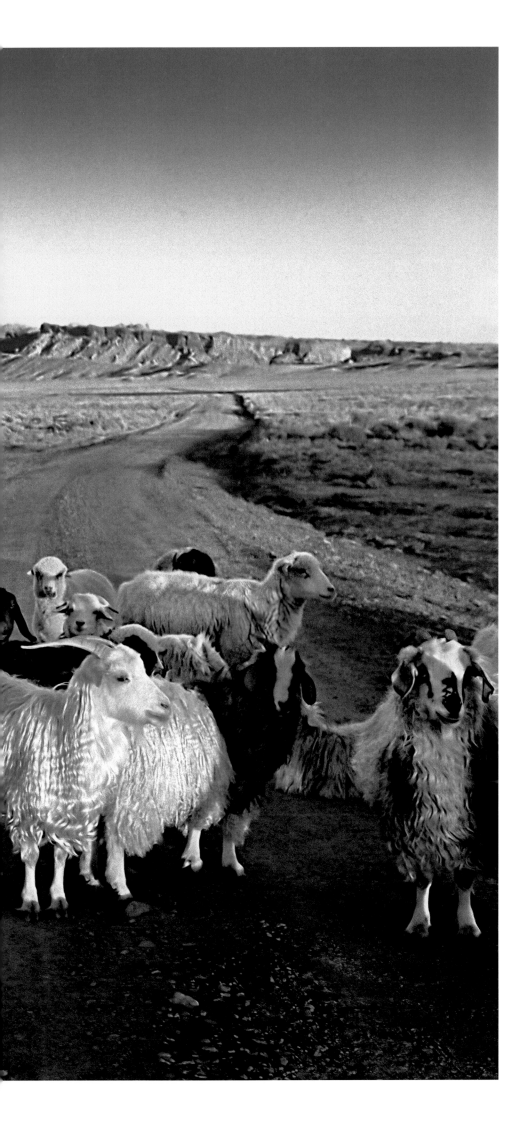

Joan Myers
*Monument Valley Sheep,* 1979

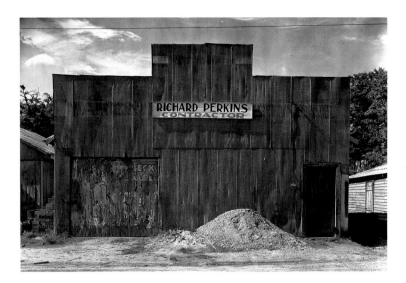

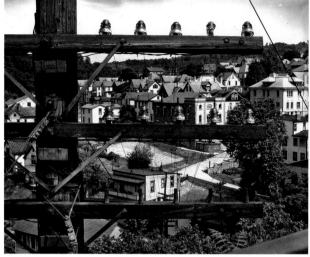

## THE DOCUMENTARY STYLE: FROM THE SOCIAL LANDSCAPE TO THE SNAPSHOT AESTHETIC

In the early 1930s, however, a different attitude toward photography had surfaced in the United States. Its model was the documentary genre as it had been practiced since the invention of the medium in 1839: lacking in artistic ambition, but desiring to use the medium's descriptive nature to faithfully capture the external world. The movement was driven by influential intellectuals such as Lincoln Kirstein and his publication *Hound & Horn*. Starting in 1928, photographer Walker Evans was an active proponent, along with a few others such as Ralph Steiner and Berenice Abbott. I won't dwell on Walker Evans's career during the 1930s and 1940s. [20] Let me simply remind the reader that, at the time, Evans laid the foundation for his work by breaking with the symbolic and artistic current of photography launched by Stieglitz. Evans favored a more neutral photography, with a style borrowed from the pioneers of documentary photography— (French "primitives" such as Baldus, Americans from Matthew Brady to Timothy O'Sullivan, and Eugène Atget)—that he developed in his own work under the name of the "documentary style." This documentary style consisted of frontal compositions, descriptive clarity and accuracy, use of both the large-format camera and 35 mm, a predilection for the vernacular subjects of the modern American civilization Evans lived in, and, especially, a literary ambition that would give his photographs an aesthetic rigor far surpassing false or simplistic documentary posturing. The work that the Farm Security Administration (FSA) commissioned Evans to do between 1935 and 1938 represents his best contribution to the genre. In 1938, Evans was given an important retrospective at MoMA, and the catalogue *American Photographs* was published; it has been regularly reprinted, extending Evans's influence to successive generations. [21] Those who had previously thought of him as simply a documentary photographer were forced to recognize both the stylistic and intellectual reach of his photography.

ABOVE LEFT:
Walker Evans
*Tin Building, Moundville, Alabama,* 1936

ABOVE RIGHT:
Walker Evans
*View of Morgantown, West Virginia,* June 1935

Once he'd gotten started, Evans did not stop for breath. Between 1938 and 1942, he shot a series of anonymous portraits taken in the New York subway (but not published until 1966, under the title *Many Are Called*). He continued with snapshots of passers-by taken in the streets of Detroit and Chicago in 1946. Evans's constant desire to experiment would not begin to influence many young photographers until the late 1950s, when his work began to emerge from the ghetto, both through new publications and shows as well as his role as a photographer and editor for *Fortune*. In 1969, Evans published an article called "Photography," which in just a few pages defined the essence of his aesthetic of the anonymous and the banal, placing particular emphasis on the stance of the photographer confronting the real: "His place is in the street, the village, and the ordinary countryside. For his eye, the raw feast: much-used shops, bedrooms, and yards, far from the full-dress architecture, landscaped splendor, or the more obviously scenic nature. . . . The photographer's eye traffics in feelings, not in thoughts. This man is a voyeur by nature."[22] One can imagine the invigorating effect this type of statement had on photographers such as Diane Arbus and Lee Friedlander, who were working in a similar spirit and had both been encouraged by Evans when they were starting out.

The work of Garry Winogrand—which, strangely enough, Evans detested[23]— underwent a major change after Winogrand's colleague Dan Wiener, whom Evans had also supported,[24] advised him to look at *American Photographs* in 1955. As Winogrand wrote in typewritten notes now in his archives: "I saw W. Evans' *American Photographs* for the first time in 1955. The photographs in the book taught me to love photographs and photography, like no other photographs I had seen up to that time . . . W. Evans' photographs are physical evidence of the highest order of photographic intelligence. His photographs do not kow-tow to anybody's idea of how photographs should look. The photographs are about what is photographed, and how things exist in photographs. No pictures-making system or visual devices are employed here, beyond clear description, lucidity."[25] In an interview with Bill Jay's *Creative Camera* magazine, Winogrand later added: "Evans's pictures changed my life and showed me there was another way of photographing the world than the way *Life* Magazine did."[26]

Evans supported both Lee Friedlander and Robert Frank in the early stages of their careers. After meeting Friedlander in 1956, Evans introduced his portfolio of television screens in *Harper's Bazaar*.[27] Friedlander later assessed his mentor in concise, simple terms: "It seems to me in retrospect that Walker had invented a kind of American photography, and he was brilliant at pursuing it. The whole work knocked me out."[28] Tod Papageorge has thoroughly described Robert Frank's stylistic debt to Walker Evans in a fascinating though occasionally systematic essay.[29]

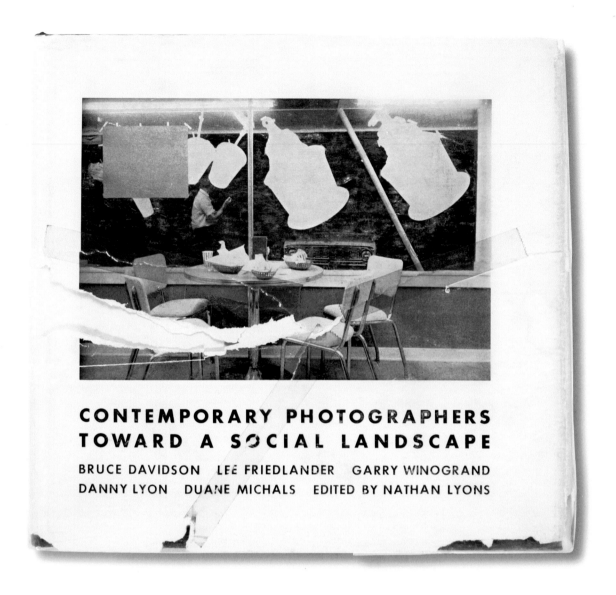

CONTEMPORARY PHOTOGRAPHERS
TOWARD A SOCIAL LANDSCAPE
BRUCE DAVIDSON    LEE FRIEDLANDER    GARRY WINOGRAND
DANNY LYON    DUANE MICHALS    EDITED BY NATHAN LYONS

Cover of *Contemporary Photographers Toward a Social Landscape* [*Toward a Social Landscape*], ed. Nathan Lyons, (New York: Horizon Press, in collaboration with Eastman House, Rochester, NY, 1966)

Two shows mounted within months of each other in the mid-1960s revealed the transformations of the photographic document during the course of the decade. The first, *Toward a Social Landscape,* held in December 1966 at the George Eastman House in Rochester, New York, was organized by the Eastman House's photography curator Nathan Lyons. The exhibition brought together fifty-five photographs by five "documentary" photographers: Bruce Davidson, Lee Friedlander, Garry Winogrand, Danny Lyon, and Duane Michals in his period of "realist" photography, which is radically different from his subsequent body of work. According to Nathan Lyons, these photographers shared a common, and extremely vague, goal of exploring a social landscape. Fundamentally, this doesn't add up to much, other than, perhaps, the attention paid by these photographers to the insignificant and the "infra-social," which justified the concept of the show and the catalogue that accompanied it.

Looking back at the works in *Toward a Social Landscape,* it is clear how much the photographs of Friedlander and Winogrand stand apart stylistically, although not

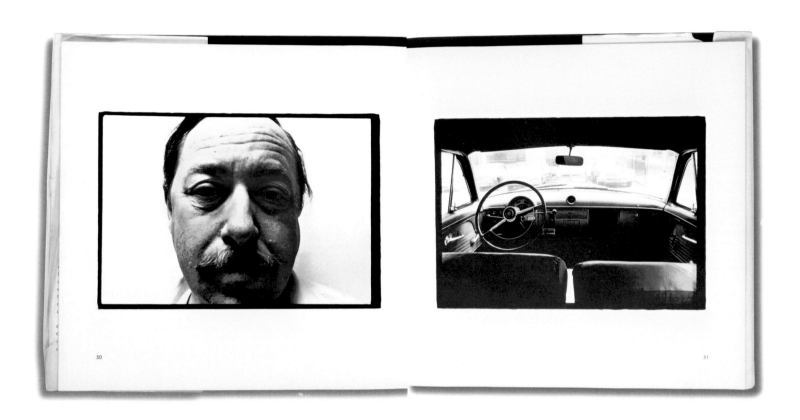

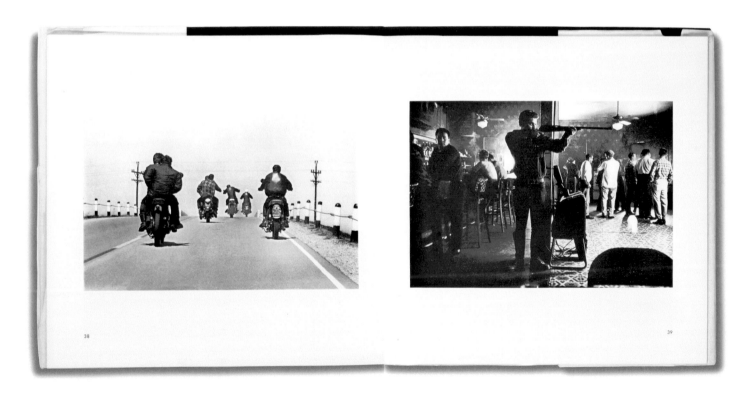

TOP:
*Toward a Social Landscape,*
pages 50–51 (photos by
Duane Michals)

BOTTOM:
*Toward a Social Landscape,*
pages 38–39 (photos by
Danny Lyon)

## DANNY LYON (B. 1942)

Biographers of Danny Lyon always emphasize that he is a self-taught photographer, as if that freedom had sheltered him from the aesthetic temptations of his era, equipping him to maintain his choice of subjects in concrete or, at the very least, socially relevant aspects of reality. Far from the occasionally formalist street photography characteristic of the 1970s, Danny Lyon shared Bruce Davidson's attachment to traditional documentary practice, in which the photographer is so deeply immersed in the scene he or she photographs that his or her point of view does not disappear behind the events recorded. Like Davidson with the Magnum agency, Lyon flourished in a like-minded photographic community. He founded the Bleak Beauty collective, an organization of "photographer activists" determined to keep their work out of the commercial gallery circuit and to control their editorial production. Bleak Beauty eventually developed into a publishing house. Yet, in many ways, Danny Lyon also resembles his friend Robert Frank. Like Frank, he worked as a film director. And, following Frank's example, Lyon distanced himself from the photo scene, preferring to live in a small town in New Mexico.

The autobiographical nature of Danny Lyon's photography is accentuated by his use of text. Indeed, for certain projects, such as *The Paper Negative* (1980), the photographer doubles as writer. Most of the time, Lyon merely expresses his commitment to the subjects he "covers" through a frequently explicit point of view, clearly shown to be part of the action itself. Avoiding a frontal, static approach, Lyon has a knack for making his images strikingly dynamic through the use of significant camera angles: "I was there! I was at that specific place in the scene!" This approach is particularly true of his famous photographs of motorcycle riders, *The Bikeriders,* 1963–67, which inspired Dennis Hopper's 1968 film *Easy Rider,* and in the devastating *Conversations with the Dead,* 1967–68, a series about death-row prisoners in Texas, whom he was authorized to photograph freely.

While Robert Frank's images often seem to be taken by someone hurtling by, with no possibility of turning back, Danny Lyon takes his time. His empathy frequently seems far greater than Frank's, buoyed by the generosity not of a voyeur but of a friend. It's no coincidence that Lyon has a deep and abiding respect for the Southern writer James Agee. The two artists share a sensibility revolted by poverty and injustice, which led the author of *Let Us Now Praise Famous Men* (1941), when confronted by the farmers of Alabama who were victims of the Great Depression, to become the fervent chronicler of a lost cause.

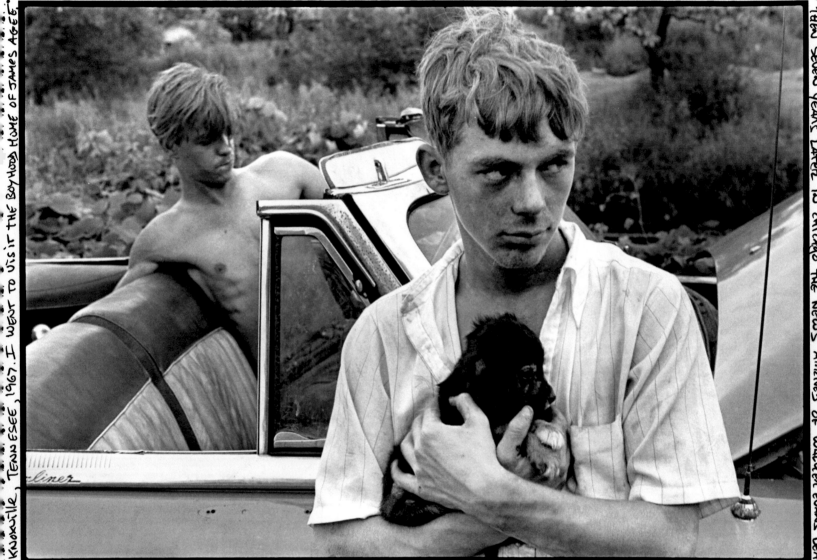

*For Walker Evans and James Agee, two gallent men, together in life, now united immortal in death.*

*Knoxville, Tennessee, 1967. I went to visit the boyhood home of James Agee.*

*Then seven years later in Chicago the news arrived of Walker Evans death.*

*Now they are both gone and we are left thoroughly alone. One would have thought that the world itself would end with this single man's death, so great was his vision, so powerful his art. We will be forever remembered and honored by his work. Like Plato, he seems to have found reality itself.*

ABOVE:
Danny Lyon
*For Walker Evans and James Agee,*
*Knoxville, Tennessee,* 1967

FOLLOWING PAGES:
Danny Lyon
*Ronnie and Cheri, La Porte, Indiana*
From the series *The Bikeriders,*
c. 1963–67

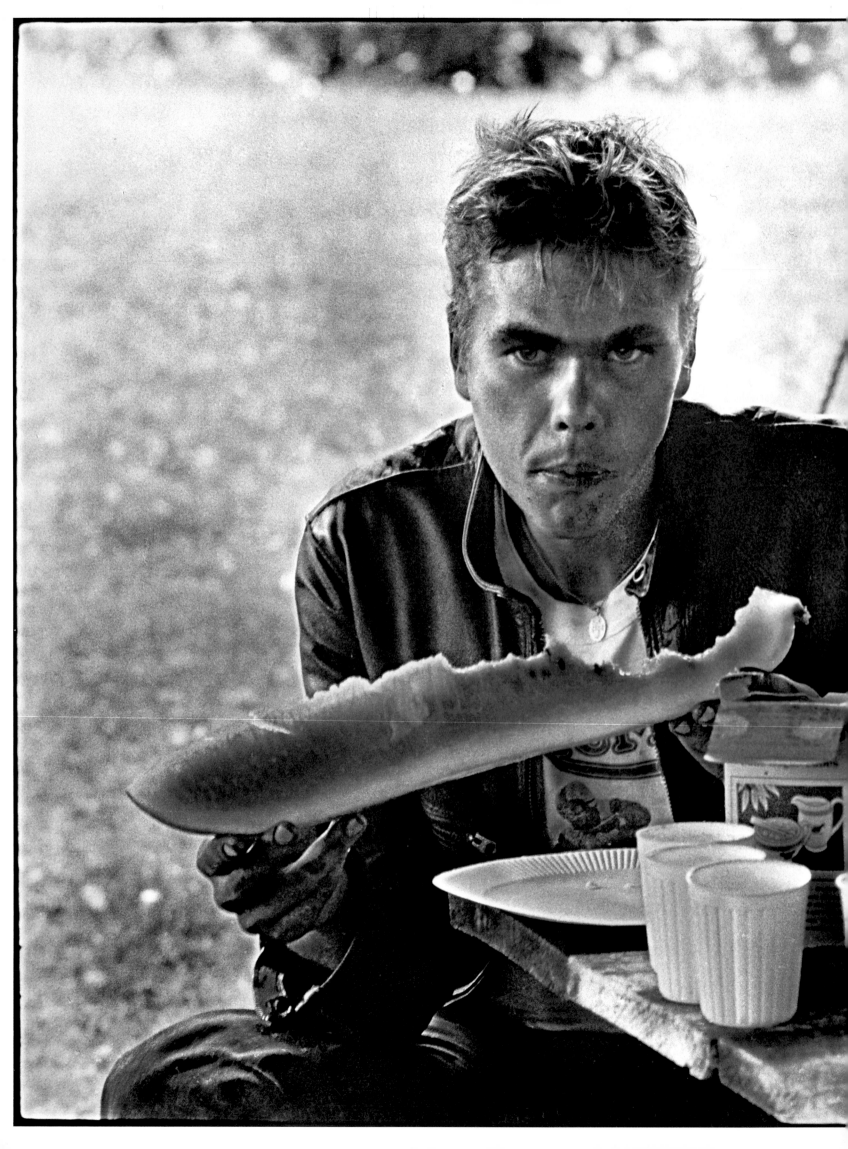

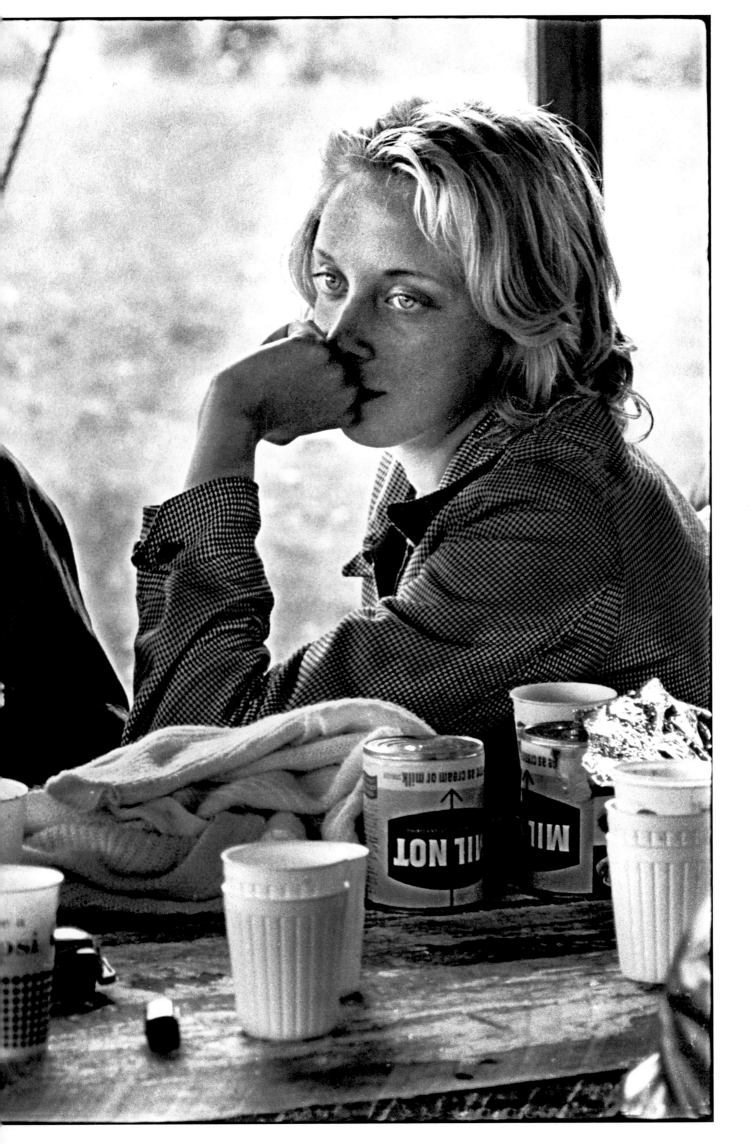

45

necessarily in terms of quality. Davidson, Michals, and, to some extent, Lyon—with *The Bikeriders,* his series on bikers—borrowed their photographic vocabulary from clearly expressive photojournalism influenced both by the social document of the Farm Security Administration (FSA) and the photography advocated by the Magnum agency, which Davidson would soon join. Winogrand and Friedlander were playing a different tune, one that deconstructed established formal values and avoided the pitfalls of treating subjects with poetic grandiosity. Their ironic detachment took them beyond the example set by Robert Frank. Curiously—and this feeling carries over to the *New Documents* exhibition

I will describe in a moment—one has the impression that Winogrand and Friedlander were cast against type, as if what they were putting in place in the late sixties escaped even their most astute contemporaries. The other focus of the exhibition, Nathan Lyons noted in his introduction to the catalogue, was in underlining the informal quality of the work of these photographers, likening it to the aesthetic of the amateur snapshot. Though the snapshot aesthetic guaranteed a picture's documentary authenticity far more effectively than the self-conscious pictorial languages of earlier photographers, it had to be matched with a rigorous subjective perspective to be credible. "When a great photographer does infuse the snapshot with his personality and vision, it can be transformed into something truly moving and beautiful," he wrote. [30]

American photography of the 1970s drew tremendous inspiration from the amateur snapshot. The snapshot became an interesting theoretical case, often the impetus for polemics, while the automation of photographic technique made it possible for anyone to take pictures in which the intention overcame the result in asserting an occasionally indistinct artistic gesture. In 1978, critic Andy Grundberg asked: "I have a photograph in my right hand, and a photograph in my left: Can you tell me which was taken by a photographer, and which by an artist?" [31] And in 1974, *Aperture,* then under the direction of Jonathan Green, published a seminal issue on the snapshot, dealing with its importance in the history of photography and the ambiguity of its very definition. Critics, historians, and photographers—including Walker Evans, who presented a few items from his postcard collection—participated in *Aperture's* debate about a style then in use by the most prominent American photographers. Lee Friedlander, Joel Meyerowitz, Tod Papageorge, Emmet Gowin, and Garry Winogrand contributed portfolios to the issue. Only Winogrand objected to the term *snapshot,* preferring the more generic *still photography.* [32]

ABOVE:
*Aperture* 19, no. 1 (1974)

OPPOSITE:
*Aperture* 19, no. 1
(1974): 120–21

Dear Jonathan

Here are the Polaroids from the „ALBUM"

First page in Album          towards End of Album

This is my selection. and I realize that even
the selecting of these 3 pages takes away
from the Angenesi. Anonymous-ness ,
quality which the Album had.
Now they become more like my „PHOTOGR-
APHS"
I thought I'd send you SNAP-SHOTS —
gone is that Time of S.S. But I hope
that they are POLAROIDS.
       Whatever
            Salut
                Robert

# ROBERT FRANK

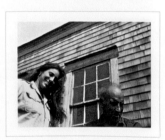

BELOW AND OPPOSITE, BOTTOM:
Cover and pages from
exhibition catalogue
*New Documents*
(New York: Museum of
Modern Art, 1967)
Cover: Diane Arbus,
*Triplets in Their Bedroom,* 1963

OPPOSITE, TOP:
Installation of the
*New Documents* exhibition,
MoMA, New York, 1967

**J**ohn Szarkowski probably analyzed all the changes occurring in the field of documentary photography while preparing the *New Documents* exhibition, which opened at MoMA in 1967. Choosing to focus on the genre's transformations in three "generational" photographers (Diane Arbus, Lee Friedlander, and Garry Winogrand), Szarkowski introduced several new concepts. In his introduction to the brief pamphlet-catalogue published to coincide with the exhibition, Szarkowski wrote: "In the past decade, a new generation of photographers has directed the documentary approach toward more personal ends. Their work has been not to reform life, but to know it. . . . What they hold in common is the belief that the commonplace is really worth looking at, and the courage to look at it with a minimum of theorizing. . . . These three photographers would prefer that their pictures be regarded not as art, but as life. This is not quite possible, for a picture is, after all, only a picture." [33] Although the essence of Evans's thinking about the ambiguity of the "documentary style" is clearly recognizable

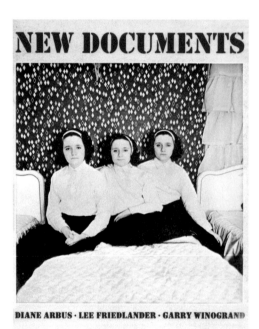

**NEW DOCUMENTS**

**DIANE ARBUS · LEE FRIEDLANDER · GARRY WINOGRAND**

## INTRODUCTION

Most of those who were called documentary photographers a generation ago, when the label was new, made their pictures in the service of a social cause. It was their aim to show what was wrong with the world, and to persuade their fellows to take action and make it right.

In the past decade a new generation of photographers has directed the documentary approach toward more personal ends. Their aim has been not to reform life, but to know it. Their work betrays a sympathy—almost an affection—for the imperfections and the frailties of society. They like the real world, in spite of its terrors, as the source of all wonder and fascination and value, and find it no less precious for being irrational.

This exhibition shows a handful of pictures by three photographers of that generation. What unites them is not style or sensibility: each has a distinct and personal sense of the uses of photography and the meanings of the world. What they hold in common is the belief that the commonplace is really worth looking at, and the courage to look at it with a minimum of theorizing.

The portraits of Diane Arbus show that all of us—the most ordinary and the most exotic of us—are, on closer scrutiny, remarkable. The honesty of her vision is of an order belonging only to those of truly generous spirit.

Lee Friedlander, standing at a greater emotional distance from his subjects, reconstructs our world in precise and elegant metaphors, showing its people in and through their most valued environments: their homes and offices and shops and pageant grounds.

Garry Winogrand's jokes, like those of Rabelais, are no less serious for being funny, and, in the best sense, vulgar. His taste for life, being stronger than his regard for art, makes him equal even to the task of confronting the comedy of his own time.

These three photographers would prefer that their pictures be regarded not as art, but as life. This is not quite possible, for a picture is, after all, only a picture. But these pictures might well change our sense of what life is like.                                        J. S.

The exhibition was selected by John Szarkowski, Director of the Department of Photography, The Museum of Modern Art, New York. The works were chosen from a slightly larger exhibition, of the same title, shown at the Museum in the spring of 1967.

Cover, Diane Arbus: *Triplets, New Jersey,* 1963

## BIOGRAPHICAL NOTES

• Diane Arbus was born in New York in 1923 and studied photography there under Lisette Model. She received Guggenheim Fellowships in 1963 and 1966. Her work has been published frequently in magazines such as *Harper's Bazaar, Show,* and *Esquire* and was shown at The Museum of Modern Art in "Recent Acquisitions: Photography," 1965. Diane Arbus lives in New York.

• Lee Friedlander was born in Aberdeen, Washington, in 1934. He began photography in 1948 and later studied under Edward Kaminski at the Art Center School in Los Angeles. In 1960 and 1962 he received Guggenheim Fellowships for photographic studies of the changing American scene. His work has appeared in magazines such as *Art in America, Harper's Bazaar,* and *Contemporary Photographer* and was shown at The Museum of Modern Art in "The Photographer's Eye," 1964 (circulated nationally, 1964-66), and "Recent Acquisitions: Photography," 1965. Friedlander lives in New City, New York.

• Garry Winogrand was born in New York in 1928 and began photographing while in the Air Force during World War II. In New York, he studied painting at The City College and Columbia University, and photojournalism under Alexey Brodovitch at the New School for Social Research. His work was exhibited at The Museum of Modern Art in "The Family of Man," 1955 (circulated internationally, 1955-65), "Five Unrelated Photographers," 1963; and "Recent Acquisitions: Photography," 1965. In 1964 he received a Guggenheim Fellowship for photographic studies of American life. Winogrand has done free-lance photography for *Sports Illustrated, Fortune, Look, Life,* and other magazines, and for advertising. He lives in New York.

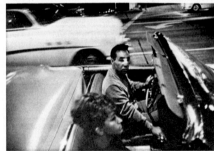

Garry Winogrand: *Los Angeles,* 1964

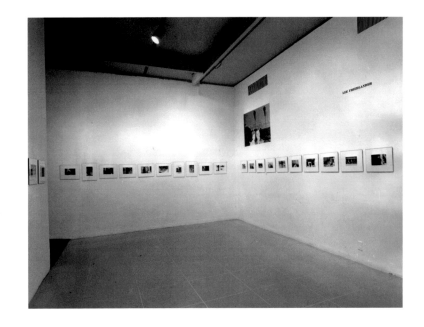

## CATALOG OF THE EXHIBITION

All works are lent by the photographers.

• Diane Arbus
1 *Two Female Impersonators, Brooklyn, New York.* 1961
2 *Exasperated Boy with Toy Hand Grenade.* 1962
3 *Junior Interstate Ballroom Dance Champions, Yonkers, New York.* 1962
4 *Married Couple at Home, Nudist Camp, New Jersey.* 1963
5 *Nude Waitress with Apron.* 1963
6 *Parlor, Levittown, Long Island, New York, Christmas.* 1963
7 *Puerto Rican Housewife, Jefferson Street, New York City.* 1963
8 *Rooming House Parlor, Albion, New York.* 1963
9 *Teenage Couple, Hudson Street, New York City.* 1963
10 *Triplets, New Jersey.* 1963
11 *Widow in Her Bedroom, 55th Street, New York City.* 1963
12 *Girl at Home with Souvenir Dog, New Orleans, Louisiana.* 1964
13 *Family, Evening, Nudist Camp, Pennsylvania.* 1965
14 *Puerto Rican Woman, Beauty Mark, New York City.* 1965
15 *Two Young Women, Washington Square Park, New York City.* 1965
16 *Woman with Locket, Washington Square Park, New York City.* 1965
17 *Identical Twins, Roselle, New Jersey.* 1966
18 *Transvestite with Torn Stocking, New York City.* 1966
19 *Young Man in Curlers, West 20th Street, New York City.* 1966
20 *Young Man on a Sofa, East 10th Street, New York City.* 1966

• Lee Friedlander
21 *Tennessee.* 1962
22 *Street Scene.* 1963
23 *Street Scene.* 1963
24 *Street Scene.* 1963
25 *Street Scene.* 1964
26 *Eddie Kaminski's Dog.* 1965
27 *Kansas.* 1965
28 *Los Angeles Dreamin'.* 1965
29 *Midwest.* 1965
30 *Move on to the Next Title, Lady.* 1965
31 *Drill.* 1966
32 *Street Scene.* 1966
33 *Street Scene.* 1966
34 *Street Scene.* 1966
35 *Somewhere Like Washington, D.C.* 1960s
36 *Mickey.* c.1960s
37 *New York.* c.1960s
38 *New York.* c.1960s
39 *Dad's Helper.* n.d.
40 *North Carolina.* n.d.

• Garry Winogrand
41 *Colorado.* 1959
42 *Central Park Zoo.* 1962
43 *California.* 1964
44 *Dallas.* 1964
45 *Forest Lawn Cemetery, Los Angeles.* 1964
46 *Forest Lawn Cemetery, Los Angeles.* 1964
47 *Klamath River, California.* 1964
48 *Lake Tahoe, Nevada.* 1964
49 *Los Angeles.* 1964
50 *Los Angeles Airport.* 1964
51 *Near Carmel, California.* 1964
52 *Palo Alto, California.* 1964
53 *San Marcos, Texas.* 1964
54 *World's Fair.* 1964
55 *Dallas.* 1965
56 *New York City.* 1965
57 *New York City.* 1965
58 *Wyoming.* 1965
59 *Central Park, New York City.* 1966
60 *Labor Day Weekend, Easthampton, Long Island.* 1966

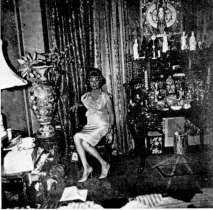

Diane Arbus: *Widow in Her Bedroom, 55th Street, New York City*, 1963

An exhibition circulated by The Museum of Modern Art, New York

Garry Winogrand: *San Marcos, Texas*, 1964

Lee Friedlander: *Los Angeles Dreamin'*, 1965

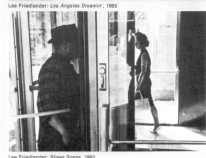

Lee Friedlander: *Street Scene*, 1963

here, neither Nathan Lyons nor John Szarkowski mentioned his name in their catalogue introductions.

The innovative nature of American street photography of this period, which is at the heart of the documentary work of Arbus, Friedlander, and Winogrand, has been established time and again. Particularly in the work of Friedlander and Winogrand, street photography reveals what could be called an "aesthetic of the instant perception." This remarkable, specific relationship between photographer and subject consists in automatically capturing what randomly, or suddenly, appears in front of the camera, in the viewfinder, without premeditation, and with the camera often preset. The possibility of using photography to record "at random" initially emerged in the United States in the late 1940s and early 1950s, probably under the influence of music (free jazz), literature (Jack Kerouac and the beat poetry of Allen Ginsberg), and the gestural language of Abstract Expressionist painting (Jackson Pollock and De Kooning). Walker Evans inaugurated this approach with his series of New York subway passengers taken between 1938 and 1942, and, especially, his portraits of passers-by on the streets of Chicago and Detroit in 1946, a project Harry Callahan would pick up in Chicago in 1950. During the course of the 1960s and 1970s, street photography gradually took hold of this new visual language.

In the street photography aesthetic, framing was important—it was often approved on the contact sheet, once the photo was taken—but composition was unnecessary. Or, rather, the attributes of composition shifted and became entirely dependent on the subject's position in front of the lens, launching a completely new visual vocabulary, sometimes rather brutal, but with an authentic iconoclastic freshness. Framing could be preset, instinctively controlled on the basis of focal length. Winogrand and many other photographers began to make regular use of the wide-angle lens, which allowed them to have greater depth of field and to integrate far more information in the picture. Lee Friedlander took advantage of increased depth of field to create the jarring foregrounds and visual clutter he was so fond of using to capture the experience of the urban or natural landscape in contemporary America.

In any case, the idea of going along with the flow, far different from capturing an image according to Cartier-Bresson's norm of the decisive moment, took root and grew. Photographers began accumulating images and selecting the most visually striking one on the contact sheet. It's not hard to see why photographers privileged the street as their theater of operations: its constant chaos, permanent vitality, and unpredictability provided a thousand possibilities to record at the level that took full advantage of the visual challenges on offer.

OPPOSITE:
Lee Friedlander
*Self-Portrait, Route 9W,*
*New York,* 1969

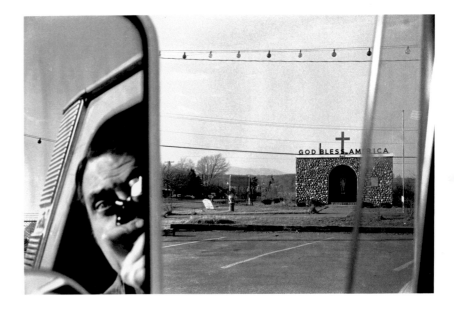

## LEE FRIEDLANDER (B. 1934)

Friedlander's mentor, Walker Evans, once described him as "an absolute eye." And when Friedlander had to choose a title for his first monograph in 1989, he turned to the eye. Borrowing from the lyrics of an obscure fifties rock 'n' roll song, he compared himself, the photographer, to *A One-Eyed Cat*—the book's title—as if the eye, body, and camera became one to accomplish his voyeur's work. This rebellious spirit epitomizes Lee Friedlander. After experiencing the shock of Robert Frank's *The Americans* in 1958, Friedlander set out to complete the photographic redefinition of the American landscape that Walker Evans had initiated in the 1930s. Friedlander's photography is characterized by an organized perception of chaos and visual obstruction; a fascination with architectural fragments, shop windows, screens, and the slices he carves out of the disjointed fabric of perception; a rejection of lyricism; and a cold, ironic recording of the street, its occupants, and its overload of visual signs. From the initial stage of his career to the present day, Friedlander has adapted the lessons of Atget and Walker Evans to the world of large American cities: visual intelligence above all; energy; culture; and distance.

Yet it would be a mistake to limit Lee Friedlander's work to street photography, the field in which his good friend Garry Winogrand excelled. Friedlander takes an equal interest in the natural and urban landscape, using both contexts to explore the questions of visual perception that form the basis of his work. In the seventies, Friedlander realized it was time to stop making landscape photography as Edward Weston had defined it since the thirties, when he photographed a country whose chaotic and industrial aspects he refused. Friedlander reformulated what was at stake in the landscape by getting rid of all metaphorical or grandiloquent intentions, employing the visual logic of his previous urban photographs to capture the abruptly overlapping planes and volumes suggested by natural chaos. The obstruction of the photograph's foreground, often due to a clutter of rocks or plants blocking the limited range of vision from eye level, became an essential rule of Friedlander's economical approach to perception. It was intended to serve as a rejection of a false, immediately legible landscape and, especially, as an opportunity to experiment visually with a new geometry. The apparent confusion of this new geometry would eventually apply to every landscape photographed by Lee Friedlander, whether natural or urban.

Although Friedlander's interest in the portrait initially developed from his early commercial jobs involving musicians, it conveys the same visual concerns. Whether his subjects are friends and fellow artists or anonymous models, Friedlander's portraits avoid any aesthetic complacency. By shooting his subjects frontally, in the raw light of the flash, Friedlander indiscriminately blends them into their trivial environments. He followed the same approach to redefine the nude as a genre, focusing on the heavy, fleshy aspects of the body, without truly allowing sensuality into the picture. The laws of optical perspective or the constraints of a semi-wide-angle lens lend naked women photographed by Friedlander the elegance of a formal twist or oddity.

There are few bodies of photographic work as little concerned with the person of the photographer as Friedlander's. Nonetheless, he has always photographed himself, to the point that many know him only for his self-portraits. There is little egotism in these self-portraits. In Friedlander's terms, they appeared in the 1960s as "a peripheral extension" of the artist, attesting to his presence in the social landscape and, often, to a disturbing visual element. When it comes to discussing his work, Friedlander's laconic stance is legendary. He is more interested in making photography than talking about it. In a career lasting more than fifty years, he has never ceased to redefine his limits and to energize his photographic projects by constantly renewing them, often turning them into books.

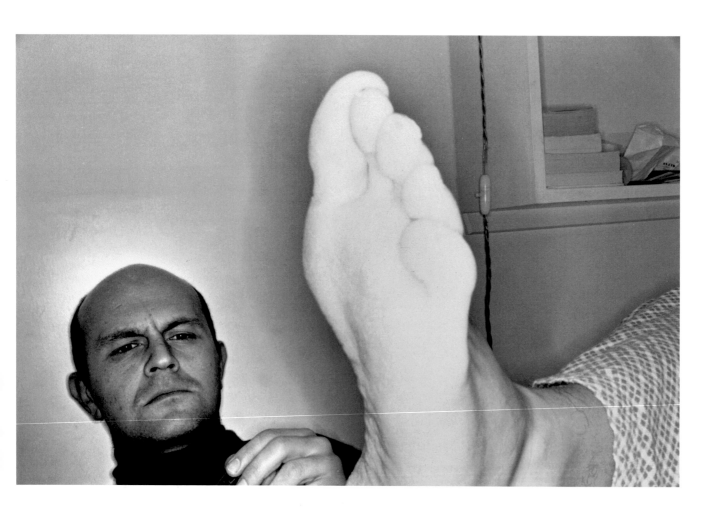

Lee Friedlander
*Jim Dine, London,* 1969

Lee Friedlander
*Frank Luke, Capitol Grounds,
Phoenix, Arizona,* 1974

## GARRY WINOGRAND (1928—1984)

The work of Garry Winogrand currently seems neglected, as if critics and publishers were frightened away by the incredible volume of images he accumulated during his career; hundreds of undeveloped rolls of films and unprinted negatives are sitting in his archives at the Center for Creative Photography (CCP) in Tucson. Maybe the present generation is irritated by John Szarkowski's dogged insistence on making Winogrand's persona and work embody the essence of his conception of photography. Yet Winogrand is more important than the handful of clichés with which we have saddled his images and his contributions to street photography and, in particular, the medium itself. Critic Janet Malcolm, who detested Winogrand, unjustly accused his work of being vulgar.[1] More than a photography "junkie," Winogrand now appears to us as a moralist, a critic of American society who bemoaned its cultural impoverishment and dissolution. His three major books, *The Animals* (1969), *Women Are Beautiful* (1975), and *Public Relations* (1977), constitute an extraordinarily relevant visual reflection on social relations at every level. *The Animals* is a fiercely ironic look at animal anthropomorphism reaching into the American street, which Winogrand perceived as a zoo. *Women Are Beautiful* presents a tender homage to the female sex, but it was violently attacked by feminist circles, which were prompt to act on the most blatant misinterpretations. *Public Relations* casts a cruel, disillusioned glance at the social rites of Winogrand's fellow Americans, particularly in the art world, often reducing them to the most grotesque effects.

Aside from the content of the pictures, Winogrand's work with form makes him truly fascinating. Few of his colleagues, with the exception of his friend Lee Friedlander, put as much energy and persistence into interpreting the very nature of the connection between photography and reality, to the point of reversing the

RIGHT AND FOLLOWING PAGES:
Garry Winogrand
*New York*, c. 1961

54

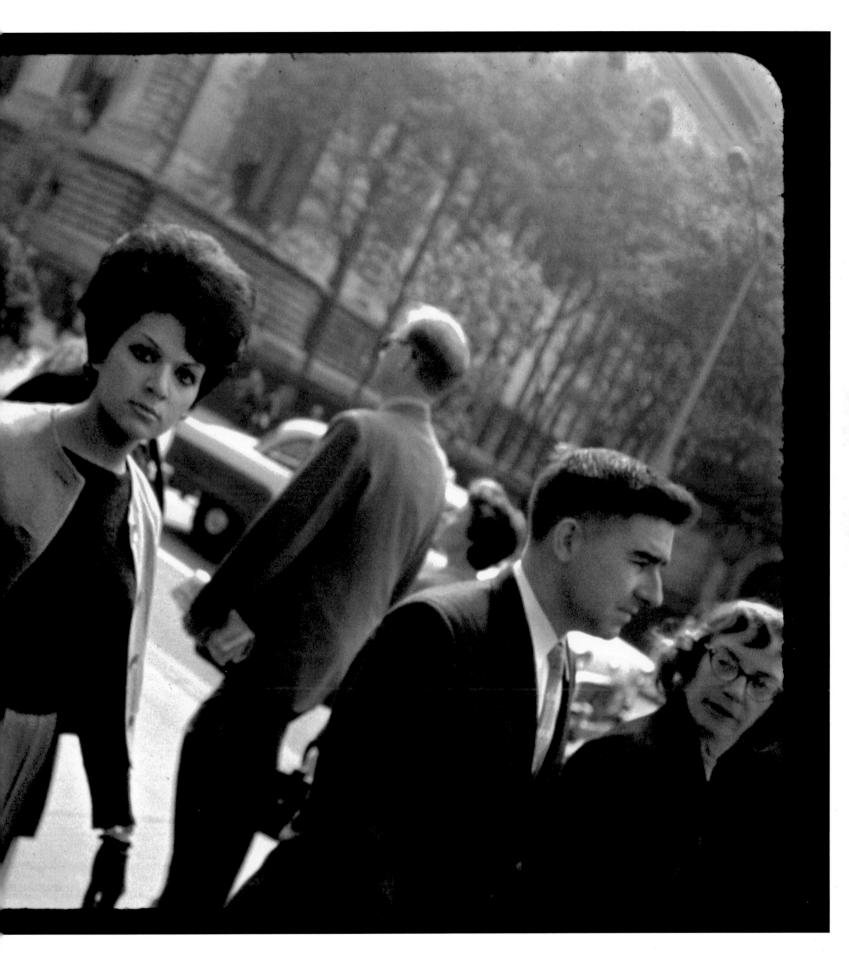

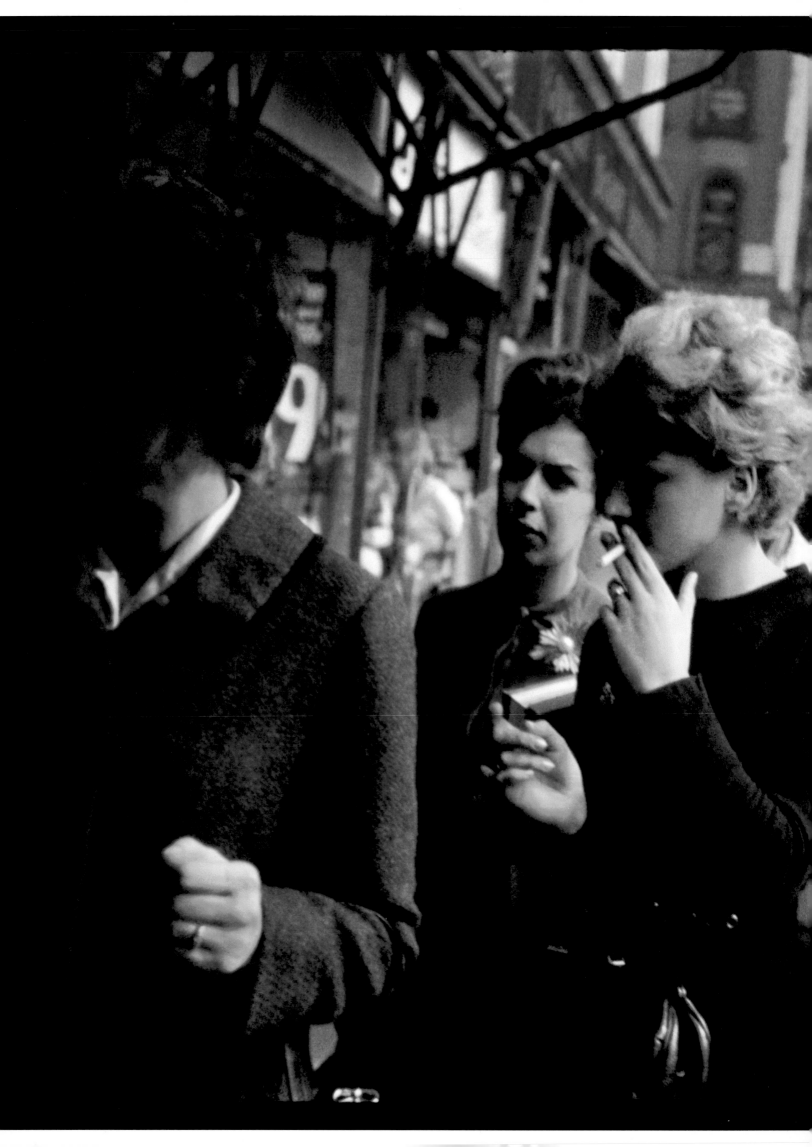

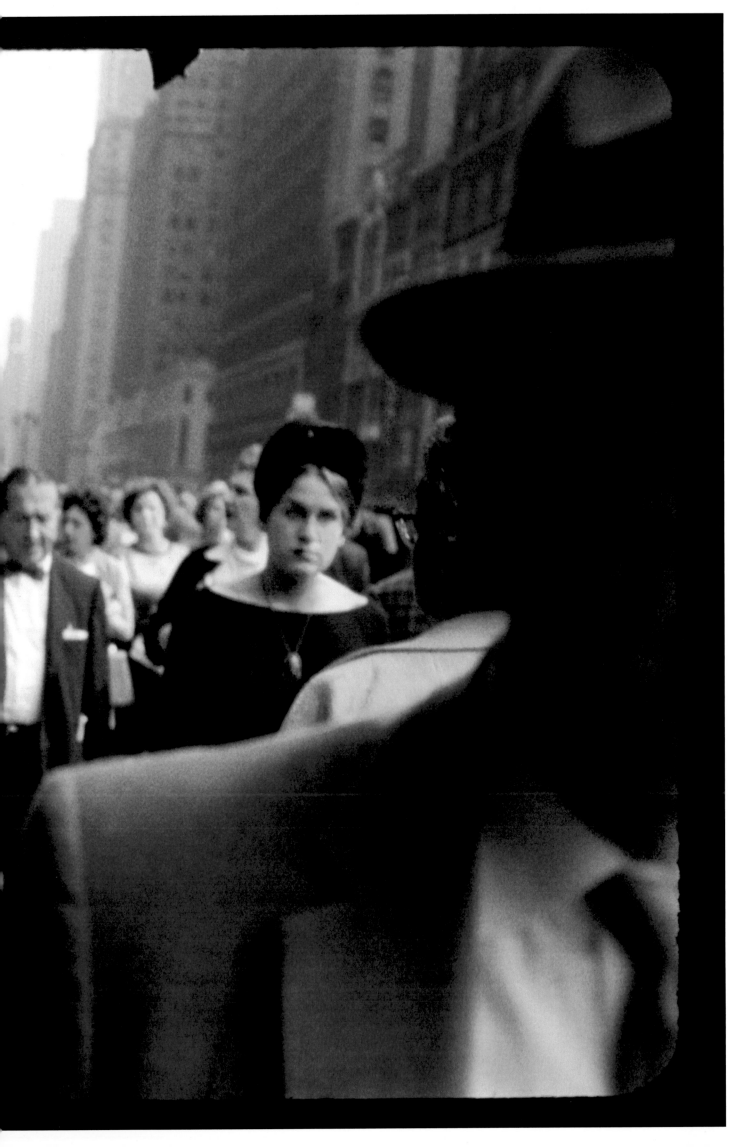

usual relationship. For Winogrand, the world existed only once it was photographed. Our knowledge of the world was therefore beholden to that responsibility. Fascinated by the transformation of the real into photography, Winogrand found the best expression for his research in street photography and its constant flow of images, through the aggression of taking the picture and its obsessive repetition, but also thanks to the dynamic exchange between the photographer and his subjects.

According to Winogrand, everything could be photographed, and no stylistic formula could lay down the law. Mechanical recording with a camera—in Winogrand's case, a 35 mm with a wide angle—was the only law accepted. Framing was systematically anarchic. Any preconceived visual coherence was rejected so that the moment of taking the picture could be left to chance, to be carefully evaluated later on, when Winogrand chose images from the contact sheet. Winogrand held that "there are no external or abstract or preconceived rules of design that can apply to still photographs."[2] Such a radical position borders on provocation.

Winogrand's aesthetic of disorder has often been described as a parody of amateur photography that signed the death warrant of the beautiful image. In fact, Winogrand's approach was only a new idea for deconstructing the well-crafted photograph in order to scare off the purists. An article published in *Newsweek* on November 7, 1977, on the occasion of MoMA's big retrospective dedicated to the *Public Relations* series, noted that "[Winogrand's] work . . . is not always easy to like or respect."[3] It is precisely the lack of superficial seduction that is one of this major artist's greatest strengths. The intentional lack of symbolism, or sentimentality, or hidden meaning in the photographs, as well as their descriptive terseness, can be ascribed to a deliberate, rigorous desire to be factual. "There is nothing as mysterious," Winogrand wrote, "as a fact clearly described." Somehow, this sense of the mystery of photomechanical recording brings us back to the wonders discovered by the first photographers at the dawn of photography.

1. See Janet Malcolm, "Certainties and Possibilities," *The New Yorker*, August 4, 1975, pp. 56–59.
2. Notes by Garry Winogrand, Austin, Texas, 1974, Winogrand Archives, CCP, Tucson, Arizona.
3. "The Medium is the Message," p. 106.

Garry Winogrand
*Park Avenue, New York,* 1959

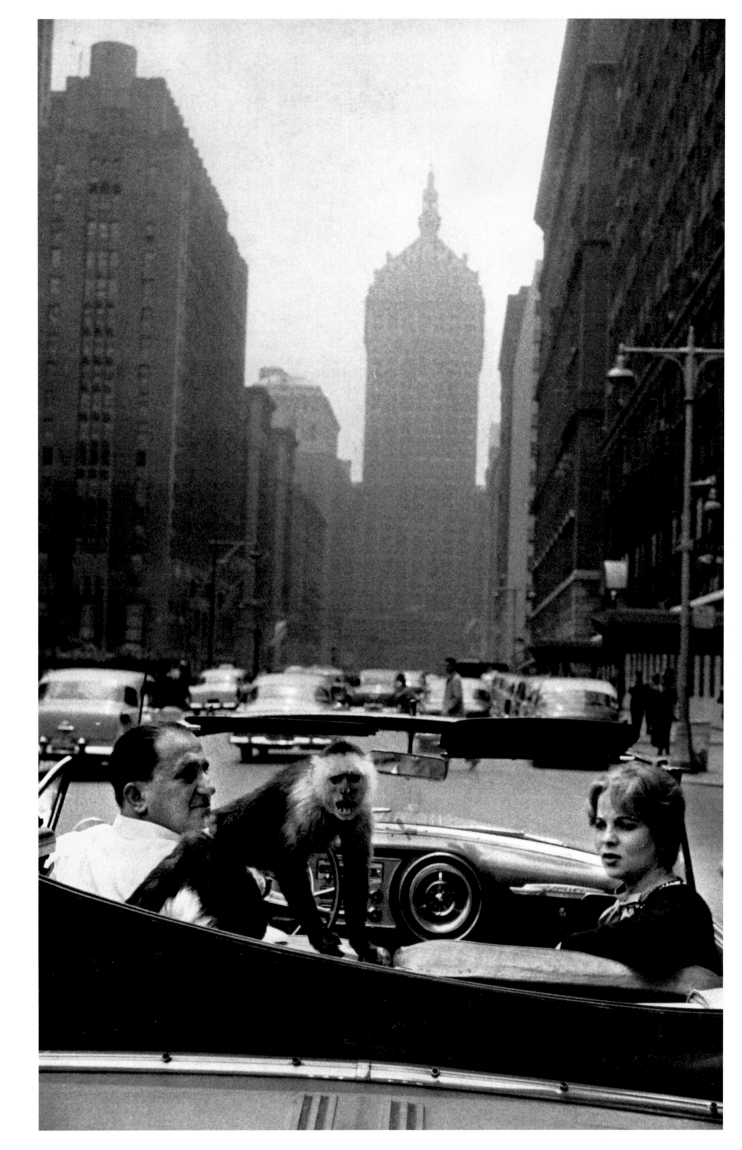

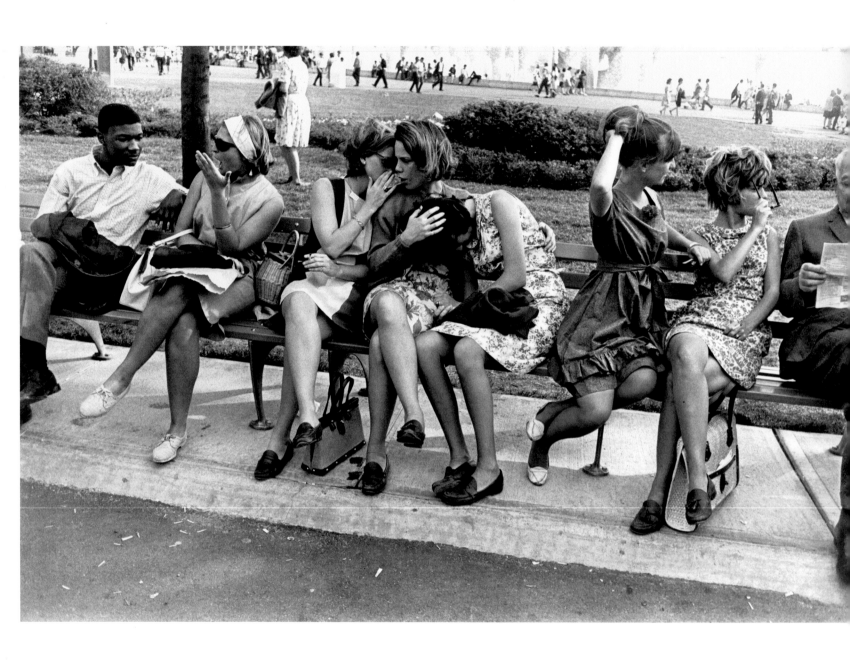

Garry Winogrand
*World's Fair, New York*, 1964

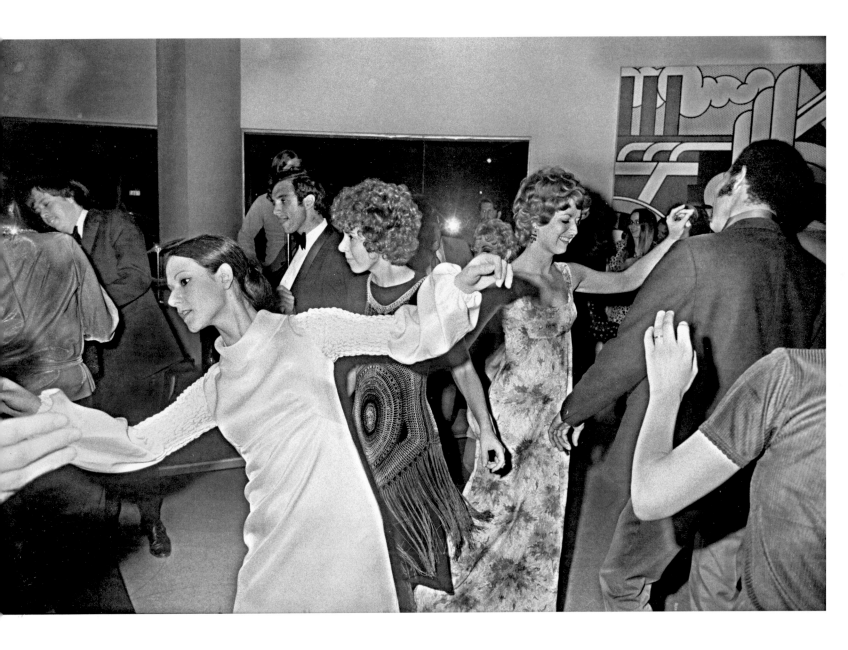

ABOVE:
Garry Winogrand
*Tenth Anniversary Party,
Guggenheim Museum,
New York*, 1970

FOLLOWING PAGES:
Garry Winogrand
*Dallas, Texas*, 1964

61

# TOD PAPAGEORGE (B. 1940)

The multitalented Tod Papageorge is a gifted street photographer, a shrewd editor (he was editor-in-chief of *Aperture*'s special issue on "The Snapshot."[1]) and a critic whose importance is due for an upgrade. His photo work demonstrates an acute attention to detail and the frequently complex spatial placement of the subject, sometimes accompanied by expressions of his genuine sense of humor or social satire.

As a curator, Papageorge organized the 1977 MoMA exhibition *Public Relations: The Photographs of Garry Winogrand* and wrote the foreword to the catalogue. He was also one of the first critics to point out the influence of Walker Evans on American photographers of the 1960s and 1970s, notably in his 1981 book *Walker Evans and Robert Frank: An Essay on Influence.*[2]

1. *Aperture* 19, no. 1 (1974).
2. Tod Papageorge, *Walker Evans and Robert Frank: An Essay on Influence* (New Haven, CT: Yale University Art Gallery, 1981).

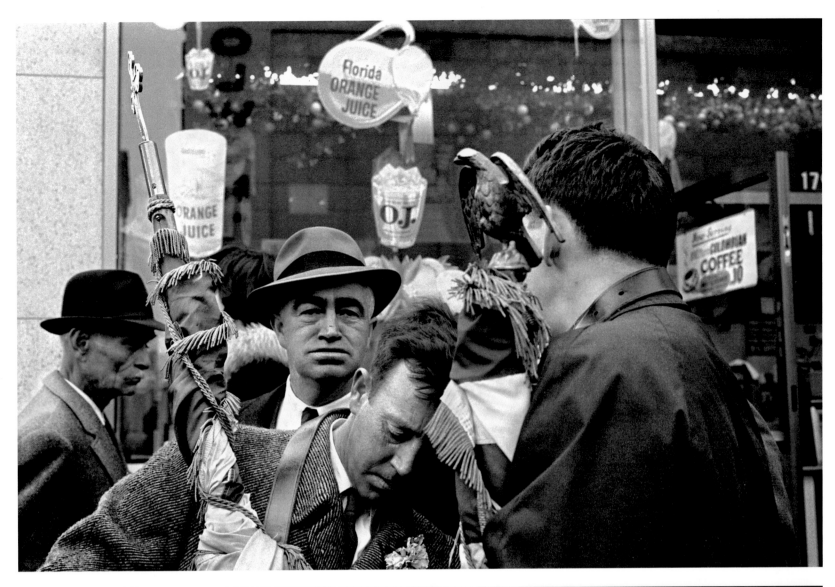
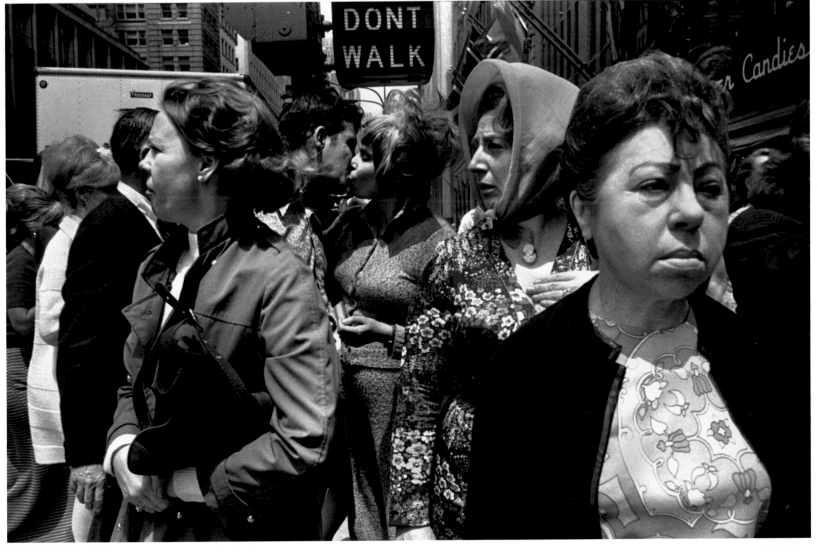

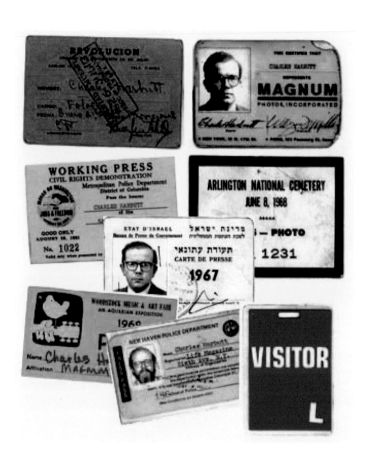

## CHARLES HARBUTT (B. 1935)

A charismatic figure of the brilliant photojournalism scene, Harbutt joined the Magnum agency in 1963. Characterized by an astonishing poetic vision and the sense of loneliness that surfaces in several of his images, Harbutt's black-and-white photography had a significant influence on the young European photographers who discovered his work during his workshops at the Arles International Conference in France during the late 1970s.

Published in 1973, his book *Travelog* [1] served as the model for a type of autobiographical travel photography. This small volume is the quintessence of Harbutt's art, a form of photography that mixes documentary work with the expression of a personal life. The French photographer Raymond Depardon, also a member of the Magnum agency, owes a great deal to Harbutt's example. Harbutt's work certainly deserves greater recognition, if only to do justice to the wealth and diversity of themes he has treated.

1. Charles Harbutt, *Travelog* (Cambridge, MA: The MIT Press, 1973).

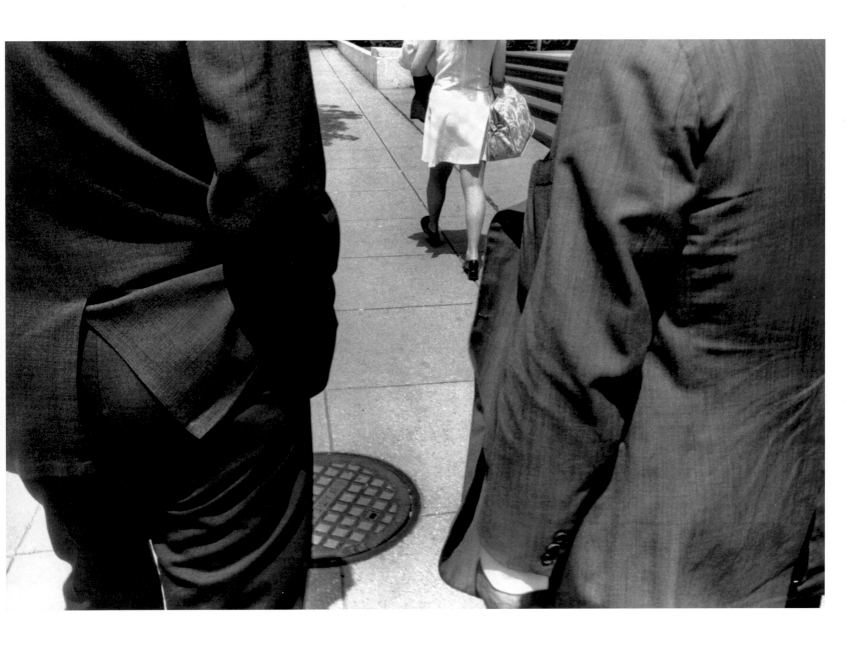

OPPOSITE:
Charles Harbutt's press cards

ABOVE:
Charles Harbutt
*Pennsylvania Avenue,*
*Washington, D.C.,* 1972

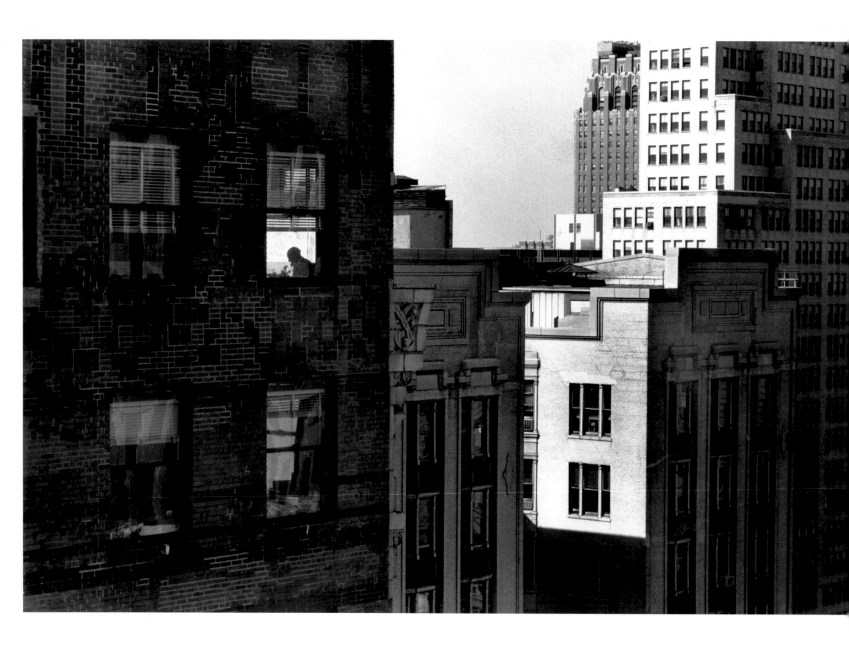

ABOVE:
Charles Harbutt
*Scrivener (Clerk), Wall Street,*
*New York,* 1970

OPPOSITE:
Charles Harbutt
*Running Man, Liverpool,*
*England,* 1971

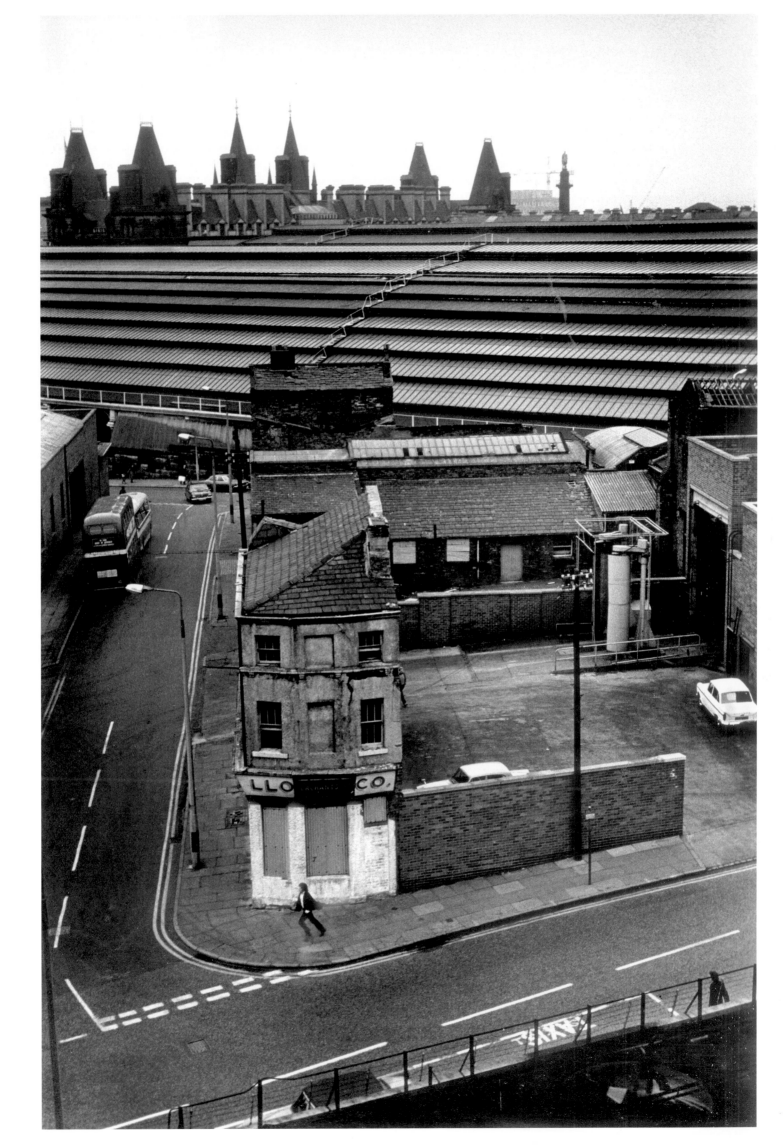

## CHARLES H. TRAUB (B. 1945)

Charles Traub is another perfect example of his generation's versatility. He has worked as an artist, critic, and gallery director, running New York's prominent Light Gallery from 1978 to 1980. He is also an influential teacher, currently heading the photography department at the School of Visual Arts in New York.

Traub's time at the celebrated Chicago Institute of Design, where he studied under Aaron Siskind and Arthur Siegel, played a formative role in shaping his work as a photographer. His work displays a profound sense of form and experimentation, going far beyond straightforward documentary practice. His theater of operations is the street, the beach, or any place dense with people. After making conventional use of the large-format camera to shoot landscapes, Traub adopted the Rolleiflex. He projected its square format on the world around him, shooting from the hip, taking one shot after another in rapid succession, often without looking through the viewfinder, turning his back on the anecdotal to focus on form, his greatest concern; "I run for form," he declared in the preface to his book *Beach*. [1] Traub is aware that as a photographer permanently influenced by other visual media, whether photographic or not, he has a narrow margin for innovation. Early on, he had an authentic postmodern epiphany: "I am thousands of images." For Traub, the essence of photography is the role played by perception—both for what the photo tells us about reality and for the changes it brings about in reality once we consider the world through its prism.

1. Charles Traub, *Beach* (New York: Horizon Press, 1978).

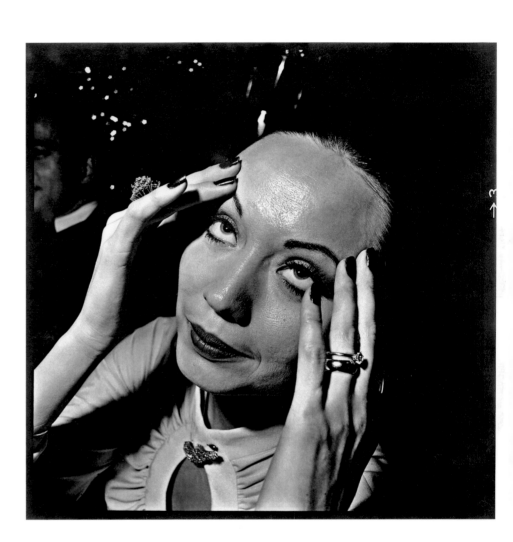

OPPOSITE:
Charles Traub
*Chicago*, 1974

ABOVE:
Charles Traub
*Party, New York*, 1971–75

71

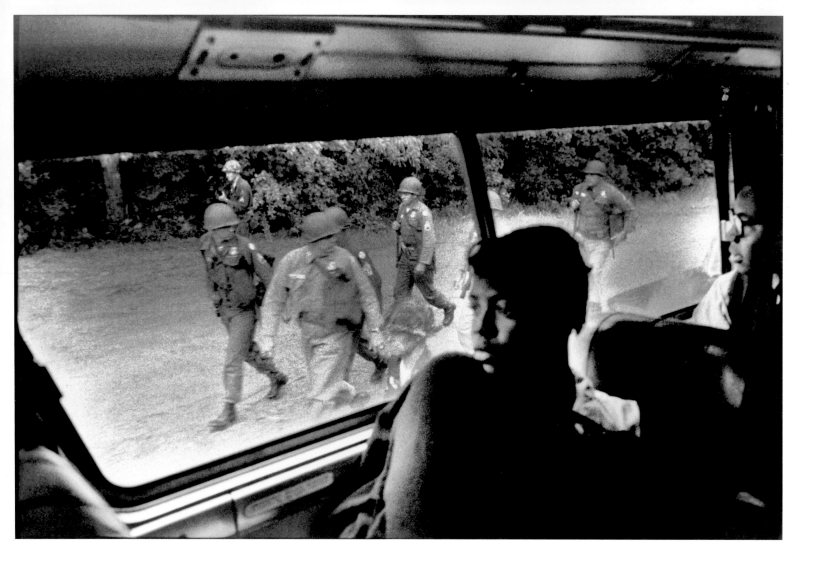

## SUBJECTIVE REALITY

ABOVE:
Bruce Davidson
From the photo series
on the civil rights
movement,
*Time of Change,
Montgomery,
Alabama*, 1961

OPPOSITE:
William Gedney
*Diane Arbus
Photographing
at a Beauty Pageant,
New York*, 1967

**F**rom then on, no subject would appear insignificant or taboo. As Winogrand put it in a memorable phrase, "all things are photographable." Especially the extraordinary, the hidden, and the repressed. In the 1960s, American society's marginalized, outcast, and neglected figures rose up before the lenses of its photographers. Society as a whole was becoming entirely visible: its racial conflicts, such as the 1961–65 Alabama riots in which African-Americans struggled to achieve integration and win their civil rights; the Vietnam War, reported in the gripping photojournalism of Don McCullin and Larry Towel; and the disadvantaged sexual minorities Diane Arbus described with near-obsessive dedication. Arbus wrote: "The sign of a minority is The Difference. Those of birth, accident, choice, belief, predilection, inertia. Some are irrevocable: people are fat, freckled, handicapped, ethnic, of a certain age, class, attitude, profession, enthusiasm. Every Difference is a likeness, too."[34] A lot of ink has been spilled about Diane Arbus and her theory of the photographic "secret," on which she herself wrote: "A photograph is a secret about a secret. The more it tells you the less you know."[35] Though the string of increasingly exhaustive books and exhibitions will continue to provide us with a better grasp on Arbus's life and work, one cannot hope to fully absorb the element of madness and incomprehensible strangeness found in her best pictures.

Yet it would be a mistake to think that in the sixties and seventies the fascination with the marginal was limited to the work of Diane Arbus. On the contrary, the profound subjectivity now prevalent in documentary practices encouraged the most outlandish themes and emphasized the photographer's attraction to subjects that were literally on the edge. In a 1972 article about Bruce Davidson's work on East 100th Street in Harlem, *New York Times* columnist and critic A. D. Coleman stated that "photographers are going to [have to] abandon their concern with Art and Beauty and start making stark, grim, ugly, repulsive images."[36] This dismissal of the "thematically correct" so clearly exemplified by *The Family of Man* could appear in a formally classical guise or in high-quality prints; in the 1980s, Robert Mapplethorpe lifted this contrast to incandescent levels; yet nothing could short-circuit the scandal of content. Arbus focused on content in her research into the people she referred to as the "quiet minorities," known to others as "freaks." Her photographic vocabulary became consistently simpler, combining a frontal approach found in the work of German photographer August Sander with the fragile quality of amateur photography. In the case of Diane Arbus, the photographic act inscribes itself in the artist's biography, and artistic commitment can no longer do without existential commitment.

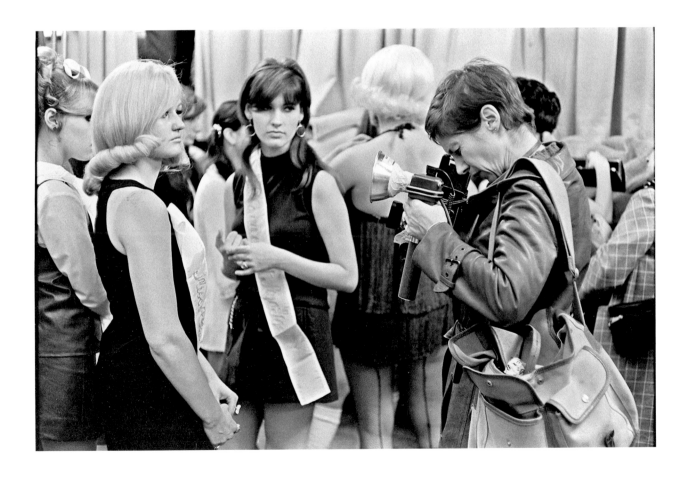

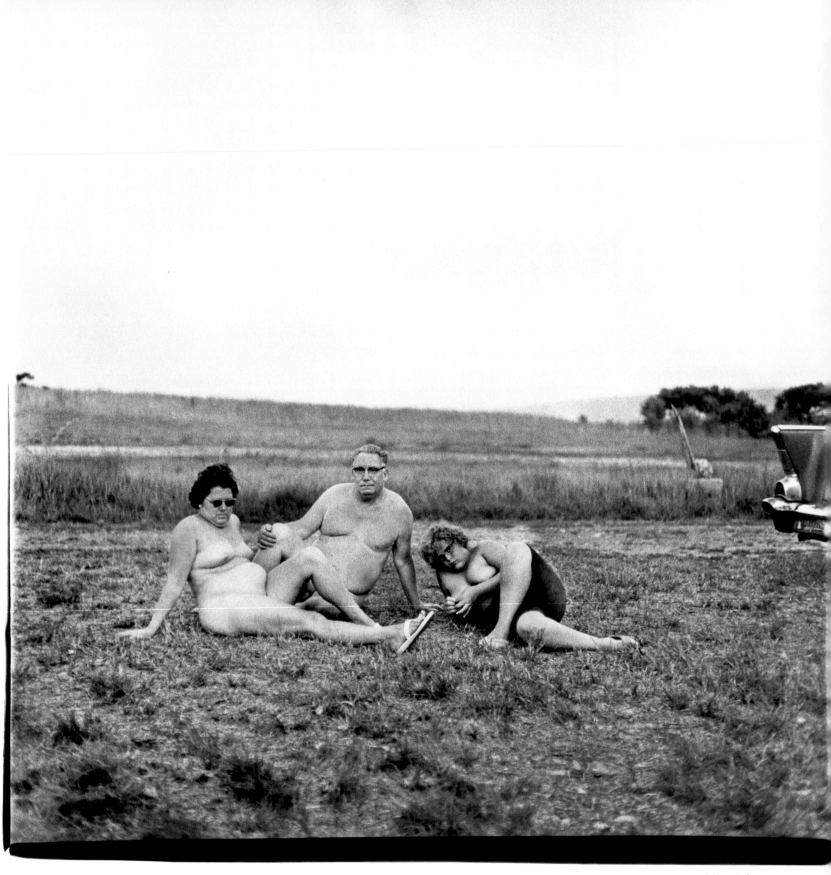

Diane Arbus
*A Family in a Nudist Camp,*
*Pennsylvania*, 1965

TRANSFORMATIONS OF THE PHOTOGRAPHIC DOCUMENT

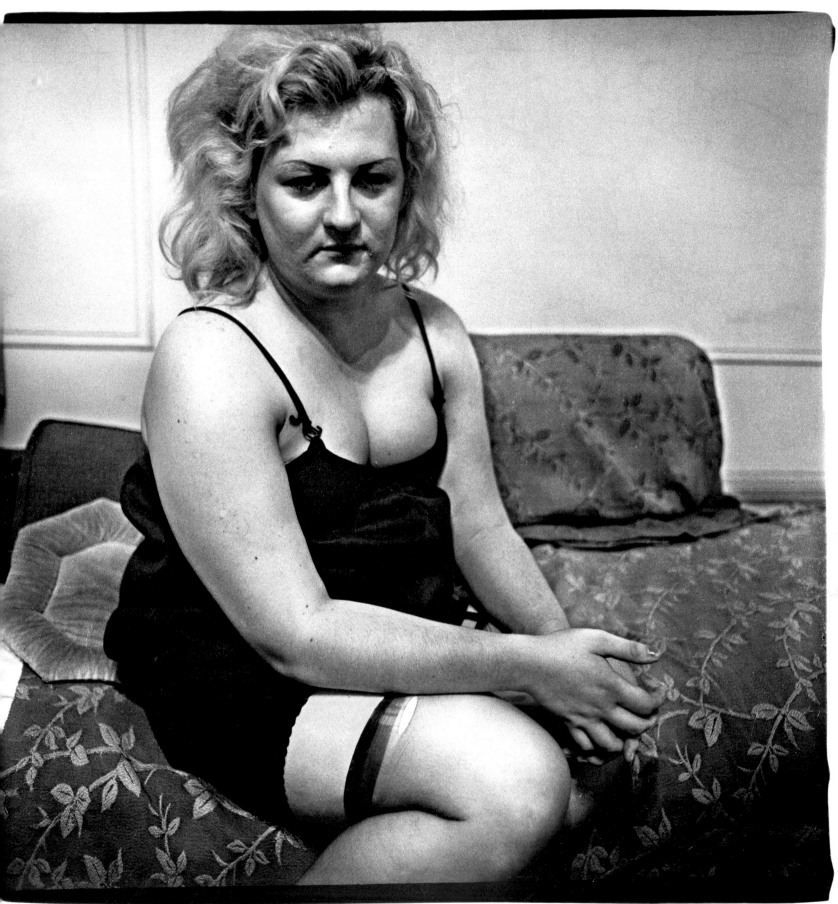

Diane Arbus
*Male Transvestite Wearing a
Torn Stocking, New York*, 1966

# DOCUMENTARY PHOTOGRAPHY
# AND MARGINALITY

**W**hen John Szarkowski hung Arbus's photographs alongside photos by Winogrand and Friedlander, he brought together two different orders of photographic values, exposing—whether consciously or not—their incompatibility. For Winogrand and Friedlander, the act of photographing required an emotional distance from the world to permit the exploration of its "photographic" qualities. Rather than seeking some unlikely photogenic quality, they were after an obvious transformation of the real through photography. Garry Winogrand's famous statement resonates to this day: "I photograph to see what the world looks like in photographs." Arbus's approach was miles away from this experimental commitment. Hers was a photographer's anxious gaze at an aspect of the world that was tortured and rejected for its strangeness. It was this example of a hyper-subjective exchange between the photographer and her model that helped Bruce Davidson, exhausted by the crippling

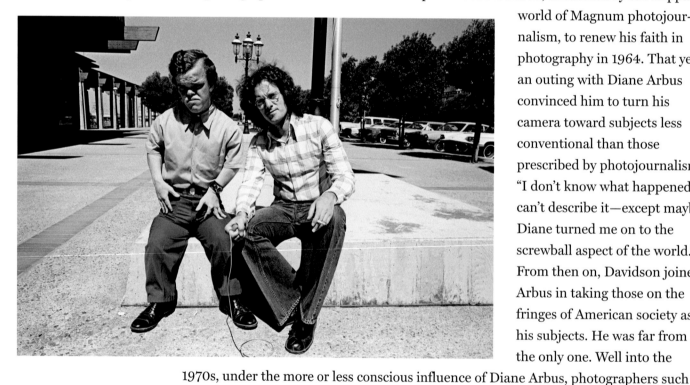

world of Magnum photojournalism, to renew his faith in photography in 1964. That year, an outing with Diane Arbus convinced him to turn his camera toward subjects less conventional than those prescribed by photojournalism: "I don't know what happened—can't describe it—except maybe Diane turned me on to the screwball aspect of the world."[37] From then on, Davidson joined Arbus in taking those on the fringes of American society as his subjects. He was far from the only one. Well into the 1970s, under the more or less conscious influence of Diane Arbus, photographers such as Larry Clark recorded the adolescent wanderings of Tulsa delinquents; a young Nan Goldin photographed Boston's drag queens; and Les Krims explored the world of dwarfs in *The Little People of America, 1971–72.* Each of these photographers seemed to take Lisette Model's advice to her students to heart: "Don't shoot until you feel it in your gut."[38] Many would eventually use photography as a substitute for a written autobiography.

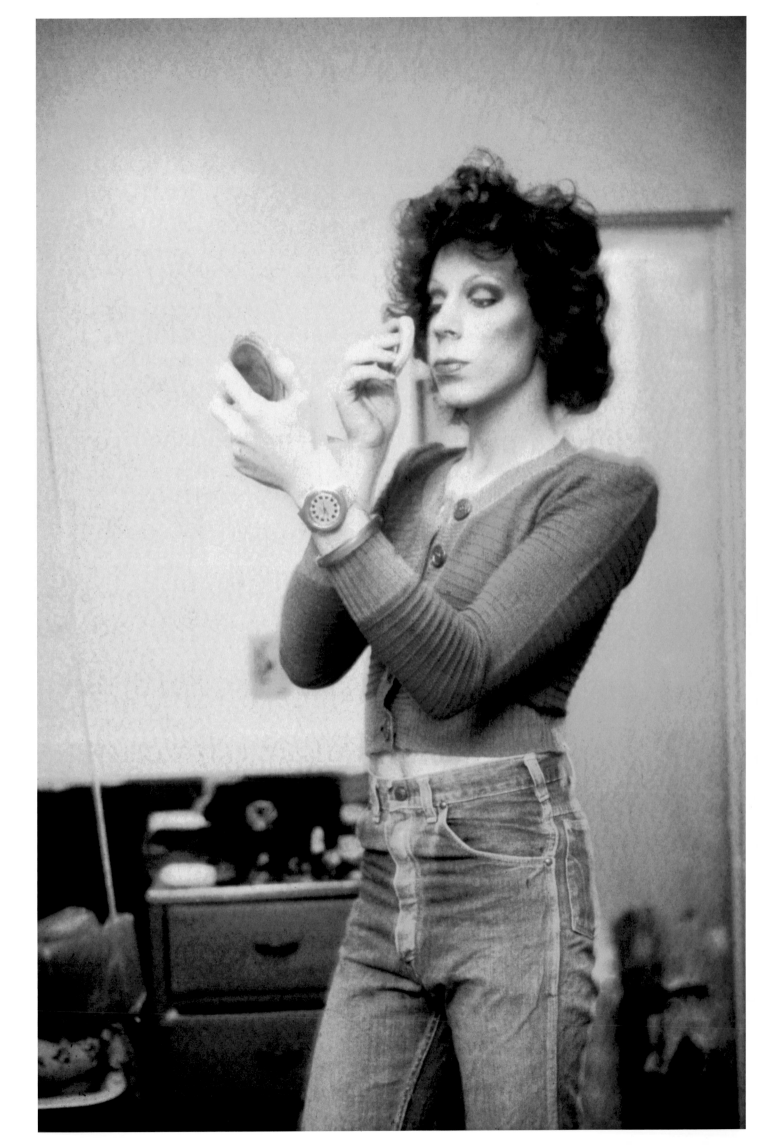

The full importance of *Tulsa*, a 1971 photography book by then-practically unknown young photographer Larry Clark, remains underestimated to this day. It was published by Ralph Gibson, himself a young photographer with a well-honed visual intelligence and the director of Lustrum Press, the small publishing house he had founded in 1969. The book begins with a concise introductory text in which Clark describes his subject: "i was born in tulsa oklahoma in 1943. when i was sixteen i started shooting amphetamine. i shot with my friends every day for three years and then left town but i've gone back through the years. once the needle goes in it never comes out." [39] *Tulsa*'s fifty-one images—photographs and frames from short amateur films shot by Clark—constituted the most important book since Robert Frank's *The Americans*; and they are radical in an entirely different way. *Tulsa*'s subject matter (drugs and sex), its identification of a peaceful Oklahoma town with the delinquent spiral of a group of its teenagers; and the brutal, direct way this spiral was photographed from the point of view not of a witness but of a participant (and therefore also a delinquent): all ensured its status as a kind of secret book that resonated far and wide. The book combines the photographic darkness of W. Eugene Smith (one of Clark's references), the spontaneous style of Robert Frank, and the photographer's genuine affection for his companions on the margins of society. Clark's people did not belong to the trendy, artsy New York drug milieu. They represented a condemned daily reality from which many wanted to believe the rural American heartland was safe. Leaving behind all documentary distance, the photography in *Tulsa* functions as an unprecedented autobiographical chronicle, without the slightest compromise, commercial posturing, or other false artistic alibi. In 1983,

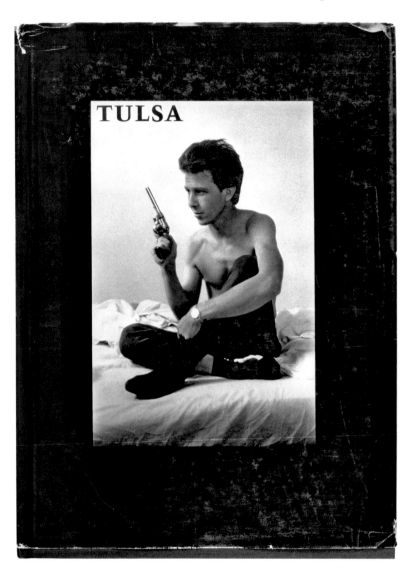

Cover of
Larry Clark's *Tulsa*
(New York:
Lustrum Press, 1971)

Lustrum Press published Clark's even more shocking *Teenage Lust*. A photographic follow-up to *Tulsa*, the more explicitly sexual *Teenage Lust* is a scorching memoir of Larry Clark's teenage years and his troubles with the law.

During the late sixties and early seventies, a number of American museums adopted the traditional approach of recapping the period drawing to a close. In this context, the commitment to documentary subjectivity surfaced as a trademark of the 1960s. Among those exhibitions, of the conventional genre that combined retrospective with analysis, two shows deserve to be considered at some length.

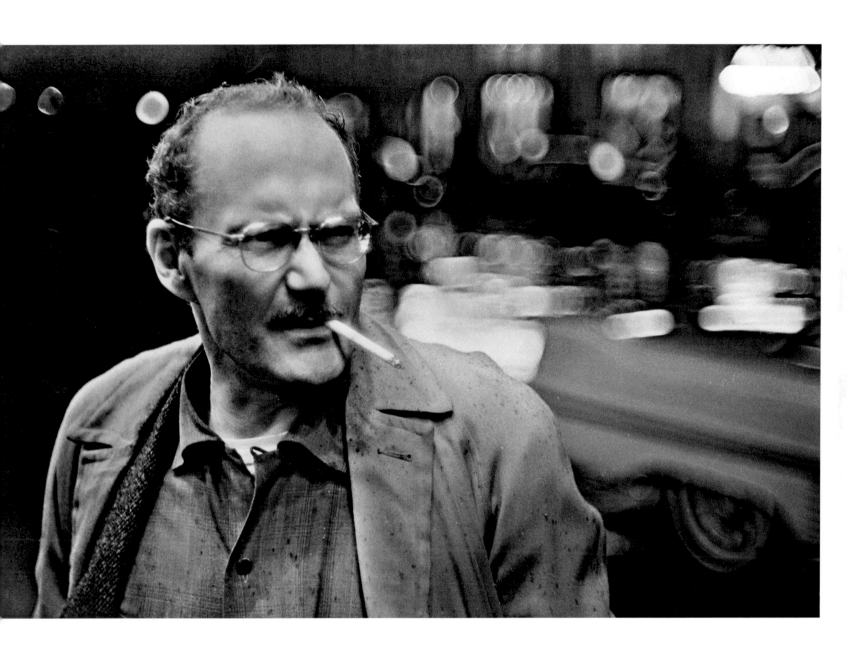

Larry Clark
*Gene Smith in New York City,* 1964
Courtesy Simon Lee Gallery, London/
Courtesy Luhring Augustine Gallery, New York

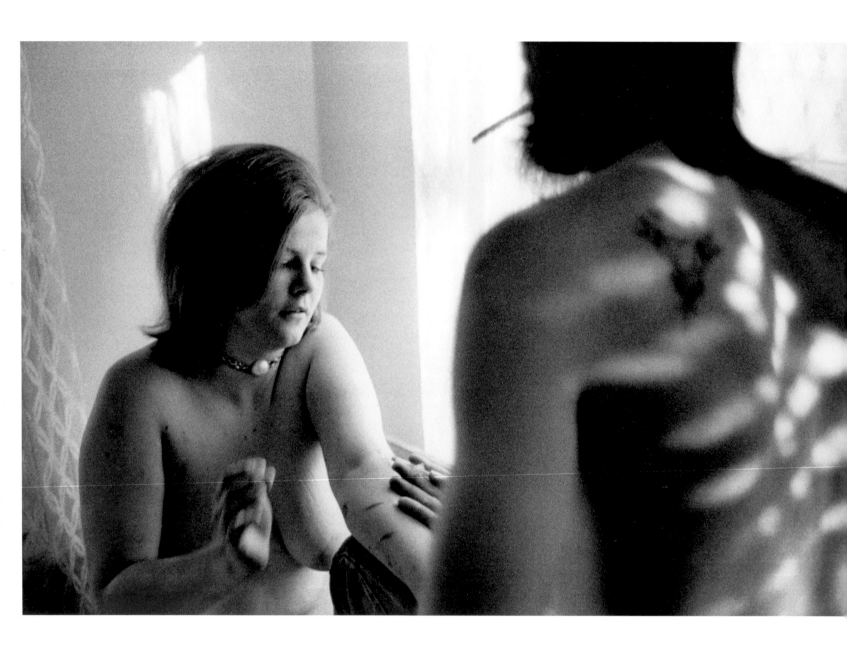

ABOVE:
Larry Clark
*Untitled (T36)*, 1971
Courtesy Simon Lee Gallery, London/
Courtesy Luhring Augustine Gallery, New York
OPPOSITE:
Larry Clark
From *Tulsa Portfolio*, 1972
Courtesy Simon Lee Gallery, London/
Courtesy Luhring Augustine Gallery, New York

TRANSFORMATIONS OF THE PHOTOGRAPHIC DOCUMENT

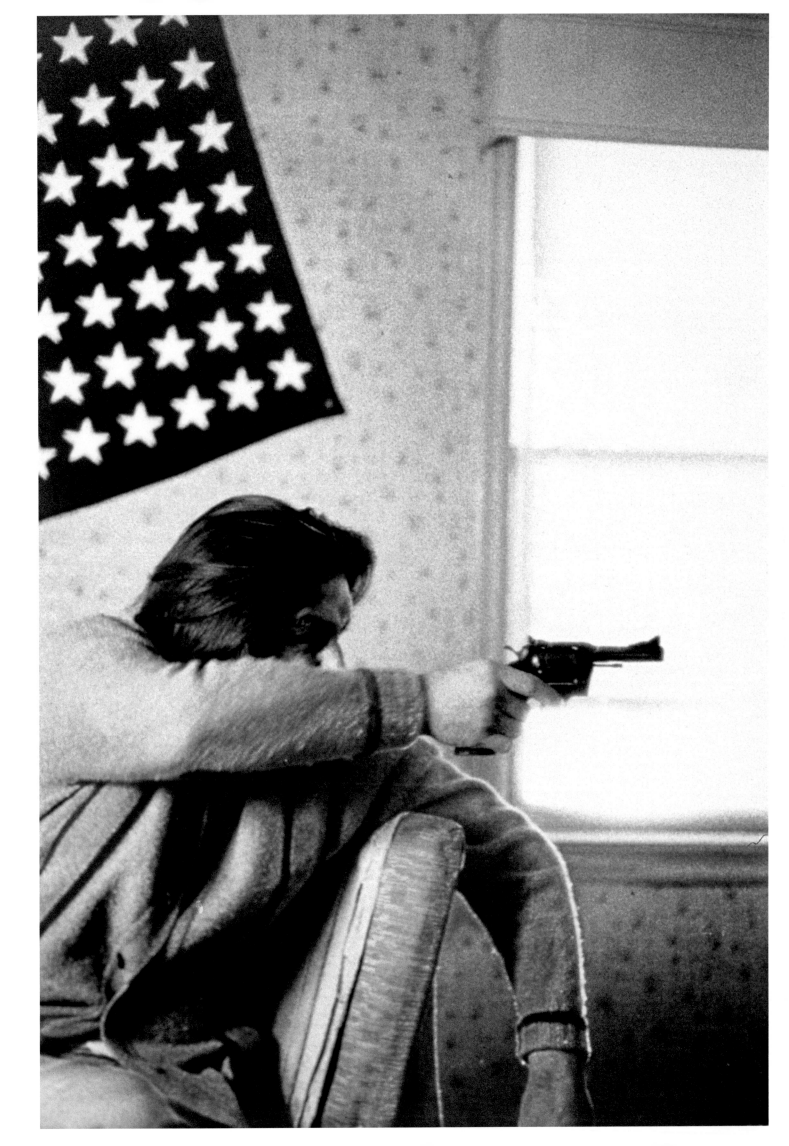

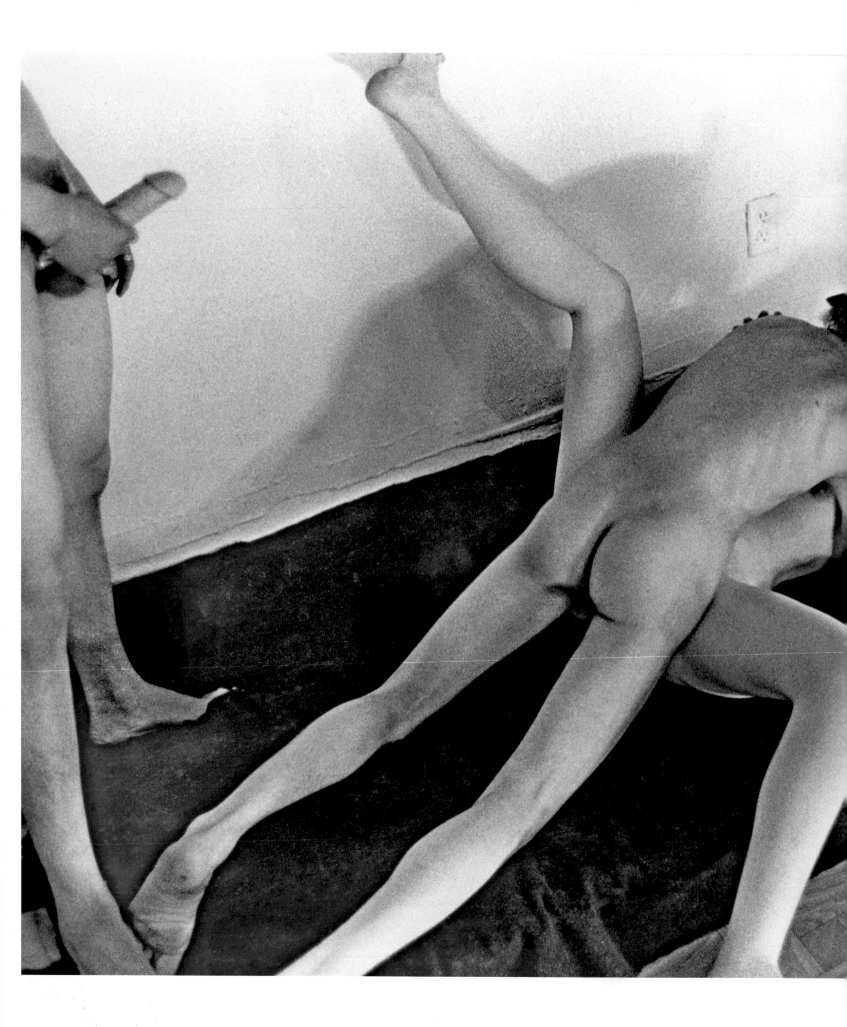

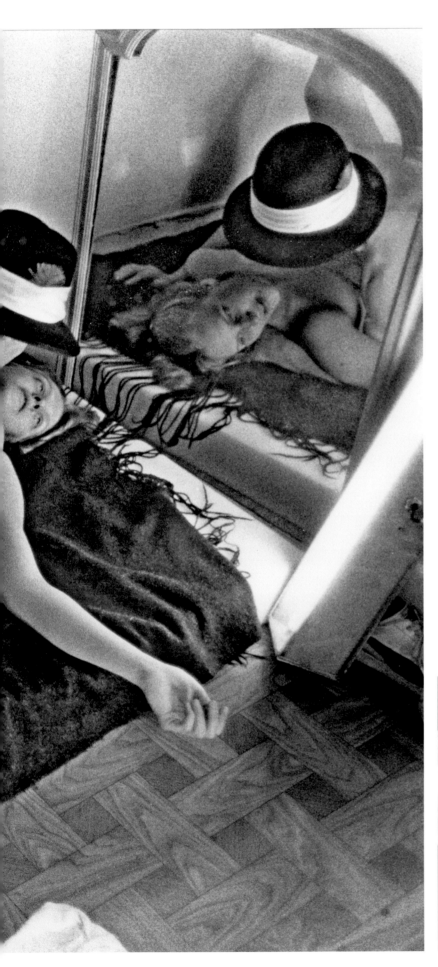

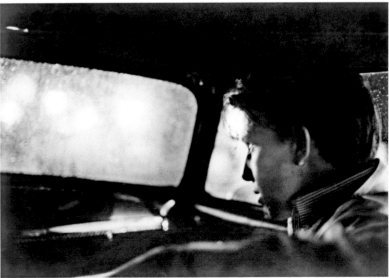

Organized at the George Eastman House in Rochester, New York, by curator, photographer, and critic Nathan Lyons, the exhibition *Vision and Expression* brought together 154 works by as many "young" artists. This show of international but predominantly American photographers proposed an approach to subjective expression, which then seemed a dominant tendency in contemporary photography. The concept was intended to be nearly scientific: "We may effectively begin to understand the meaning of the limitations, as well as the possible extensions, of photography as it relates to human expression."[40] Far from being restricted to the representatives of "straight photography," the choice of works included a significant majority of experimental pieces constructed by means of a variety of techniques: photograms, sequences, collages, montages, cut-outs, solarizations, rayograms, as well as Belgian artist Pierre Cordier's "chemigrams." *Vision and Expression* considered photography not as a simple act of documentary recording, but as a practice requiring construction. According to Nathan Lyons, "For many picture-makers, preconceptions about the photographic medium seem less significant at this time than they have in the past."[41] At a time when the desire to confine the photographic medium within the limits of straight photography was gaining traction through the influence of John Szarkowski and MoMA, *Vision and Expression* seemed like an act of resistance, an attempt to affirm experimental expansion and take into account practices neglected or rejected by the current ideology. Joyce Neimanas, her husband Robert Heinecken, Larry Colwell (1901–1972), Tom Barrow, Betty Hahn (b. 1940) and Leland D. Rice, for instance, were busy reviving a tradition of European experimentation that had gradually disappeared from the New York scene, but was increasingly prevalent on the West Coast.

BELOW:
Cover of exhibition catalogue *Vision and Expression* (Rochester, NY: George Eastman House, February 1960)

OPPOSITE, LEFT:
Page 96 of exhibition catalogue *Vision and Expression* (photo by Larry McPherson)

OPPOSITE, RIGHT:
Page 139 of exhibition catalogue *Vision and Expression* (photomontage by Joyce Neimanas)

Larr        Joyce Neimanas

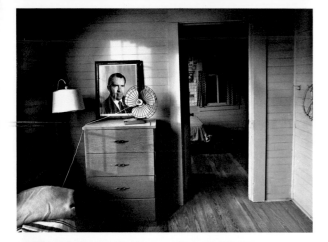

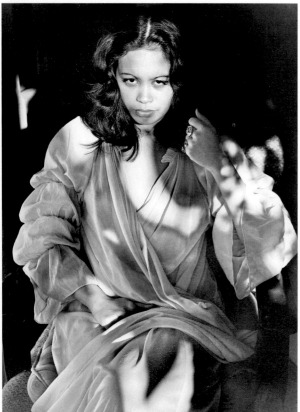

In 1971, The Museum of Fine Arts, Boston, opened the exhibition *Private Realities: Recent American Photography,* organized by its young photography curator Clifford Ackley.[42] The title of the show was chosen to reveal that "although all the works in this exhibition make use of objective camera realism, they are primarily concerned with the recording of subjective states of feeling. These works are not so much documentary as surreal, fantastic, autobiographical, profoundly personal. Many of these images represent a conscious divergence from the purist and documentary tradition that crystallized in the 1920s and '30s and which emphasized direct, non-manipulative recording of the external world."[43] The photographers in the exhibition included Emmet Gowin, Jerry Uelsmann, Linda Connor, and Judy Dater, some of whom had radically different approaches to photography. For example, the "post-visualization" operations characteristic of Jerry Uelsmann (b. 1934) do not have much in common with Emmet Gowin's delicate autobiographical work with a large-format camera.

TOP:
Jack Welpott
*Beach House Bedroom,*
*St. Augustine, Florida,* 1974

CENTER:
Judy Dater
*Maria Theresa,* 1974
From the portfolio
*Men and Women,* 1974

BOTTOM:
Linda Connor
*Three Rings Floating on*
*Water,* 1974

OPPOSITE:
Jerry Uelsmann
*Untitled [Figure Stands in*
*Water],* 1975

ABOVE:
Emmet Gowin
*Edith, Danville, Virginia*, 1967

OPPOSITE:
Emmet Gowin
*The Hint That Is a Garden,
Siena, Italy*, 1975

## EMMET GOWIN (B. 1941)

The strain of American photography born in the 1960s was shaped by movements and influences that were both private and boldly proclaimed. Emmet Gowin placed his first monograph, published in 1976,[1] under the double patronage of a photographer, Frederick Sommer, and a Southern writer, James Agee. Aside from his celebrated connection with photography, Agee wrote the script for the film *The Night of the Hunter,* which Gowin cites as one of his sources. Gowin drew from Sommer's intellectualized formalism and Agee's openness to life, his strong feeling, as well as his sense of lyricism.

His first autobiographical images were taken in intimate circles and familiar places, in his hometown of Danville, Virginia, with members of his family. He celebrated his wife Edith's sensuality, photographing her as she urinated standing up, basking in her freedom, backlit in the door of a barn. He recorded his children lost in the whirl of their games. He also photographed death. Like Sommer, Gowin linked death to the effects of material and temporal dissolution. While traveling, he occasionally turned his camera to some serene landscape, revealing an elemental harmony. Later, aerial landscape photography would become Gowin's major interest. Many of Gowin's images are heavily vignetted, as if he wanted to clearly assert that they belong to the photographic medium, without erasing the formal and visual transformations inherent in photography. In this, Gowin clearly follows the example set by his mentor Harry Callahan.

1. *Emmet Gowin Photographs* (New York: Alfred A. Knopf, 1976).

**S**ubjectivity followed mysteriously different paths through the work of many American photographers of the era, ranging from intimate subjects to a far more grandiloquent, now obsolete, symbolism. During the sixties and seventies, references to Surrealism undoubtedly served as a catalyst for the appearance of a dreamlike American photography that pushed the already predominant strain of subjective expression even further away from traditional documentary photography. Curiously enough, this frequently staged mode of photography found its epicenter in the southern United States. A European tradition, far removed from the modernist American spirit, it had two prolific, brilliant American precursors: Clarence John Laughlin (1905–1985) of Louisiana and Frederick Sommer (1905–1999), the Arizona outsider. Laughlin's career was shaped by his attachment to the mysteries of New Orleans, which he explored through fantastical images derived from a tradition of "black gothic." His theatrical pictures superimposed tormented faces of ghosts, frequently masked women in cemeteries, and decrepit buildings buried in Spanish moss. Sommer, who was more introverted and more complex, created disturbing photographs, such as a 1949 shot of a doll placed on a monstrous scrap-metal creature that explicitly referred to the outlandish paintings of Surrealist painter Max Ernst. This demanding artist, writer, and musician was supported throughout the 1960s by Minor White, both as a representative of the abstract photography movement and as an artist of the "surreal." (White published the first significant book about Sommer in 1962.[44]) Beginning in 1956, *Aperture* featured Sommer's work on several occasions, notably in 1961, when Jonathan Williams drew the connection between his surrealist aesthetic and the work of Laughlin and Wynn Bullock.[45] It would be unfair to omit another photographer, California artist Edmund Teske (1911–1996), whose enduring disregard for straight photography served as a strong example to the generations that followed him. Teske was a master of collage and of combining images in the darkroom.

These artists soon exercised their influence on several young photographers determined to follow paths other than documentary straight photography, which was often accused of factual platitude. In 1954, after having spent a few years taking amateur photographs, a young optician named Ralph Eugene Meatyard (1925–1972) became a member of the Lexington Camera Club in Lexington, Kentucky. In 1956, he was joined by Van Deren Coke,[46] a professor of photography at Indiana University and a fellow Lexington native and photographer. Coke's encouragement would help Meatyard develop his talent. During the course of the next decade, this local photo club, hundreds of miles from the New York bustle and California progressivism, became an active artistic center that brought together artists and writers, including Guy Davenport,[47] and promoted regular exhibits, classes, publications, and debates.[48] In 1968, the Lexington Camera Club organized a remarkable show featuring the work of young photographers (Nathan Lyons, Charles Traub) alongside more classic but equally atypical photographers, such as Henry Holmes Smith and Van Deren Coke himself.

This local context, remarkably open to the outside photographic world, allowed Meatyard to produce a body of work astonishing both for the oddity of its themes and the power of its content. The photo world would take a long time to properly assimilate the importance of Meatyard's legacy after his premature death in 1972. Like the work of Clarence Laughlin, Meatyard's was long confined to a form of typically decadent Southern regionalism. In 1974, *Aperture* published his first important monograph, but it did not register with contemporary critics, who found Lexington far too provincial to give rise to an actual genius. As in Laughlin's pictures, Meatyard's models often wear masks, blurring their identities.

After struggling several months with an incurable cancer, Meatyard died in 1972 at the age of forty-seven, leaving more than five thousand prints that constitute a genuine puzzle reminiscent of his 1965 or 1966 self-portrait. His photographs delineate an impressive mental universe in which the family and childhood play essential parts. Finished shortly before his death, *The Family Album of Lucybelle Crater* is a grotesque, masked parody of family life. Meatyard's lens finally revealed childhood freed from the conventional sweetness and tremulous preciousness that photographers other than Lewis Carroll and Lewis Hine were in the habit of depicting. Using his children as protagonists, Meatyard provoked and recorded visual fictions that, by means of games and rituals, suggest secret ceremonies, abandoned places, vibrations and stridencies, a landscape held taut between magic and menace, and the profound insecurity of childhood. These themes were clearly expressed in the struggle of light forging its way through the world of secrets and shadows in which the pictures are anchored.

Ralph Eugene Meatyard
*Self-Portrait Rebus*, 1965–66

TRANSFORMATIONS OF THE PHOTOGRAPHIC DOCUMENT

OPPOSITE:
Ralph Eugene Meatyard
From the series *The Family Album of Lucybelle Crater and Other Figurative Photographs*, 1970–72

ABOVE:
Ralph Eugene Meatyard
*Romance from Ambrose Bierce #3*, 1962

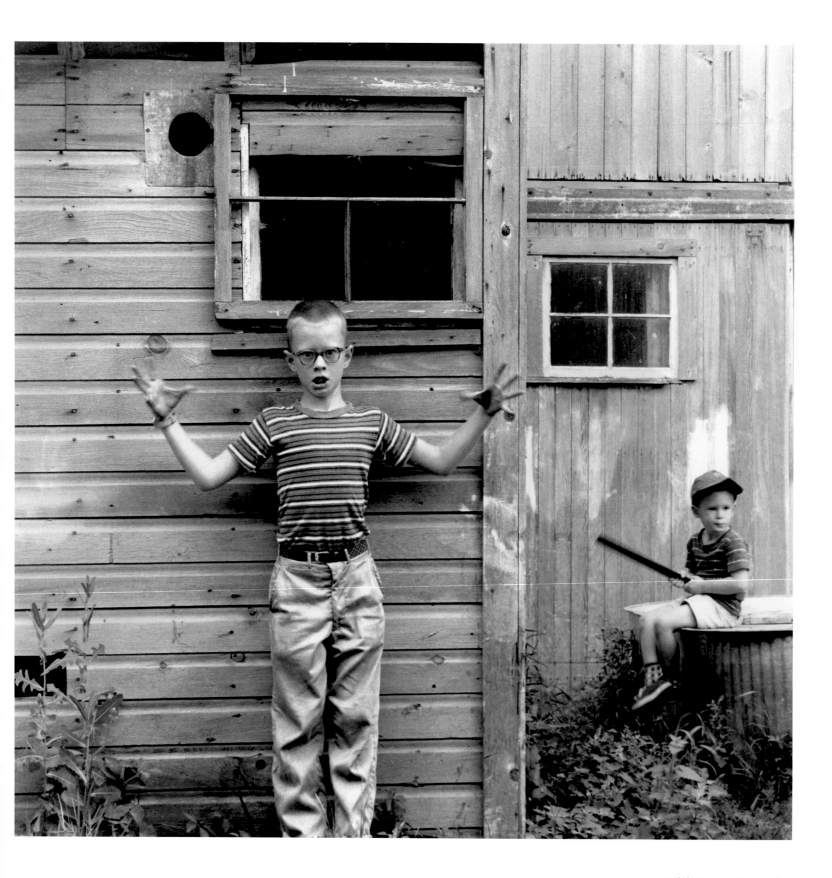

Ralph Eugene Meatyard
*Boy Gesturing*, 1959

TRANSFORMATIONS OF THE PHOTOGRAPHIC DOCUMENT

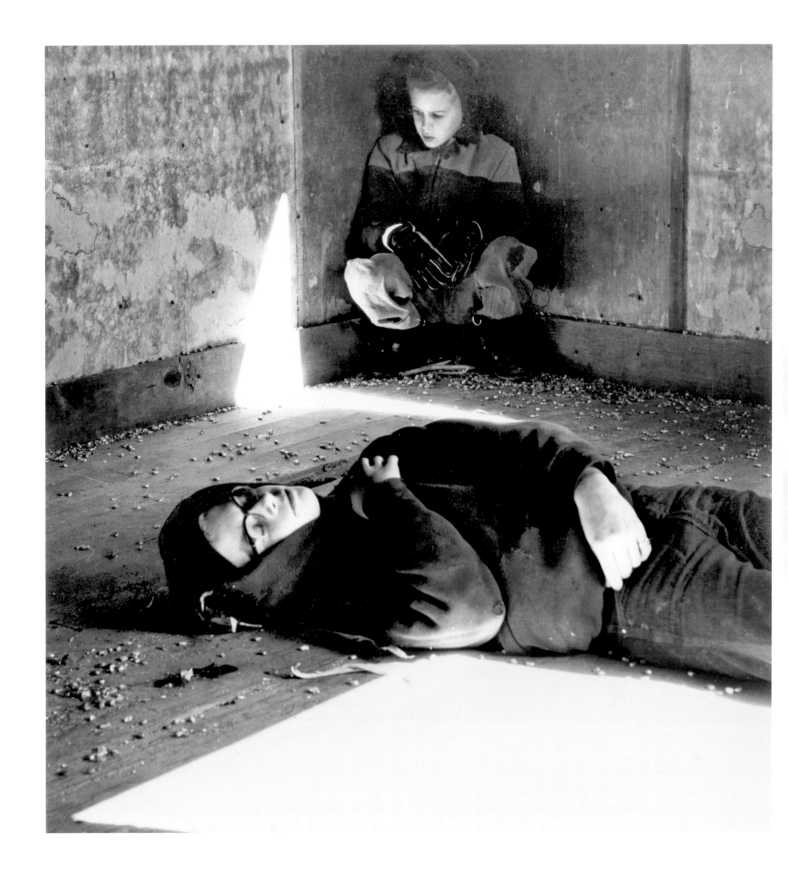

Ralph Eugene Meatyard
*Untitled*, 1959

Les Krims was vigorously engaged in a systematic demolition job on the American way of life. He held a deep-seated hostility toward the intellectual milieu of his era, which was often accused of supporting a dominating leftism destructive of authentic critical values. It comes as no surprise that these aspects of his personality were expressed through a heavily conceptual style of photography. Krims is probably the most prominent representative of what critic A. D. Coleman called the "directorial mode" in 1976.

According to Coleman, the "directorial mode," which refers to film directing, can be defined in simple terms: "Here the photographer consciously and intentionally creates events for the express purpose of making images thereof."[49] In selecting his examples of the directorial mode, Coleman turned to Krims, who in 1970 had stated: "I am not a historian, I create history. These images are anti-decisive moments. It is possible to create any image one thinks of; this possibility, of course, is contingent on being able to think and create. The greatest potential source of photographic imagery is the mind."[50]

Far removed from backward pictorialism or adulterated reality, this type of

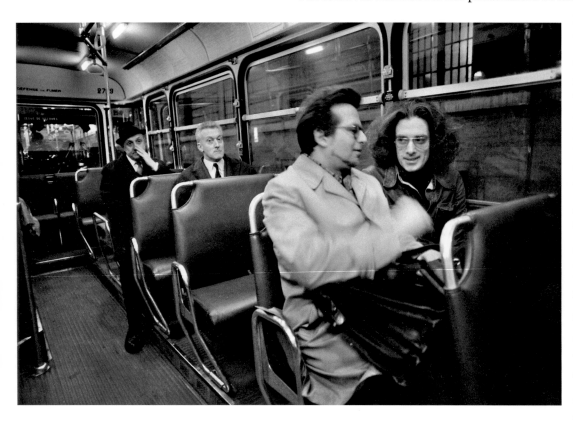

Jean-Claude Lemagny and
Les Krims, Paris, 1972
(photo by Bernard Plossu)

photography announced a shift toward viewing the image as a construction rather than a recording. The trend had already begun with the work of Clarence Laughlin, Frederick Sommer, Ralph Eugene Meatyard, and a few other photographers. Throughout the 1970s, it was cemented by artists such as Les Krims, Arthur Tress, Duane Michals, Ralph Gibson, William Wegman, David Levinthal, Lucas Samaras, and many others—up to Cindy Sherman and her *Untitled Film Stills* (1977–80). In the 1980s, this would be transformed into "staged photography," a kind of postmodern alternative to "straight photography" that was taking hold progressively. In November 1979, Van Deren Coke organized the exhibition *Fabricated To Be Photographed* at the San Francisco Museum of Modern Art. Leslie Krims's work was shown, of course, along with the photos of James Casebere, John Pfahl, and Robert Cummings, "surrounded" by the work of their historical predecessors, Frederick Sommer and Ruth Bernard. The rather mixed reception to the exhibition demonstrated how difficult it was for photography to escape a traditional approach dominated by the "found" rather than the "constructed."[51]

Les Krims
*Spitting Out the Word*
*P.h.o.t.o.g.r.a.p.h.y.*, 1970

## LES KRIMS (B. 1942)

In a recent statement, Les Krims looked back on his work as a photographer and came up with this definition: "I tried to make interesting pictures, using passion and skill, nourished by all sorts of art, unconstrained by ideology. Activist photography, and the academic art offshoots of some of art's sillier stuff, often suggested satirical images to me."[1]

From the moment he took hold of photography in 1970, Krims could best be described as a photographic activist, an agitator using images to make trouble. He entered the fray with strong ideas about how he could use the camera, particularly by turning his back on the realist illusion of the document. If the term conceptual applied to photography refers to a process intended to go beyond the plain mechanical recording of reality and its passive inscription on a roll of film, then it serves as a marvelously apt description of Les Krims's work. Could he be suggesting that every photographic image is an illusion of reality? Witness Les Krims, the Edgar Allan Poe of the photographic image, creating his *Incredible Case of the Stack o' Wheats Murders*, 1972, an astonishing detective story in which the accumulation of pancakes covered in maple syrup simulates the growing number of bodies dispatched by a serial killer, while melted Hershey's chocolate stands in for the blood of naked victims, their genitals clearly visible. One of these images was later featured in John Szarkowski's 1978 *Mirrors and Windows* exhibition at MoMA. Along with two previous portfolios, *The Deerslayers* and *The Little People of America*, of 1971, the series is a rare example of a more documentary approach in Krims's body of work. It was also the stepping-off point for the "conceptual/fabricated work" that, Krims believed, "would be a most important direction in new photography."[2]

Krims explored overtly sexual themes with clear Freudian undertones, using fabricated images with occasionally enigmatic or intentionally convoluted titles. His fetishistic photographic relationship with his voluptuous mother, Sally Krims, who is often photographed naked, wearing provocative undergarments or with her ample breasts prominently displayed, blatantly evokes the Oedipus complex. His work constantly puts forward a sense of provocation that sometimes flirts with the adolescent prank. But in the background, one discovers a satirical look at a hypocritical, prudish American culture frightened by the ever-present yet repressed realities of sex.

More widely recognized in Europe than in the United States during the 1970s and 1980s, Krims likes to consider himself the victim of a curse cast on him by the photographic intelligentsia of his era, dominated, according to him, by "the totalitarian leftist ideology."[3] He is also perfectly aware of the influence that his work has had on subsequent generations, particularly on artists of the fabricated image such as Joel-Peter Witkin or Cindy Sherman, who was one of his students at Buffalo State College. His role during the years of triumphant photographic realism was unique. He had never worked with color until, following in the footsteps of Lucas Samaras and Walker Evans, in 1973 he began to use the Polaroid SX 70. Suddenly, by mistreating the surface pigments of his Polaroid prints, he turned his most provocative images, the *Fictcryptokrimsograph* series, into gentler pieces, at the risk of drowning their indecency in pure decoration.

1. Les Krims, letter to the author, November 29, 2006.
2. Ibid.
3. Ibid.

OPPOSITE:
Les Krims
*Stacked Double Portrait,*
*Deerslayer,* 1971

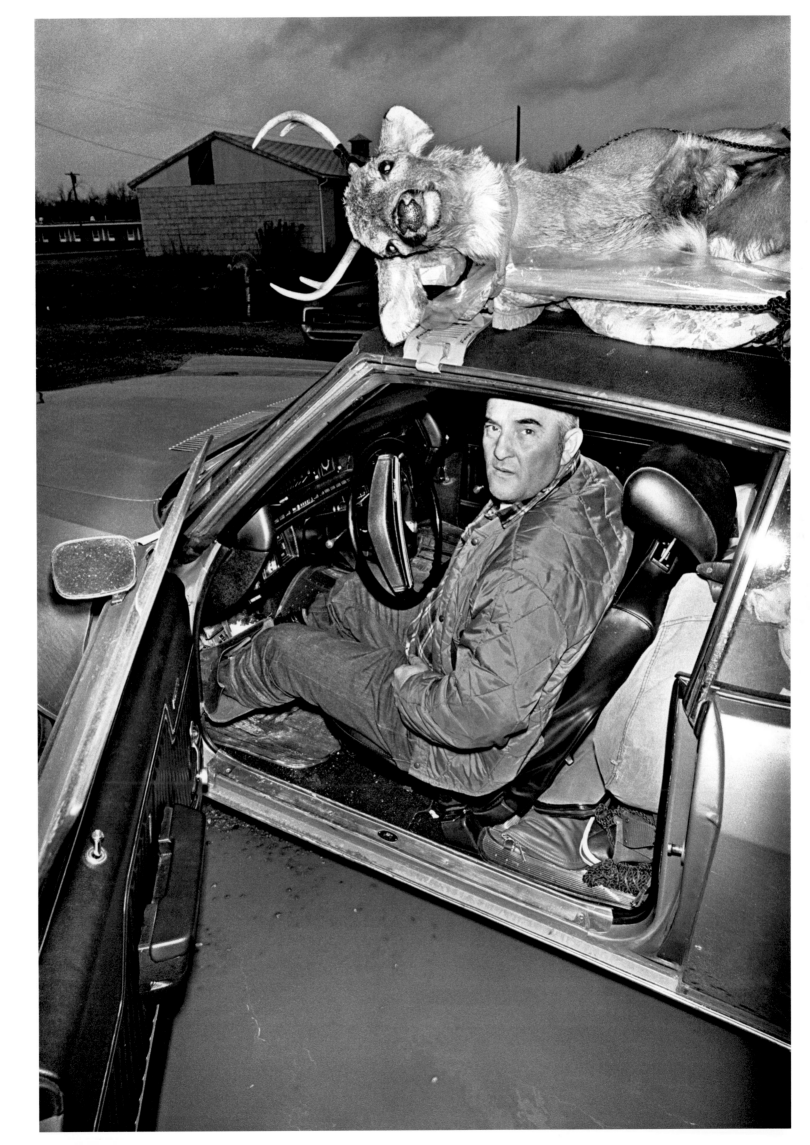

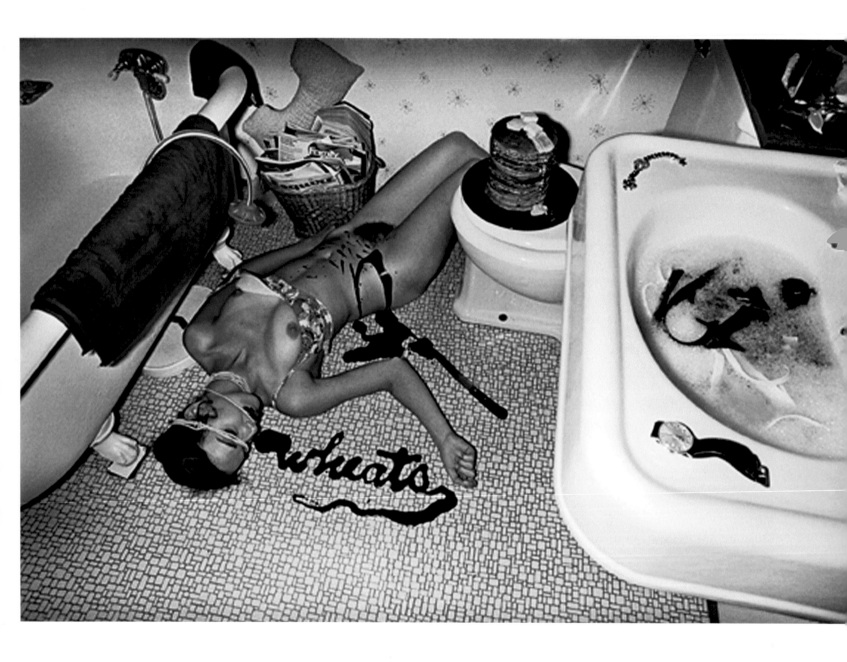

Les Krims
*Wheats*, 1972
From the portfolio
*The Incredible Case of the*
*Stack o' Wheats Murders*, 1972

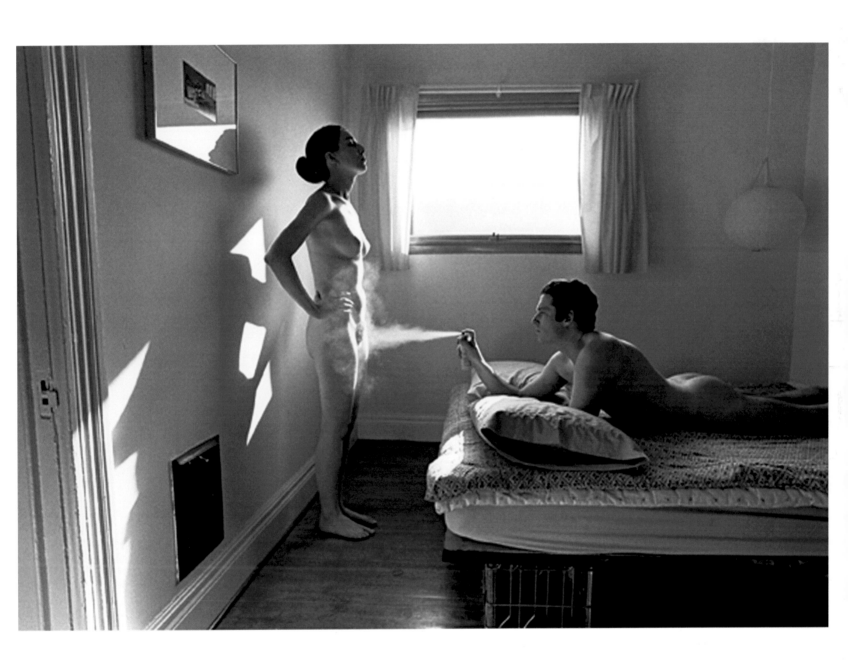

Les Krims
*Les Krims Performing Aerosol Fiction,*
*Buffalo, New York,* 1969

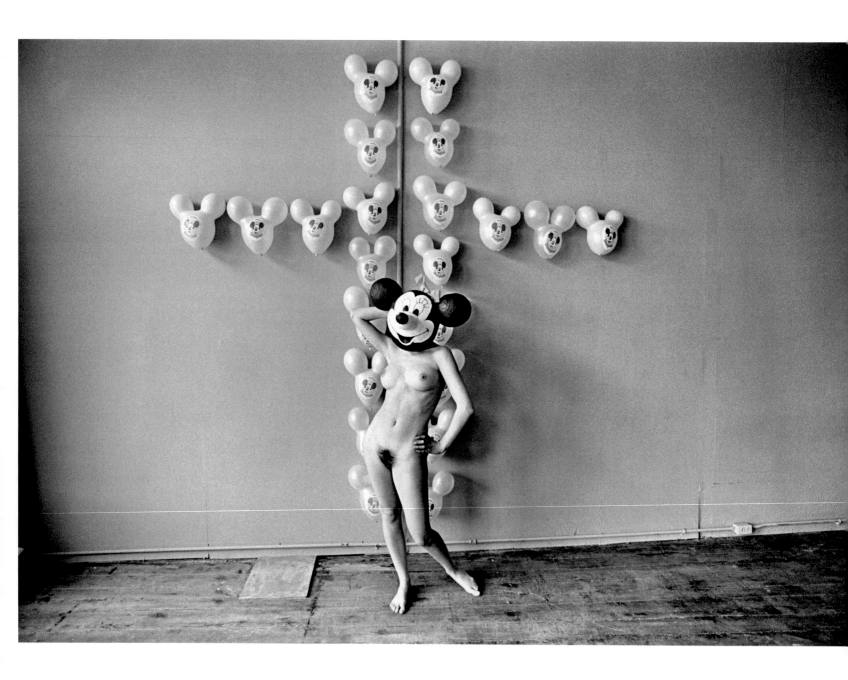

Les Krims
*The Static Electric Effect of Minnie*
*Mouse on Mickey Mouse Balloons,*
*Rochester, New York*, 1968

102

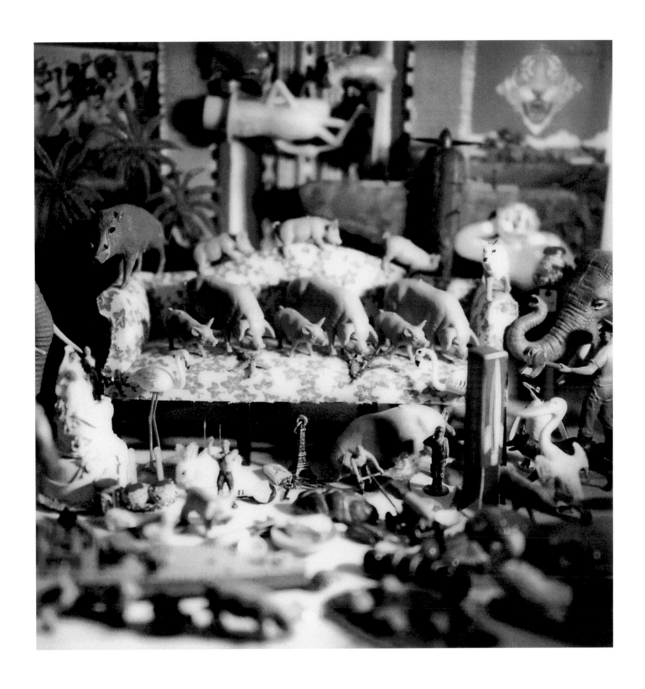

Les Krims
*Happy Easter Christians*, 1978

## DUANE MICHALS (B. 1932)

Although he started off in the documentary camp with a series of remarkable portraits taken in the Soviet Union in 1958, Duane Michals soon moved toward the exploration of his subconscious, developing several major innovations along the way. The combined influence of Magritte's Surrealist paintings and Freud's theories encouraged Michals to find new photographic forms to match the psychic and dreamlike content of his images. In 1965, he began adding handwritten text to his pictures, eventually displaying them in the sequential, narrative structures that would come to characterize his art. In Michals's work, photographs are always combined with narration in the form of a written commentary. His aesthetic can be said to derive from both the photo-novel and the "narrative art" he helped restore to prominence. The subjects of his sequences are sometimes funny, unusual, or disturbing, and can also seem overly metaphysical. Yet his open conception of photography has been highly influential. According to Michals, "photography has to transcend descriptions.... It can never pretend to give you answers. That would be insulting."[1]

Duane Michals
*Now Becoming Then,* 1978

1. See James A. Cotter's article featured on www.photoinsider.com in the Duane Michals section.

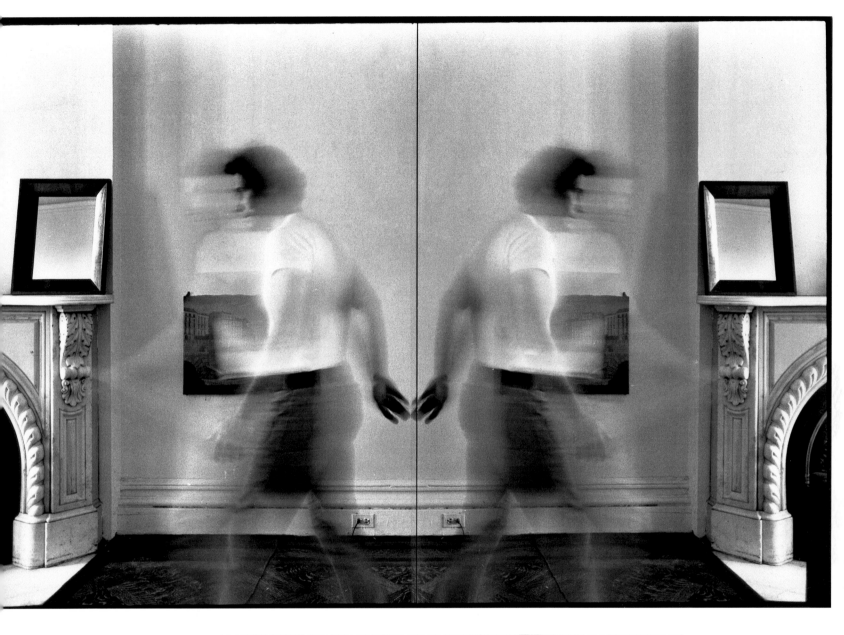

Now becoming Then

When I say, "This is now.", it becomes then.
There is no now. It appears to us as a moment,
   but the moment itself is an illusion.
It is and isn't. And this illusion is a series
   of about-to-bes and has-beens, that put together
seem an event. It is a construction, an invention
   of our minds. It's familiarity makes it invisible.
Our lives are real dreams that have been
   just one moment, all at once, now.

Arthur Tress
*Boy with Painted Dragon,*
*Coney Island, New York,* 1970

# ARTHUR TRESS (B. 1940)

As with some other "heroes" of American photography, posterity has confined Arthur Tress to such a reductive image—in his case, that of a photographer in the surrealist vein—that it has become almost impossible to evaluate the real nature of his work. Paradoxically, Tress has been widely celebrated for the dreamy, fantastical aspects of his work, while his photographs lean toward realism, especially when compared with the images of photographers such as Les Krims, with whom Tress is frequently grouped. In fact, if one considers Tress's work since he began taking pictures in 1952, the only accurate description for the often overlooked or simply forgotten initial stage of his career is that of documentary realism. Having given up his goal of becoming a painter but having acquired a solid cultural background, Tress moved to Sweden in 1968 to take a position as a photographer at the Stockholm Ethnographic Museum: there could hardly have been a more appropriate way to launch a career in documentary photography. Throughout his earlier travels in Europe, Mexico, Africa, and India, Tress had shown a keen interest in cultural rituals, which would find echoes in his subsequent "constructed" photographs.

Also in 1968, Tress made time to shoot his first significant photo essay in the Appalachians, *The Disturbed Land,* documenting the damaging environmental effects of coal mines for VISTA.[1] The text he wrote to accompany his exhibition at the Sierra Club Gallery in New York in October 1968 was a pioneering condemnation of the harm done to our land in the name of profit. And the photographs demonstrated a rare visual balance and finesse, avoiding the pitfalls of cheap compassion. Tress's style seemed to come from the heart and soul, full of tenderness for the subjects he photographed, and enriched by a gift for effective, discreet observation. Spurred by his environmental concern, Tress put this style to work two years later to realize his remarkable project, *Open Space in New York City* (see p. 145), focused on open spaces in polluted urban centers such as New York.

Then, in 1972, Tress seemed to leave behind the straight photographic document to take up the aesthetic of constructed or "staged" photography, drawing on Carl Jung's theories to explore his interest in dreams, a theme extensively treated by the European Surrealists. Anxious to avoid outgrowing a medium that suited him well, Tress decided to expand its possibilities: "The photographic frame is no longer being used as a documentary window into undisturbed private lives, but as a stage on which the subjects consciously direct themselves to bring forward hidden information that is not usually displayed on the surface."[2] Tress began by bringing forward images of childhood, often haunted by fears and shadows. As an adult he seized on these shadows to depict himself in an astonishingly original way; *Shadow: A Novel in Photographs* (1975) is a true anthology of initiation rites and protocols told through a variety of narrative sequences. Previously, Tress, the "dream collector"—*Dream Collector* is the title of a book he published in 1972—had found his images in banal reality, without forcing the objective realism of everyday life, which made the images seem even more disturbing. In this phase of his work, Tress makes visible the concept of "the uncanny" that Freud used to define the birth of anxiety. Many of the visual elements Tress employs here are reminiscent of the work of his contemporary Ralph Eugene Meatyard. And if the fantasy of a double sexual nature lurks in some of Tress's images— explicitly in *Bride and Groom, New York,* 1970 (p. 108)—it is the terror of death and dissolution that pervades his best work. A final portrait of his father, photographed on a chair in the middle of the snow, already frozen in the horror of final agony (p. 109), puts aside the parodic homosexual imagery that Tress would later indulge in.

1. Founded in 1965, VISTA (Volunteers In Service To America) was an organization concerned with nascent environmental problems. VISTA published a magazine of the same name.
2. Arthur Tress, *Arthur Tress: Photographs* (Boston: Bulfinch, 2001).

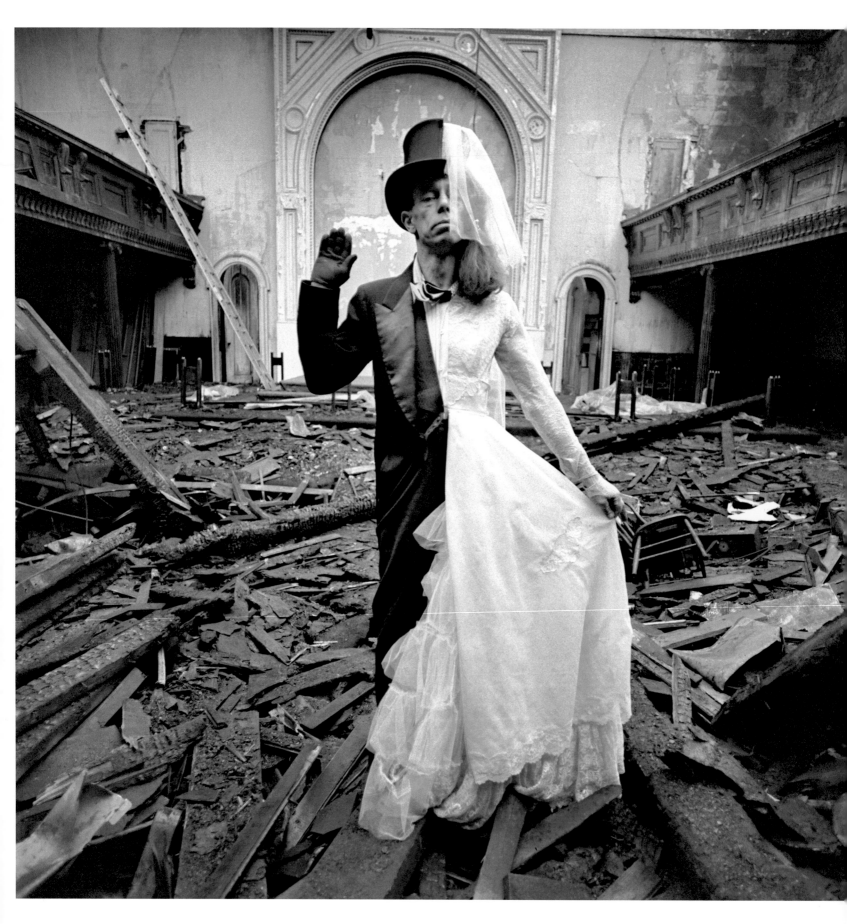

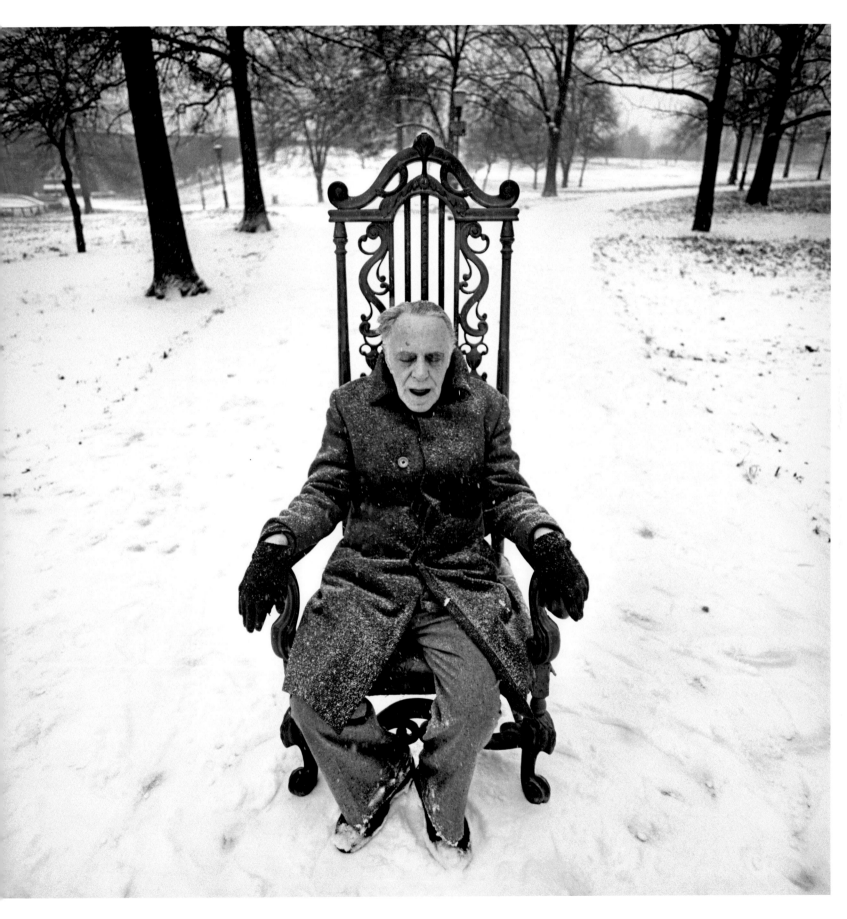

## EXPERIMENTAL AND CONCEPTUAL PHOTOGRAPHY

**B**eyond the "surrealist" tonality of their work, these photographers shifted the medium from the notion of recording reality to its mental construction, the image. In so doing, they accomplished a conceptual leap that would gradually lead photography in new directions. Indeed, throughout the sixties and seventies, the criteria for a purist, "straight" photography were put to the test. Growing numbers of photographers turned the "straight" documentary approach on its head in an attempt to get around its limitations. Occasionally grouped under the pejorative rubric of "conceptual photographers," they shared a compulsion to question the medium's realist illusion. Tom Barrow (b. 1938), a professor and photographer at the University of New Mexico in Albuquerque and a former student of Aaron Siskind, typified the need among certain photographers to critique the realist illusion of documentary straight photography with a series titled *Cancellations*, 1974. Though the series may have bordered on caricature, it was undoubtedly effective. Barrow violently scratched his negatives while they were still wet, simultaneously affirming their character as constructed images and negating the reality they were supposed to reproduce. In a less radical manner, but following the same imperatives, Kenneth Josephson (b. 1932), another agitator influenced by the teachings of the Chicago Institute of Design, had obtained a similar result in the 1960s by examining the image within the image, confronting the real with its photograph.

In the early seventies, several galleries brought together practitioners of straight photography and those who were questioning it as a form. In January 1973, the American Greeting Gallery in New York's Pan Am Building

PREVIOUS PAGES, LEFT PAGE:
Arthur Tress
*Stephan Brecht, Bride and Groom, New York,* 1970

PREVIOUS PAGES, RIGHT PAGE:
Arthur Tress
*Last Portrait of My Father, New York City,* 1978

RIGHT:
Kenneth Josephson
*Matthew,* 1965

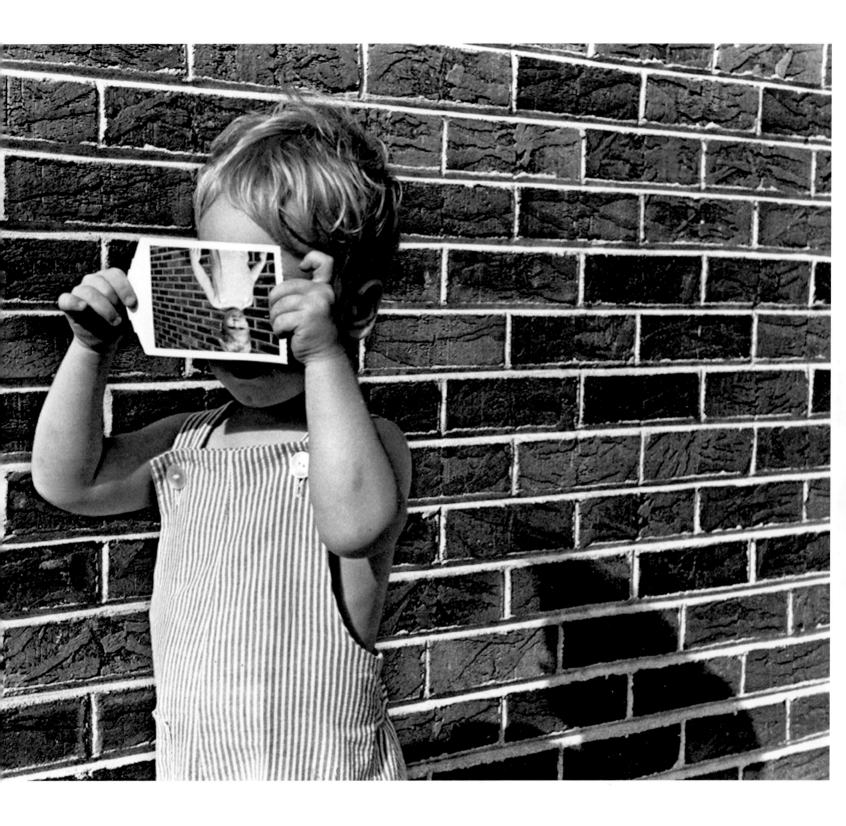

EXPERIMENTAL AND CONCEPTUAL PHOTOGRAPHY

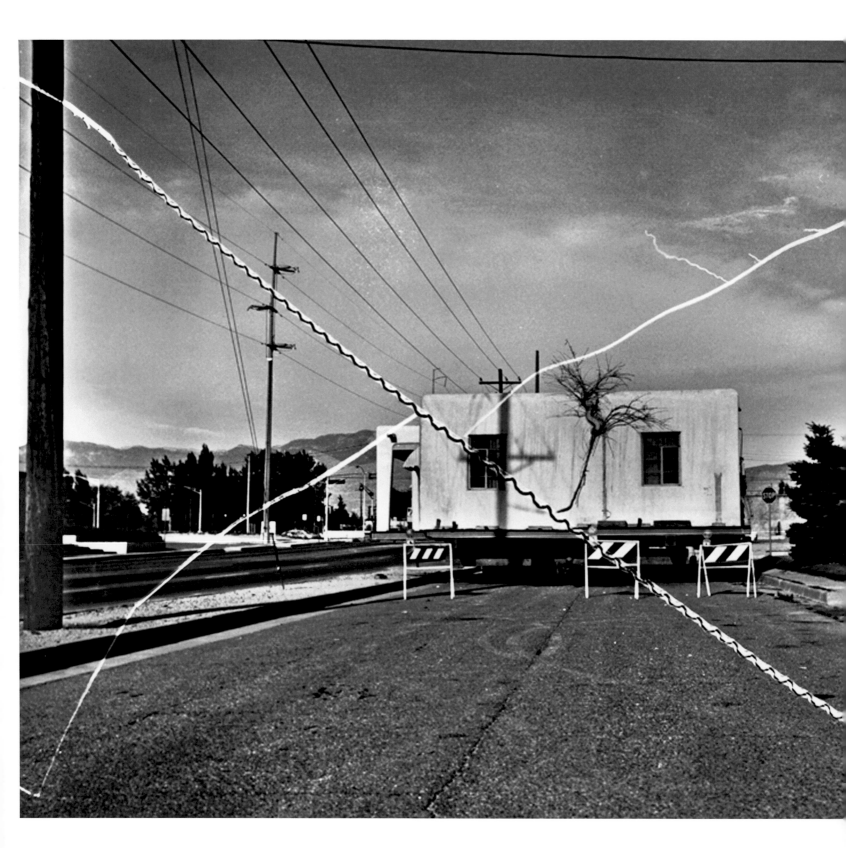

TRANSFORMATIONS OF THE PHOTOGRAPHIC DOCUMENT

opened the exhibition *Nine Photographers Look Beyond,*
which featured interpretations of the American landscape
by artists ranging from conceptual photographer Thomas
Barrow and image manipulator Jerry Uelsmann to the far
more "traditional" André Kertész and Harry Callahan. But
with the public not quite ready for this level of critique,
the disparity of approaches was once again explained by
the sacrosanct—and convenient—principle of the freedom
of expression afforded by different photographic
techniques. [52]

In 1978, John Szarkowski organized his manifesto-
exhibition at MoMA in New York titled *Mirrors and
Windows: American Photography since 1960* (including
many works from the 1960s and even the 1950s).
Szarkowski was probably not willing to see what lay just
ahead, limiting himself to a system of classification whose
weaknesses are clearly visible with hindsight. Szarkowski
detected a fundamental division in contemporary photo-
graphy between those who believe in photography as a
means of expression and those who seek to use it as a
method of exploration, opposing an expressive, "romantic"
attitude to a strictly documentary, "realist" ambition.
For Szarkowski, photography remained a single entity
in the face of reality; only the responses to reality—either
personal or analytical documents—varied. According
to Szarkowski, Les Krims and Duane Michals were of
the same school as Danny Lyon and Bruce Davidson, the
subjective "mirror" school. Diane Arbus was grouped with
Lee Friedlander and Ed Ruscha among those whom
Szarkowski described as looking at reality through a
window. Ralph Eugene Meatyard, whose work was left
out of the exhibition, did not illustrate either point of view.

LEFT:
Thomas Barrow
*Mobile Home,* 1974
From the series
*Cancellations,* 1974

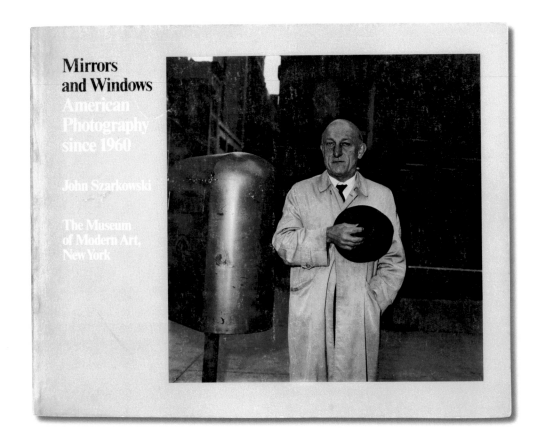

ABOVE:
Cover of
exhibition catalogue
*Mirrors and Windows*
(New York: Museum of
Modern Art, 1978)

OPPOSITE, TOP:
Cover of book by
Ed Ruscha,
*Twentysix Gasoline Stations*
(Alhambra, CA: Cunningham
Press, 1969. Third Edition.)

OPPOSITE, BOTTOM:
Pages from
*Twentysix Gasoline Stations*
(1969)

To avoid seeing his photographic world shatter, the star curator of the era had attempted to unify it through the creation of these illusory concepts. [53]

The 1978 mega-exhibition *Attitudes: Photography in the '70s* had a take on 1970s American photography that was very different from Szarkowski's. Organized by curator Fred Parker at the Santa Barbara Museum of Arts, the show culled 485 pieces from the collection Parker had assembled for the museum. [54] It celebrated the decade's eclecticism and the growing hybridization of art photography, a trend particularly apparent among West Coast artists. At a time when the New York photo world seemed to be asserting its supremacy, critical voices were rising up to contest its overpowering, questionable influence, and drawing attention to other richly creative areas. California photography, which had too frequently been reduced to pleasant, exotic regionalism, was certainly deserving of recognition. [55] In 1965, Ed Ruscha (b. 1937) published his first artist's book, a small volume featuring twenty-six (poorly) reproduced images of gas stations that he had photographed on the California to Oklahoma stretch of Route 66 in 1962. With the publication of his book, Ruscha declared "fine art photography" obsolete, stating the medium was

restricted to purely utilitarian recording purposes: "I think photography is dead as a fine art; its only place is in the commercial world, for technical or information purposes."[56]

Two years later, John Baldessari picked up on the premises of a utilitarian, carefully "de-aestheticized" photography in his series of "phototexts" on acrylic canvas. Each phototext featured a photograph (some taken by Baldessari or a friend, and others found photos) flanked by a caption simply indicating the location. Though the method of photography Baldessari adopted may have had conceptual motivations, it was, in fact, quite similar to methods used by Robert Frank or Garry Winogrand: "I drove with one hand and pointed the camera out the window with the other, not looking where I was shooting pictures. . . . I wanted things the way they were, with ugly wires and telphone poles, without beautification, and with the quality of newspaper photo-reportage, which the photoemulsion images resembled because of their grainy emulsion."[57]

Beyond the conceptual questioning of "photographic truth," the dominant trends surfacing at that time in California shared a tendency to integrate into photographic practice, by a wide variety of means, motives and concerns borrowed from other art forms, including painting. The work of Robert Heinecken, which reflected on the image in mass media, borrowed its style and themes from the works of De Kooning and Robert Rauschenberg.

## ROBERT HEINECKEN (1931—2006)

Try as you might, it is impossible to sum up Robert Heinecken with a tidy place in the art history books under "multimedia artist." His way of seeing things, and in particular the photographic image (especially as it was used and abused by the media), sprang from an authentic need to question rather than from a calculated aesthetic pose. An ex-fighter pilot in California, Heinecken participated in what he called "the artistic guerilla,"[1] a vitally determined stand against visual stereotypes that no one, including artists, could escape. This little man with a pony tail and a slightly heavy jaw described himself as a "paraphotographer" or a "photographist" to avoid being mistaken for a plain old "photographer," which he was in only the most begrudging way. An anarchist at heart,[2] Heinecken followed in a tradition already rich with artists past and present who questioned the boundaries and possibilities of the photographic image by mistreating it, literally pushing it to the limit. Heinecken put photography through various shock treatments, manipulations drawn from other art forms he had studied: drawing, design, printmaking, and contemporary reproduction techniques, such as Polaroid, and the like. Yet he never lost sight of photography, his own or that of his colleagues, original or recycled.

Heinecken's obsession with photography is probably what differentiates him from Robert Rauschenberg and Andy Warhol, artists who used the photographic image but were not exclusively concerned with it. Like Les Krims, Heinecken chose to be a part of the photography world rather than the art world. In the mid-1970s, this question of status began to damage both Heinecken's and Krim's places in history, largely for financial reasons. Heinecken is not granted the importance that—justly—is given to Rauschenberg, largely because he never belonged to the world of the art galleries.[3] He described his work by stating that "My ideas are *photographic ideas,* they are not drawing ideas, and most printmaking ideas are drawing

ideas."[4] This is quite clear in his series using press photos, such as *Are you Rea,* of 1966–68. Here, the recycled material seems to be used in the same way that it would by a photographer recording it in the real world. Heinecken modified the pictures and devised their layout to make them as visually attractive and intriguing as they would be when shot directly by a photographer, "much in the same way that some contemporary documentary photographers are doing."[5]

Heinecken's 1974 series incorporating pornographic material—*Fetishism, Lesbianism, Autoeroticism*—was inspired by French filmmaker and novelist Alain Robbe-Grillet's film *Glissements progressifs du plaisir* (The Slow Sliding of Pleasures). The photos have an erotic power completely unmatched in the conceptual photography of the era, which was oddly limited in this sphere. Although intended as reflections on the boundaries between erotic and pornographic images, they are most striking as troubling representations of desire freed from the exacting morality of the activist feminism of the time (such as Bea Nettles: see p. 117). Along with Les Krims and Ralph Gibson, Heinecken was one of the few photographers of his era to touch on the subject of sex. Its important role in his work may partially account for his lack of popularity. This was certainly the case with the color Polaroid series *He: Lying there—the sun is directly in my eyes,* 1976–78, which alternates close-up shots of vaginas and eyes, open and closed.

1. Robert Heinecken, interview with Charles Hagen in *Afterimage* (April 1976): 10.
2. Ibid.
3. Robert Heinecken's death in 2006 nearly went unnoticed. When I invited him to the Rencontres internationales de la photographie d'Arles (International Photography Festival in Arles, France) in 2000, during my time as the festival's artistic director, his presence did not elicit any great enthusiasm. Few art critics requested interviews. Alone and inactive, he seemed to have resigned himself to this indifference.
4. Introduction to the portfolio *Are you Rea: A series of 25 magazine page photograms.*
5. Ibid.

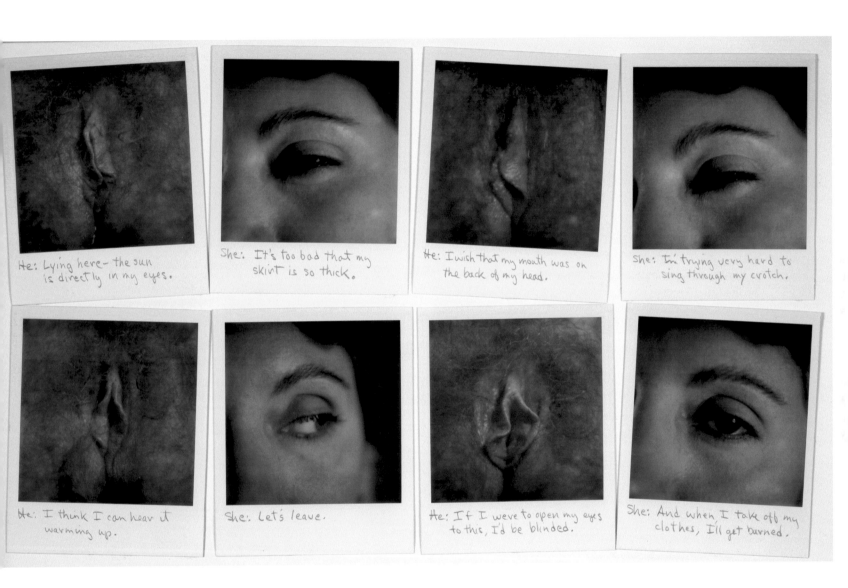

He: Lying here—the sun is directly in my eyes.

She: It's too bad that my skirt is so thick.

He: I wish that my mouth was on the back of my head.

She: I'm trying very hard to sing through my crotch.

He: I think I can hear it warming up.

She: Let's leave.

He: If I were to open my eyes to this, I'd be blinded.

She: And when I take off my clothes, I'll get burned.

ABOVE:
Robert Heinecken
*He: Lying here—the sun is directly in my eyes,* 1976–78
Number one of two SX-70
Polaroids and text on board

FOLLOWING PAGES:
Robert Heinecken
Sample page spread
from *Glamour Recycled*
magazine, 1971 [Vietcong
superimposed on Chanel
and Faberge ads]

# A happy user of our waterproof eye liner.

Water won't do a thing to your Fabergé Magic Liner, whether it comes from a faucet or from your own eyes.

Magic Liner is both liner and adhesive. It holds your Fabergé Swim-Lashes so super-tight neither surf nor sobs can faze them.

With Magic Liner you use only one product to line and to hold your lashes. So putting on lashes is now a one-step job instead of two.

Doesn't that make you happy enough to cry?

*Fabergé*

COSMETICS EXTRAORDINAIRE

FABERGÉ SWIMLASHES ARE JUST AS WATERPROOF AS THE MAGIC LINER, FOR ON OR OFF-SHORE DUTY IN SLATE, SABLE OR TIGRESS STRIPE. MAGIC LINER, AVAILABLE IN SLATE OR SABLE, COMES WITH LINER BRUSH.

FABERGÉ, INC. · NEW YORK · LONDON · TORONTO · PARIS

120

Chanel No. 5 Spray Perfume and Spray Cologne, each 6.00.

# CHANEL

## JOHN PFAHL (B. 1939)

A successful example of the links between painting and photography, Pfahl's *Altered Landscapes* series—realized in the latter half of the 1970s and published in 1981[1]— followed in the path of Land Art artists by imitating their deliberate actions upon the environment. Choosing landscapes with marked pictorial, even romantic connotations, Pfahl imposed physical changes on the sites by drawing or painting on them according to a predetermined concept. Once photographed, his changes reconfigured the landscape through the laws of optical perception, which "flattens" any photographic reproduction of reality into two dimensions. The results of Pfahl's interventions display a significant formal elegance. Yet the conceptual gesture rises to the fore, revealing the artificiality of the photographic approach, which can no longer claim its innocence.

1. John Pfahl, *Altered Landscapes* (San Francisco: The Friends of Photography, 1981).

John Pfahl
*Big Deeper, North Carolina,*
April 1976

# DAVID LEVINTHAL (B. 1949)

David Levinthal is part of that generation of artists for whom television, more than photography or the print media, has formed their way of seeing. Yet, he also belongs to that artistic current for whom the analysis of historical and cultural events depends on a critical reinterpretation of the role played by the history of photography and, more generally, by images, on our perception. Beginning in the late 1970s, the possibility of simultaneously perceiving the artificial and the real in a single event led artists to reinterpret our world and its myths by means of the visual strategies that described them. These artists were referred to as Postmodern.

David Levinthal's *Hitler Moves East*,[1] a collaboration with Garry Trudeau, who wrote the text, "describes" the Nazi army's 1941–43 military campaign against the Soviet Union in a narrative form. The book consists of groups of photographs related to the campaign. However, the images are not drawn from archives, but rather are staged photos of lead soldiers, miniature tanks and scale models constructed and photographed by Levinthal. A few more "authentic" documents, such as postcards and business cards, are scattered throughout the book to provide what Roland Barthes called a "reality effect."

1. David Levinthal and Garry Trudeau, *Hitler Moves East: A Graphic Chronicle 1941–1943* (New York: Sheed, Andrews and McMeel, 1977).

David Levinthal
*Untitled #5*
From the series
*Hitler Moves East,* 1975

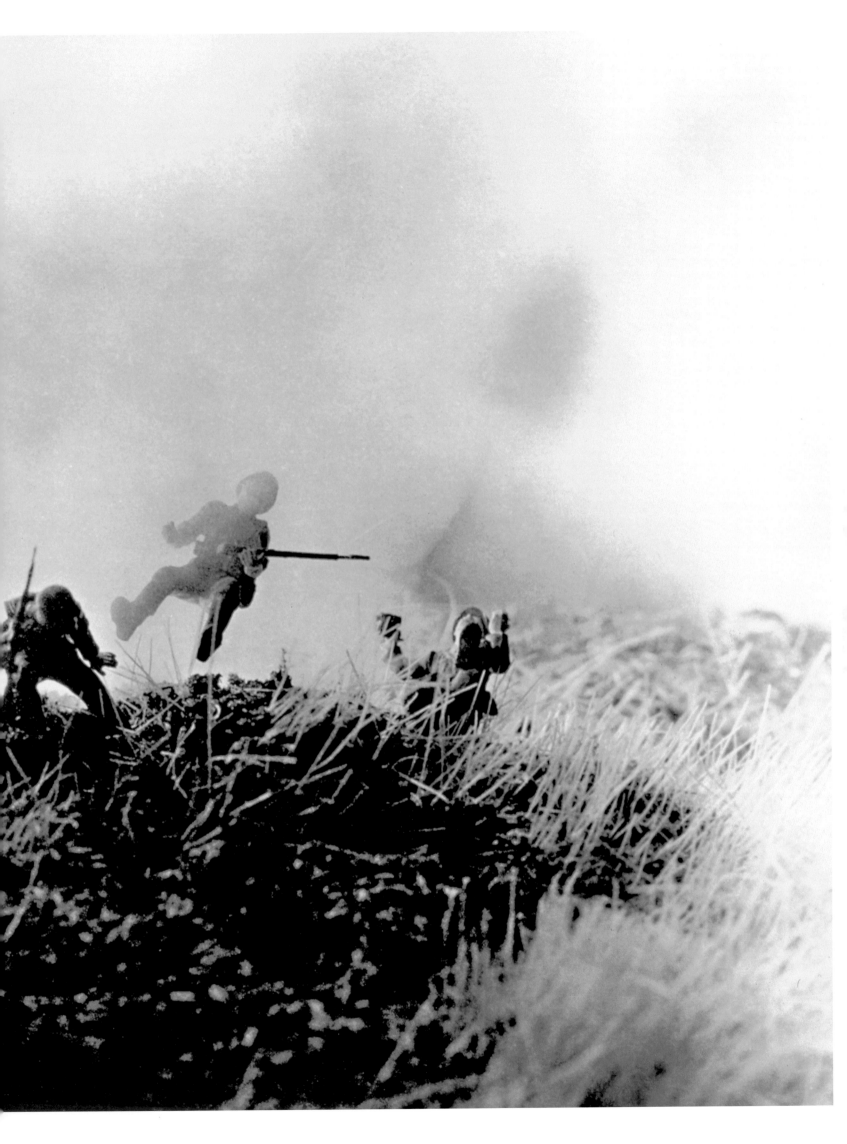

AMERICAN PHOTOGRAPHY OF THE SEVENTIES:
THE MAKING OF HEROES

# THE JOHN SZARKOWSKI GALAXY

In 1978, American photography appeared to be at the height of its glory, with its convictions well established. This state of affairs was largely due to what must be called the "Szarkowski system," organized around the now very—too?—influential MoMA curator. With a few books and exhibitions—particularly *The Photographer's Eye* (1966) and *Looking at Photographs* (1973)—Szarkowski had succeeded in drawing a map of photography that served as a fundamental definition and reference by which he could assess and rank photographers and their work. His theory was simple: photography is a specific art form, different from other modes of visual expression, because of its unique aesthetic characteristics and special technology. [58] The photographer's work is expressed in this context. Thus a historical tradition that legitimizes photography as an art form (photography historian Beaumont Newhall having opened the way) [59] serves as its reference and runs through European and American modernity, from Eugène Atget to Walker Evans—two central figures in the Szarkowski system—through press, applied, and amateur photography. To go beyond these confines was to betray the medium. Every one of Szarkowski's exhibitions, every one of his texts, argued his essential convictions in order to perpetuate them. He also knew how to use the power of the press to expose his views to a broad audience. The definitive title he chose for a long article published in *The New York Times Magazine* on April 13, 1975, asserted his profession of faith: that photography is indeed "A Different Kind of Art." [60]

Szarkowski left MoMA in 1991 after organizing *Photography Until Now* (February–May 1990), the exhibition and book that felt like the summation of his legacy. He had not budged from his initial convictions in the slightest, bolstered by his institutional "Mount Olympus" at MoMA. [61] Excluding commercial photography from his pantheon—he did make a few exceptions, such as a 1975 retrospective dedicated to the work of fashion photographer Irving Penn—Szarkowski was the champion of a new photographic art, a sort of "anti-traditional photography" that was more primal, instinctive, energetic, even brutal. Garry Winogrand's work served as the ideal prototype [62] in black-and-white photography, followed by William Eggleston's in color. At the very most, Szarkowski accepted a slight compromise in his introduction to *Mirrors and Windows* (1978) by noting—as demanded by the increasingly hybrid production of the 1970s—the creative fertility provoked by encounters between photography and other

media and means of expression. He explained these encounters by the importance given to photography education in the universities, rather than assuming the reverse.

Szarkowski's writing is always lively and sensual, revealing a visceral, intuitive understanding of photography. Its powers of persuasion are the consequence of effective, down-to-earth rhetoric miles from deadly theoretical or academic language. His role in the photography world of the 1970s was more or less unprecedented. His power, both direct and indirect, was enormous. An exhibition at MoMA was as important for a photographer's reputation as the cover of *Life* would have been during the 1950s. It

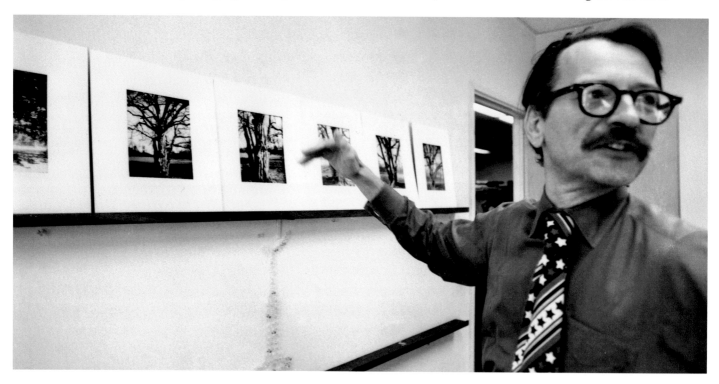

John Szarkowski in his office
at MoMA, New York, 1981
(photo by Bernard Plossu)

allowed photographers to be discussed at universities, to get more grants, and to increase their gallery sale prices significantly. The doors of publishing houses opened to the artist privileged enough to have a foreword written by Szarkowski. One could almost say that, at the time, MoMA's photography curator was single-handedly carrying the past, present, and future of American photography.

The exhibition *Mirrors and Windows* opened at MoMA in New York on July 28, 1978, accompanied by a catalogue of the same name. The event unleashed an unprecedented media canonization of the "Szarkowski system." In the July 23, 1978, issue of *The New York Times Magazine,* Hilton Kramer published a glowing seven-page account of the show titled "The New American Photography." With a title like that, Kramer did not leave the reader with any doubt that Szarkowski's choices for the exhibition reflected the historical reality of contemporary American photography. Analyzing the unparalleled photography boom as a social phenomenon for a public "that is now so avid for photography," Kramer applauded the curator's aesthetic choices nearly without reserve and anticipated the show's public success even before it had opened. [63]

# THE PHOTOGRAPHY MARKET:
## THE RISE OF THE GALLERY

One sign of the stunning success photography had been enjoying for a decade was its flourishing commercial presence on the art market. The irresistible rise of American photo galleries was closely linked to this trend. In 1954, Helen Gee founded her modest Limelight establishment, which doubled as a bar and a small gallery at 91 Seventh Avenue in New York. The following year, African-American photographer Roy DeCarava used his apartment as an exhibition space, known as A Photographer's Place. By 1969, when Lee D. Witkin opened the Witkin Gallery in New York, the uninterrupted pace at which similar venues were opening supported and probably accelerated the recognition of the photographic medium by the general public and collectors. In 1969–70, the *International Directory of Arts* listed 131 museums and art galleries dedicated to photography in New York. Only thirteen of these establishments were private galleries. The 1977–78 edition listed 529 private galleries! [64]

The Witkin Gallery may have had the most extraordinary history of any of these private galleries, a history due, as was often the case at the time, to the determination, passion and tone-perfect intuition of Lee D. Witkin (1935–1984). In the late 1960s, following his studies in journalism and art history, and a stretch as an editor at *Popular Science* magazine, Lee Witkin took notice of photography's new status and the unprecedented upswing in the New York art market. Despite advice to the contrary, he invested all his savings in creating a unique establishment. The Witkin Gallery opened in March 1969 at 237 East 60th Street, where it remained until its move to 41 East 57th Street in 1976. It was the first East Coast gallery to represent photographers' work commercially and make a profit.

Lee Witkin's gallery was conceived in reaction to the kind of cubic space in which modernism had confined public and private exhibitions since the advent of the Julien Levy Gallery and The Museum of Modern Art in the 1930s. It was an atypical place with a delightfully domestic atmosphere. Photographs benefited from the warmer, more personal context provided by a chimney; small, comfortable rooms; shelves of photo books available for purchase; and, most important, the charismatic presence of the gallery's owner. Witkin's eclectic but assured taste rapidly propelled him to a dominant position in the emerging market for art photography (though John Szarkowski did regret Witkin's lack of a definitive aesthetic direction [65]). The subjects of shows at the Witkin Gallery ranged from historic photographers such as Atget in May 1969 to successful artists such as Henri Cartier-Bresson or Ansel Adams in February 1970; but they also took in the experimental work of young beginners, such as Bea Nettles in February 1978. The Light Gallery, which opened in 1971 on Madison Avenue, focused more exclusively on contemporary photography. Also in 1971, Witkin published limited-edition portfolios

Lee D. Witkin in his gallery,
New York, 1977
(unknown photographer)

AMERICAN PHOTOGRAPHY OF THE SEVENTIES

by several photographers. When Doubleday followed suit the same year, publishing portfolios by Les Krims and then Jerry Uelsmann, each containing six photo-engraved images and available for $6.95, collecting photography became that much more accessible to the general public.

In 1976, *Fortune* featured an article dedicated to the recent economic history of photography and, particularly, to its rising prices. The article provided a better understanding of the unprecedented context in which American photography was now operating. That year, profits from auction sales of early and modern photography were multiplied ten- to twentyfold.[66] Contemporary work was developing less ostentatiously, but continued to make significant advances. At its Christmas sale on December 6, 1975, the Witkin Gallery sold a Diane Arbus, *Boy with Hand Grenade*, for $150, while a Lee Friedlander photograph from the *Photography of Flowers* portfolio could be had for $200. In July 1981, the fifteen pictures from this same portfolio would change hands for $6,500.[67] Full-out speculative madness caught hold of the photography market. Private collectors such as Samuel Wagstaff Jr., initially the curator for contemporary art at the Detroit Institute of Arts, or Chicago lawyer Arnold H. Crane, who had collected 55,000 early and contemporary prints by 1976, built collections that were constantly increasing in value. Corporations soon got into the game. The National Exchange Bank of Chicago started its collection of photographic images in 1966, with an annual budget of $250,000. In 1973, Seagram & Sons spent $90,000 on a group of prints on the theme of "the American city" and hung them on permanent display in its administrative offices in Manhattan.[68] In 1975, New York's prestigious private Marlborough Gallery mounted its first photography show, dedicated to Richard Avedon, under the guidance of young curator Pierre Apraxine. By joining the fray, Marlborough consecrated photography as a powerful economic and symbolic vector, worthy of significant investments.[69]

However, signs of a recession began to appear as early as 1975, indicating the market might be reaching a saturation point. The October Sotheby's auction was deemed "cautious and conservative," with buyers facing such a profusion of creative and commercial goods that they no longer knew exactly what to bank on, preferring to fall back on the historical sure bets than on contemporary photographers whose work had not yet been unanimously recognized.[70] The full deterioration, or even collapse, of the photo market came in 1980, with the general economic stagnation of the period. In August 1982, *Décor* magazine released a special photography issue, in which a series of interviews with gallery owners and dealers confirmed that the golden age of American photography had come to an end. A bitter Lee Witkin explained: "Institutional buying such as the museums has dropped off. And a lot of big collectors seem to have retired. . . . I guess hope is running out."[71] In lamenting the brutal slowdown of the market from 1978 to 1980, gallery owner Robert Mann blamed the excessive overvaluation of young photographers.[72]

OPPOSITE:
Contact sheet showing the Witkin Gallery, New York (unknown photographer)

**Y**et American photography of the sixties and seventies also found backing for its extraordinary development in other venues. As we have seen, the role played by museums grew year by year, and not only in the case of MoMA, which served, especially since the appointment of John Szarkowski, as a type of barometer for rising photographic values, but also in the country's other most visible institutions, such as the venerable Art Institute of Chicago founded in 1879. David Travis, who was named assistant curator at the Art Institute in 1974, then head photography curator in 1977, did not take on a flamboyant role in the style of John Szarkowski, but rather that of an art historian at ease in presenting classic photography. Critics noted that his January 1979 exhibition, *American Photography in the 1970s,* a response of sorts to Szarkowski's *Mirrors and Windows,* felt more like a gathering of the top sellers on the market, influenced by East Coast galleries and institutions, than the fruits of a personal choice and analysis. [73] When considering the seventies, one has the impression of a proliferation—even an uncontrollable surge—of museum activity across the country, whether it be the consolidation of the George Eastman House, first opened in Rochester, New York, in 1947, or the creation of the Center for Creative Photography (CCP) in Tucson, Arizona, in 1975, spurred on by James Enyeart and Ansel Adams. In 1973, the New Orleans Museum of Arts hired new curator E. John Bullard and started its own photo collection. The Pasadena Art Museum served as eloquent testimony that the West Coast did not lag behind. From the time young photography curator Fred R. Parker arrived in 1969, when he started the photography department, to his departure in 1974, the museum's collection grew from 48 to 500 pieces. All this without a specific budget, merely Parker's militant charisma! [74] The eclecticism of Parker's choices—Robert Heinecken, Betty Hahn, and Robert Flick photos alongside the work of Roy DeCarava, Henry Wessel Jr., and Lewis Baltz—puts to shame the far more reductive, purist vision then imposed by the New York coterie.

Relayed through the education network, the embrace of photography at the university level was unique. Between 1964 and 1967, the number of universities offering photography courses grew from 268 to 440. [75] In 1962, the Society for Photographic Education (SPE) was founded, with James Alinder as its first chairman. The SPE would publish, irregularly, an important periodical, *Exposure.* The most notable photographers also became professors: this was the case, as we have seen, of Aaron Siskind and Harry Callahan; of Minor White at the Massachusetts Institute of Technology; and later, among many others, Charles Traub and Tom Barrow at the University of New Mexico, and Les Krims at Buffalo State College. Photographers also spent part of their time teaching hugely successful photo workshops for students or amateur photographers. [76] With a few exceptions, the new system of workshops and courses generated a sterilizing

## MIKE MANDEL (B. 1950)

In 1975, the young California photographer Mike Mandel made a series of photographs printed in the format of baseball cards. Mandel's twist on the popular form was to replace the pictures of famous baseball players with pictures of stars of the contemporary American photo world. He succeeded in photographing nearly every one on his list, posing his 143 subjects in baseball uniforms and coded athletic stances. On the back of each card, the photographer, curator, or collector was described according to his or her vital statistics and personal interests, as in a classic baseball card, and was asked to provide a brief statement of purpose that summarized his photographic work. Mandel received significant support from Robert Heinecken, who lent him the money to realize the project. The cards proved to be a genuine commercial success, confirming a broad audience's interest in the "heroes" of photography. In October 1975, Mandel wrote Heinecken: "The cards seem to be a success. Every gallery or museum that I've been able to place a carton with has sold out in a couple of weeks. Light Impression soon will be distributing them 'en masse.' *Popular Photo* interviewed me last week. I got stoned for the event."[1]

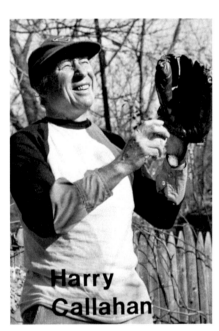

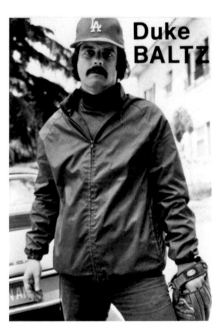

1. Mike Mandel, letter to Robert Heinecken, July 10, 1975, CCP archives, Tucson, Arizona.

academicism that elevated photographers to the levels of stars. In an article in *New York* magazine, Jack Somer nicknamed the beneficiaries of this attention the "gurus of the visual generation."[77] West Coast photographer Mike Mandel brought the system to its pinnacle by designing and marketing a set of cards, modeled on baseball cards, representing the current stars of the photography world.

Lisette Model, an accomplished, mature photographer, accurately sized up the limits of this approach to teaching when she was invited to lead a series of workshops at the New School for Social Research in New York. She declared that it was "basically impossible to teach someone how and what to photograph."[78] Garry Winogrand was

Van Deren Coke and
Thomas Barrow
at the University
of New Mexico,
Albuquerque, 1974
(photo by Bernard Plossu)

concerned about the eventual negative impact of a strategy of photography education at any cost.[79] But the movement was all the rage and well on its way to becoming a national cause. In *The New York Times* of November 21, 1971, A. D. Coleman published a "Manifesto for the Teaching of Photography," in which, evoking Moholy-Nagy's sentence about the future illiterates of the camera,[80] he called for photography education to be integrated into every level of the school system, from kindergarten to the universities.

The intellectual counterpart of this sweeping "schooling" was the development of the field of criticism. Photography's rise in the academy encouraged an aesthetic approach to the medium, as initiated by Beaumont Newhall, the photography historian

who had joined Van Deren Coke and Tom Barrow as a professor at the very active University of New Mexico in Albuquerque. As early as 1952, Minor White had called for the development of criticism that was more suited to its subject. His demands would be echoed throughout the sixties and seventies. In a speech at a 1980 conference on criticism, Andy Grundberg summed up the results of this difficult quest. Though he noted the healthy status of "applied criticism"—often associated with journalism and with applied critics such as Janet Malcolm who wrote about photography for a broad audience—he pleaded for an expansion of "theoretical criticism," in keeping with the theoretical semiotic or socioeconomic Marxist models then found in Europe. Stating that old models of approaching photography now had to confront a far more fragmented, plural photography, Grundberg called for new, equally pluralistic critical tools. [81] For, with a few exceptions, the critical mode most widely practiced throughout the 1970s embraced documentary, or straight, photography's dominant aesthetic along with the views of John Szarkowski. Susan Sontag's bestselling *On Photography* (1977), in the form of a philosophically-minded meditation, approached historical and modern photography by largely ignoring contemporary practice, with the exception of Diane Arbus. Sontag reinforced the documentary connection between photography, reality, and its social implications, launching—as would Roland Barthes in France—an enthusiasm for the photographic object that would triumph among intellectuals during the 1980s. The great American critical texts, such as those of Max Kozloff, [82] appeared in the late 1970s and early 1980s.

The conjunction of developments in photographic institutions, education, and the market shaped a quasi-administrative system. In 1965, the National Endowment for the Arts (NEA) was founded. The federal organization's initial budget of 2.5 million dollars would grow to 7.8 million by 1969. [83] NEA grants favored commissioned art, but also allowed museums and institutions to increase the scope of their collections and exhibitions. By the mid-1970s, American photography had established a structured, professional organization that had a hierarchy but avoided compartmentalization. Eventually the machine began running on empty, serving primarily to support a new economic sector in the art world. Critic Michael Lonier pointed out as much in March 1979, in his harsh assessment of seventies photography as reflected in a retrospective held at the Art Institute of Chicago: "Regardless of minor teleological triumphs here and there, the overriding condition of the past ten years has been ennui. . . . The continuation will not spring from any vitality of the medium . . . but from the support apparatus that a decade of art photography has installed around what used to be a quirky occupation. . . . Curators need photographs to curate, critics need pictures to write about, teachers have to teach, and all continue to produce with greater efficiency. Already there are signs that the support system for art photography is every bit as articulated and organized as that surrounding show business or journalism." [84]

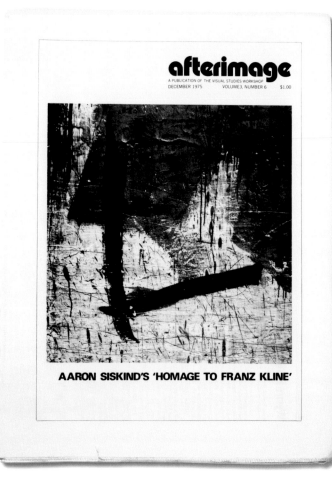

AARON SISKIND'S 'HOMAGE TO FRANZ KLINE'

**A**t the same time, the inflation in photographic production pushed publishers to recognize the medium and use it to attract a new audience. Several new periodicals and magazines hit the newsstands beside well-established publications such as *Popular Photography* and *Modern Photography,* both of which had long targeted amateur photographers. *Aperture* magazine, which had quickly developed into a publishing house, exported creative American photography to the international market by publishing monographs and special issues. *Afterimage* began publication in 1972 as an offshoot of the Visual Studies Workshop, started in Rochester in 1969 by Nathan Lyons and a handful of photographers and students determined to consider photography in its broadest dimensions through the field of visual studies. [85]

Interest in early and contemporary photography in universities and among collectors combined with the medium's growing visibility in widely read newspapers such as *The New York Times,* which hired regular contributors to review photo books and exhibitions, [86] to facilitate wider circulation of the photography book. The photo book was the ideal format in which photographers could carry out their personal projects. One could say, to some extent, that American photography of the period was following the example of European photography between the two world wars, when the book became the privileged vector of a new photographic language, offering the artist a creative space with its own laws that he or she could determine. Two book projects stand out as the best examples of this kind of editorial creativity, where photographers rejected the role of an editor or art director in claiming authorship not only of their images, but also of their books' layout and design: Ralph Gibson's "trilogy" (*The Somnambulist,* 1970; *Deja-Vu,* 1973; *Days at Sea,* 1975) (see p. 138) and Lee Friedlander's majestic *American Monument* (1969). Ralph Gibson (b. 1939) moved to New York in 1963. In 1969, he decided to start his own publishing house, Lustrum Press, to maintain complete control of the reproduction of his work. Lustrum Press published books by photographers such as Larry Clark and Robert Frank (*The Lines of My Hand,* 1972), as well as innovative volumes on landscape or darkroom methods. Founded by Leslie G. Katz in 1966, the Eakins Press Foundation counted Walker Evans's *Message from the Interior* (1966) and Friedlander's celebrated *American Monument* (1976) among its standout publications.

With its large format (12 by 16 inches) and unusual design, *The American Monument* sums up the period's editorial ambitions. Friedlander presented *American*

ABOVE:
Cover of
*Afterimage* 3, no. 6
(December 1975)

OPPOSITE, TOP:
Cover of *The
American Monument* by
Lee Friedlander (The Eakins
Press Foundation, 1976)

OPPOSITE, BOTTOM:
Page from *The American
Monument* (1976)

*Monument* as a contribution to the American bicentennial. The book picked up on a project initiated by Walker Evans when he was working for the Farm Security Administration, in 1935, archiving the wildly diverse commemorative monuments scattered about every American town. During the Depression, between 1934 and 1943, the FSA hired photographers to document living conditions reflecting the economic crisis in rural and urban America. Friedlander's book introduced a level of interactivity unprecedented in the medium. Indeed, the roughly 500 meticulously reproduced images could be removed from the binding, allowing the reader to reconfigure the order according to his or her own taste, or even to frame a photo and hang it on the wall.

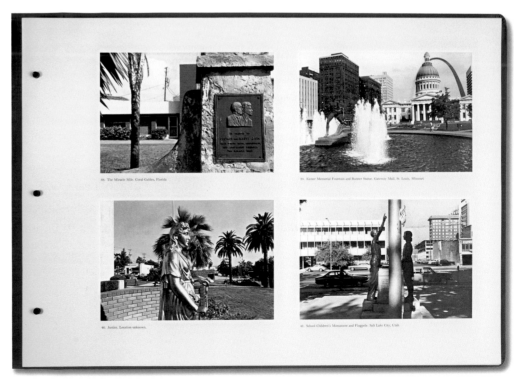

## RALPH GIBSON (B. 1939)

Ralph Gibson may be the most European of the American photographers of his generation. His overt references to 1920s and 1930s photographic styles, such as the New Vision, Surrealism, and Bauhaus—with their attention to form, aesthetic of the detail, structuring role of black-and-white, and Leica "mythology"—as well as the influence and importance of his work in the Old World were discovered, enthusiastically discussed, and imitated there.[1] Europe—in particular France and Italy—has always been drawn to photography with intellectual associations; and it was quick to find what it was looking for in Ralph Gibson's photography. It was Jean-Claude Lemagny who provided the best description of his work: "It is the most controlled and the most lucid."[2] Gibson practiced snapshot photography only at the beginning of his career, in 1960 and 1961. The rest of his work rests on two levels of construction: first, the image, a model of rarefied visual composition, printed in the most exquisite black-and-white; then, preparation of the book and its layout. Gibson's "surrealist" trilogy published between 1970 and 1974 remains a powerful example of what he can achieve through the photo book.

1. Many American photographers active in the 1960s found a hero's welcome in Europe, particularly once the creation, in 1969, of the Rencontres d'Arles by French photographer Lucien Clergue provided them with a launching pad to European fame. Clergue invited the new generation of American photographers to hold photography workshops and to show and discuss their work in lectures that attracted more and more enthusiasts every July. France was particularly important in promoting these new photographers by exhibiting and purchasing their work for large institutional collections. Jean-Claude Lemagny, photography curator at the Bibliothèque Nationale de France since 1968, has played a crucial role in this process.
2. In *L'Ombre et le temps: Essais sur la photographie comme art* (Paris: Nathan, 1992), p. 157.

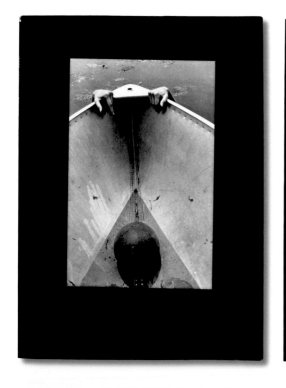

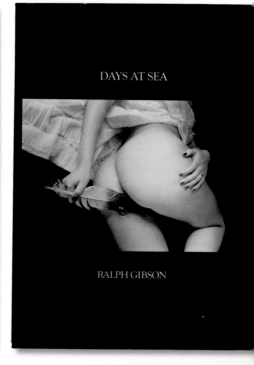

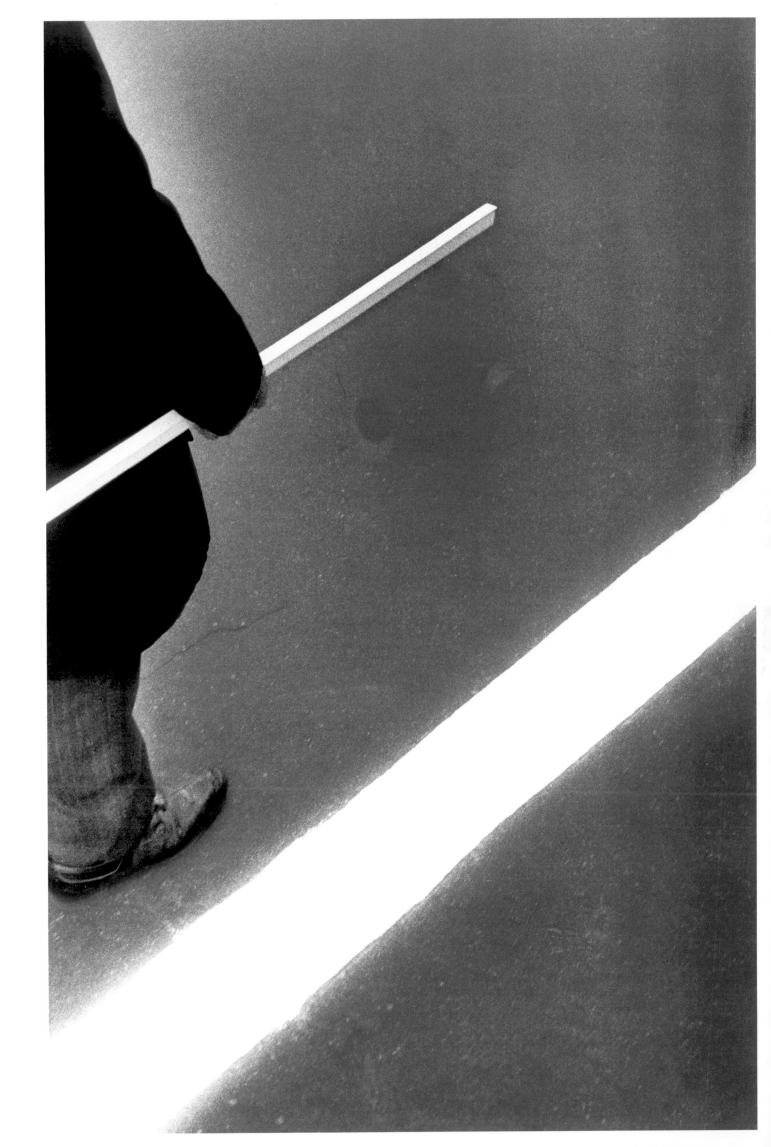

PAGE 138, TOP:
Ralph Gibson
Back cover of *Deja-Vu* (1973)
by Ralph Gibson

PAGE 138, BOTTOM LEFT:
Cover of *The Somnambulist*
(1970) by Ralph Gibson

PAGE 138, BOTTOM CENTER:
Cover of *Deja-Vu* (1973) by
Ralph Gibson

PAGE 138, BOTTOM RIGHT:
Cover of *Days at Sea* (1975) by
Ralph Gibson

PAGE 139:
Ralph Gibson
Photograph from *Deja-Vu*
(1973)

LEFT:
Ralph Gibson
Photograph from *Deja-Vu*,
(1973)

OPPOSITE:
Ralph Gibson
Photograph from
*The Somnambulist* (1970)

THE LANDSCAPE IN FOCUS

## THE LURE OF THE ENVIRONMENTAL

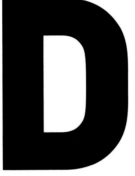During the latter half of the nineteenth century, a tradition of the virgin American landscape developed around the breathtaking natural sites discovered during the final explorations of the American West between 1860 and 1885. The photographers hired for these expeditions, such as Carleton E. Watkins, Timothy O'Sullivan, Eadweard J. Muybridge, and William Henry Jackson, were the first to capture these landscapes. [87] Their large-format documentary photography—the word *documentary* is fully justified by the terms of the mission they were assigned by the American government—was as admiring in the face of natural beauty and grandeur as it was contemplative. It triggered an awareness of the natural landscape largely identified with the American West. East Coast American photography, as defined by Alfred Stieglitz, Paul Strand, and Charles Sheeler, would be associated with the urban landscape. In both cases, from the mid-nineteenth century to the peak of modernity in the late 1960s, from pictorialism to straight photography, American photography would define its aesthetics in relation to the natural and urban landscape.

Edward Weston as well as the aforementioned photographers were characterized by the way they visually interpreted their environment and made use of both the properties and limitations of their medium. Until the 1960s, photography rarely displayed signs of a critical conscience capable of provoking a deliberately distanced view of the environment in order to observe its evolution and changes. In the years before his death in 1958, Weston's photographs of California beaches did record the first signs of pollution, but only from an anecdotal point of view; the scattering of trash merely served an aesthetic purpose. To his last picture, Ansel Adams never stopped fighting to preserve the illusion of a natural landscape safe from the harsh environmental changes it suffered in the wake of the postwar economic boom. In the 1970s, Adams was at his zenith. The photo world embraced a steep climb in the value of his work in the galleries and on the auction block, along with the deceptively soothing aesthetic that justified the price hike.

Only a few photographers active in the years between the two world wars, such as Walker Evans or Charles Sheeler, had prepared the viewer to absorb the changes brought by intrusive advertising and rapid industrialization. The foreground of their images became increasingly cluttered with signs, poles, telephone and electricity cables, and odd buildings. Lee Friedlander would later remember their example and powerfully apply it

to his own work. Yet, overall, with just a few exceptions, the photographers active during Friedlander's time would turn away from these environmental questions or, at most, use them as interesting visual or conceptual pretexts. This was most flagrant in Pop Art's use of mass-market products. The Campbell soup cans and Coca Cola bottles increasingly polluting the American environment were being gleefully lined up to decorate New York art galleries. Having rediscovered the pleasures of straight photography in 1978, Robert Rauschenberg used a similar approach to photograph Boston [88] and a variety of places between Baltimore and the Florida coast. "The photos of *In + Out City Limits*," he wrote, "make no attempt to totally document, moralize or editorialize the specific locations. They are a collection of selected provocative facts (at least to me) that are the results of my happening to be there." [89] The seminal artist's sharp take on big cities served as an excuse to exercise his visual cleverness and curiosity, without a hint of critical, sociological, let alone environmental, reflection about the desecrated urban landscape.

Nonetheless, certain venues and organizations did encourage environmental awareness. The Sierra Gallery, for instance, opened in 1970 in New York, where it has since served as a showcase for the Sierra Club, the organization devoted to environmental protection since it was founded in San Francisco in 1892. Edward Weston and Ansel Adams contributed photographs to projects initiated by the Sierra Club, thus helping to disseminate an aesthetic of untouched nature.

With ecological questions becoming increasingly pressing in the United States, in 1970 the Sierra Gallery presented with the Arthur Tress exhibition *Open Space in the Inner City: Ecology and the Urban Environment*. In conjunction with the exhibition, it published a portfolio of photos that had been displayed at the Smithsonian Institution in Washington in 1969. Tress's work dealt with the degradation of large cities due to pollution and overpopulation. Possessed of a rather European humanist spirit, Tress photographed urban alternatives to the ravages of "open spaces," abandoned docks, roof terraces, and empty parking lots. The exhibition mixed photographs with non-photographic material such as plans and development projects. It drew a great deal of attention, including the praise of A. D. Coleman in a long review published in *The New York Times* on March 15, 1970. Nearly thirty years later, a revisited version of the exhibition was mounted in New York in 1998, long after Tress had developed his surrealist style. The author of *The New York Times* review published on May 3, 1998, now saw Tress's urban images only as the backdrop against which he staged his sexual fantasies of childhood. Tress's willfully lyrical style is recalled in a series of images by Nicholas Nixon (b. 1947), in which Nixon describes a similar relationship between urban space and private space through photographs of couples taken in his hometown of Boston.

**Open Space in the Inner City**

Ecology and the Urban Environment/Photographs by Arthur Tress
An exhibit portfolio by the New York State Council on the Arts for the New York Museums Collaborative

Cover of portfolio by Arthur Tress, *Open Space in the Inner City: Ecology and the Urban Environment,* 1970

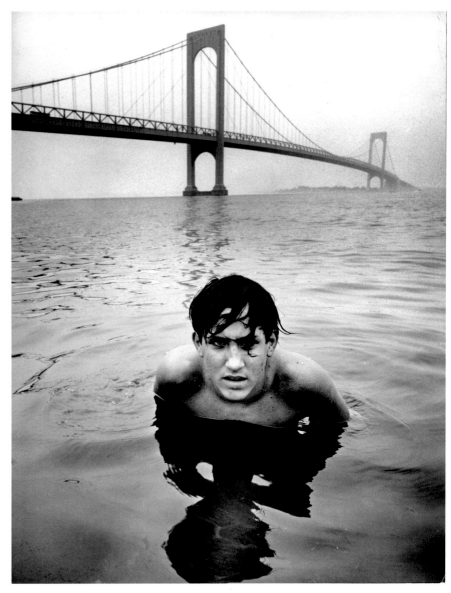

RIGHT:
Arthur Tress
*Francis Lewis Park, Queens,*
*New York City,* 1970
From *Open Space in the*
*Inner City*

BELOW:
Nicholas Nixon
*Boston,* 1980

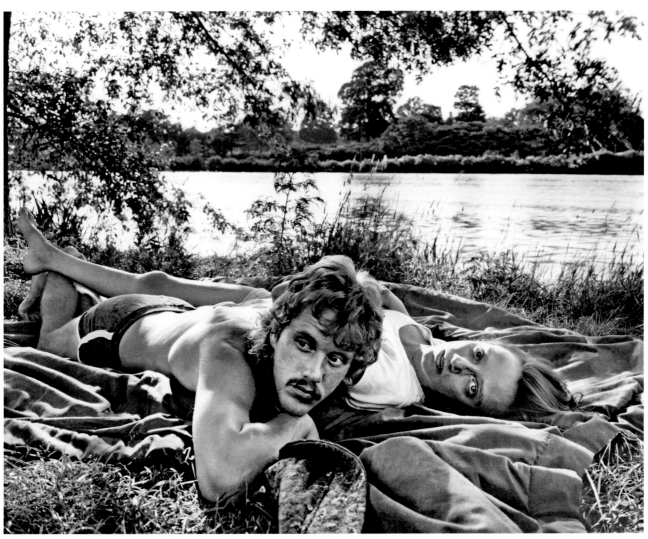

## BILL OWENS AND *SUBURBIA*

**A**nother environmental approach to photography appeared on the West Coast, where the most advanced version of the "American way of life" was flourishing. A marked increase in population movement from east to west took place throughout the sixties, confirming California's vocation as a model of social and economic life, favored by attractive weather conditions, apparently boundless open space, and the illusion of a freer lifestyle. Los Angeles and San Francisco provided the active scene for countercultural expression—hippie communities in the hills of San Francisco that in 1967 began to replace beatniks—as well as radical changes in mental attitudes— sexual liberation and political radicalism spurred by growing resistance to the war in Vietnam. [90] These social and economic changes generated new modes of behavior, a new environment, and galloping urbanization. It fell upon photography to explore these social zones as expressions of a new modernity far different from that of the East Coast, which was shaped by more traditional, but equally normalizing, habits.

Bill Owens and family, 1974
(photo by Bernard Plossu)

## BILL OWENS (B. 1938)

Although Bill Owens was an atypical figure in American photography of the seventies, the publication of his book *Suburbia*[1] in 1972 played a central role in providing new social subjects for the photographic documents. Still active today, Owens has notably expanded his fields of interest; he is the founder of the Buffalo Bill microbrewery and editor of *American Brewer* magazine.[2]

In the fascinating little book *Documentary Photography*,[3] published in 1978, Owens explained the ideas and working methods behind *Suburbia,* which he originally intended to call "Instant America." Shot in the new suburban neighborhoods of Livermore, California, around San Francisco Bay, Owens's quasi-anthropological work described the American model of the "good life" allegedly provided by these new architectural projects. Owens's initial idea was to make a photographic document about a place with which he was familiar— thereby moving away from the exotic reportage typical of the genre—and which he had covered since 1970 as an independent photographer for the local paper, the *Livermore Independent.* The essence of Owens's work was the lack of distance between photographer and subjects— Owens photographed friends and neighbors—the banality of the "tiny" lives that he had to confront, and the share of the American Dream borne by each of these lives and shaped by the deceptively positive ideology of the American way of life. Owens recorded exteriors, interiors, and their inhabitants with great descriptive clarity, anticipating the subsequent approach of the New Topographics. He eventually managed to obtain a $500 grant to finish the project and, working entirely outside established institutions, published his book of 126 images with a small publishing house, a subsidiary of the iconic sixties journal *Rolling Stone.* He spent a total of $3,600 and was responsible for all artistic decisions concerning the layout. The pictures are accompanied by a text, a kind of soundtrack composed of comments by the people he photographed. Owens's frontal framing and his stylistic neutrality perfectly accentuate the standardization stemming from the new lifestyles of the American middle class. Yet there is no satirical ambition at work in Owens's photographs. His neutral documents, he believed, could offer people the opportunity to "become aware of their lifestyles, and have a better appreciation of it, [so] they could change it for the better."[4] If the spectator/reader projects a critical interpretation on the world of *Suburbia,* it derives more from his or her own understanding of the photos than from the photographer's artistic decisions.

Owens produced three more books in the same vein as *Suburbia. Our Kind of People* (1975) presented the work and leisure rituals of the American working class. *Working* (1977) explored the workplace, a neglected subject that Bill Owens and Lee Friedlander were among the few photographers of their generation to investigate.

Short of money and not particularly interested in becoming part of an artistic establishment that, when it came down to it, more or less ignored him, Bill Owens stopped taking photographs in the late 1970s. His images hark back to the tradition of the FSA, notably to the photos of Russell Lee and Marjorie Collins. Those who followed him into documentary photography may not want to acknowledge it, but they owe a great deal to Bill Owens.

1. Bill Owens, *Suburbia* (San Francisco: Straight Arrow Books, 1972).
2. See Owens's Web site, www.billowens.com, for more information about the life of the man who once humorously described himself, with a touch of provocation, as a "photographer, a father, a brewer, a gardener, and founder of the American Distilling Institute."
3. Bill Owens, *Documentary Photography: A Personal View* (Danbury, NH: Addison House, 1978).
4. Ibid., p. 17.

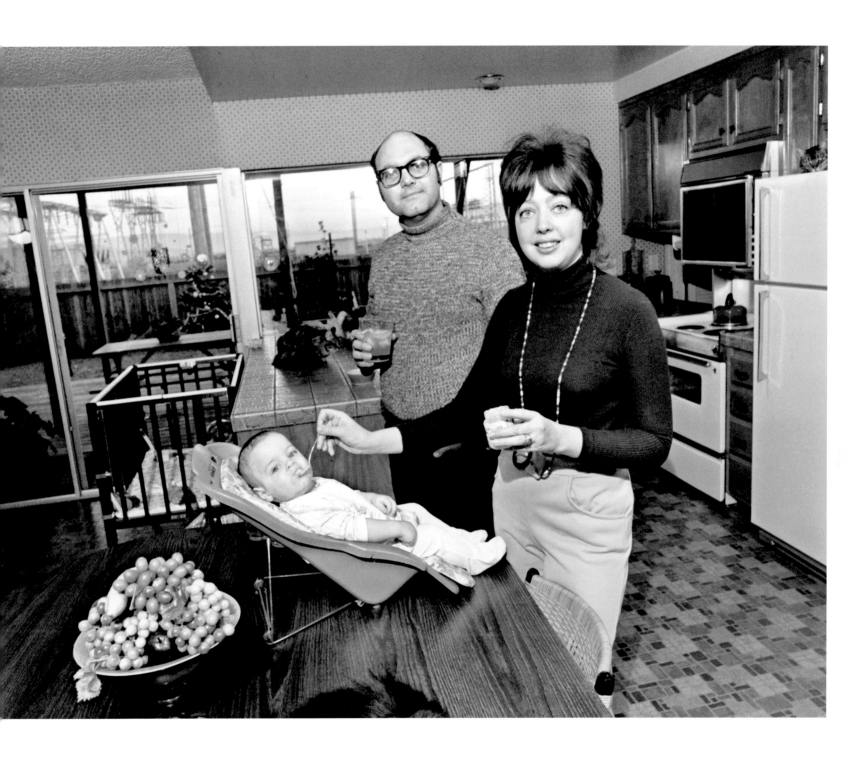

Bill Owens
*We are really happy,* 1972

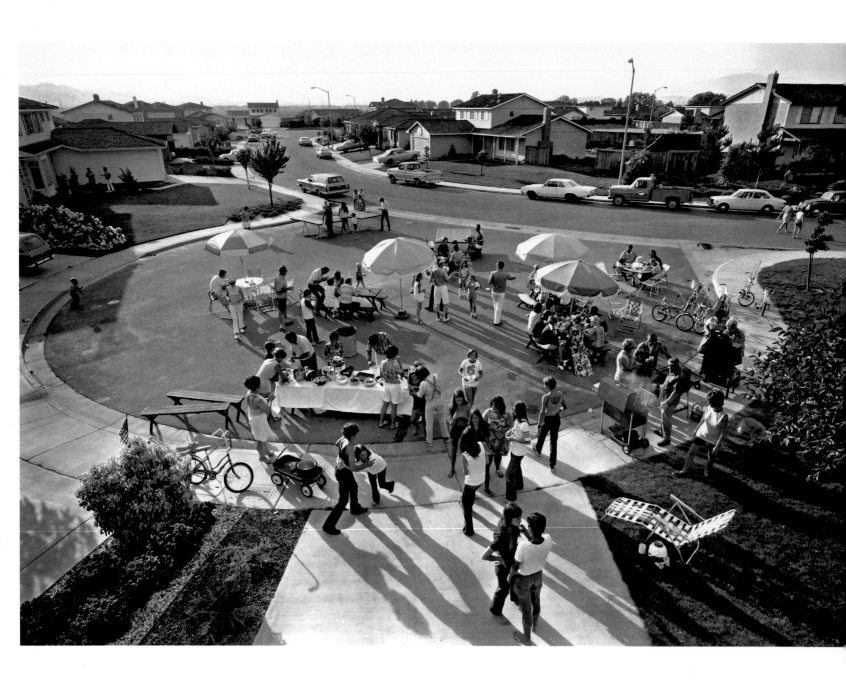

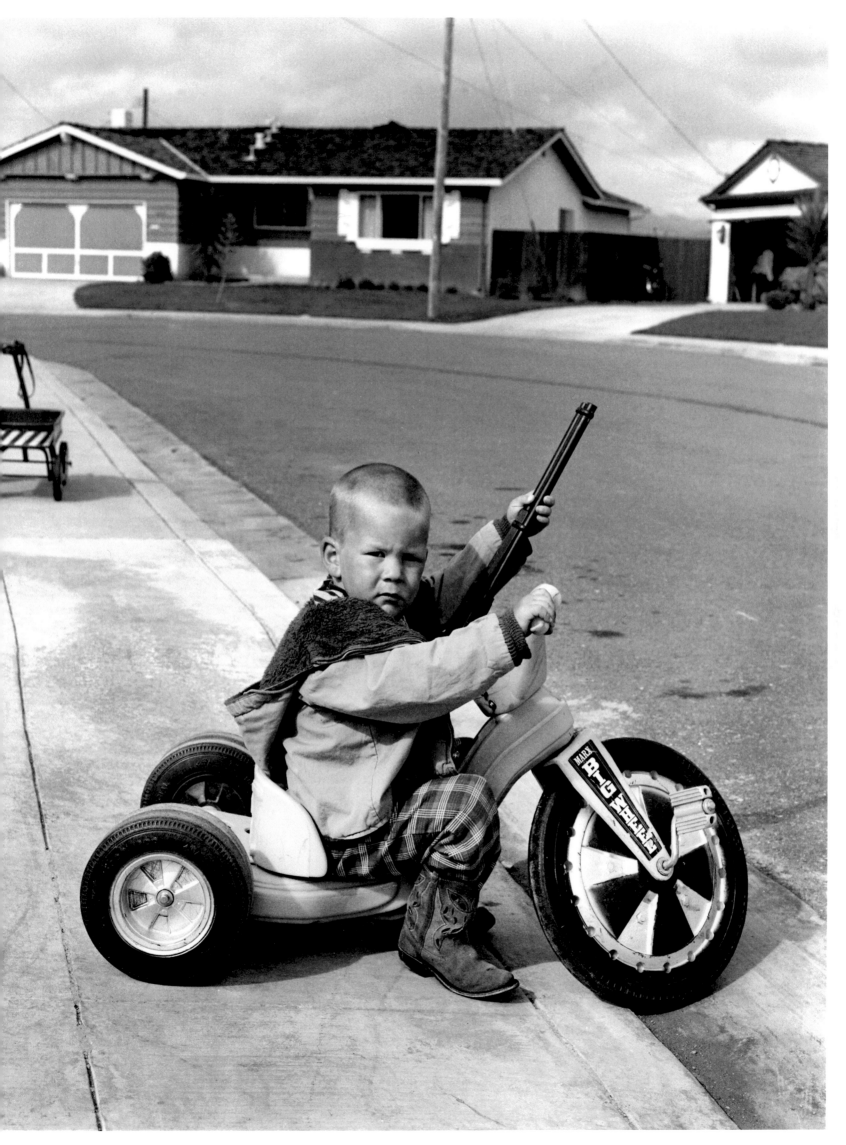

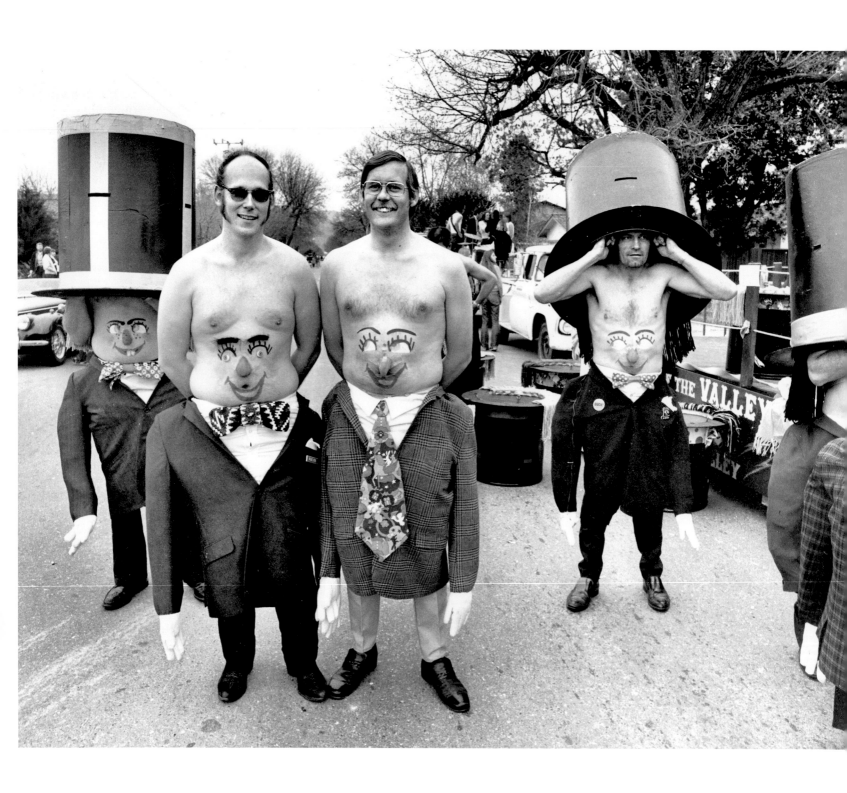

Bill Owens
*Voice of the Valley Radio Club,*
1974

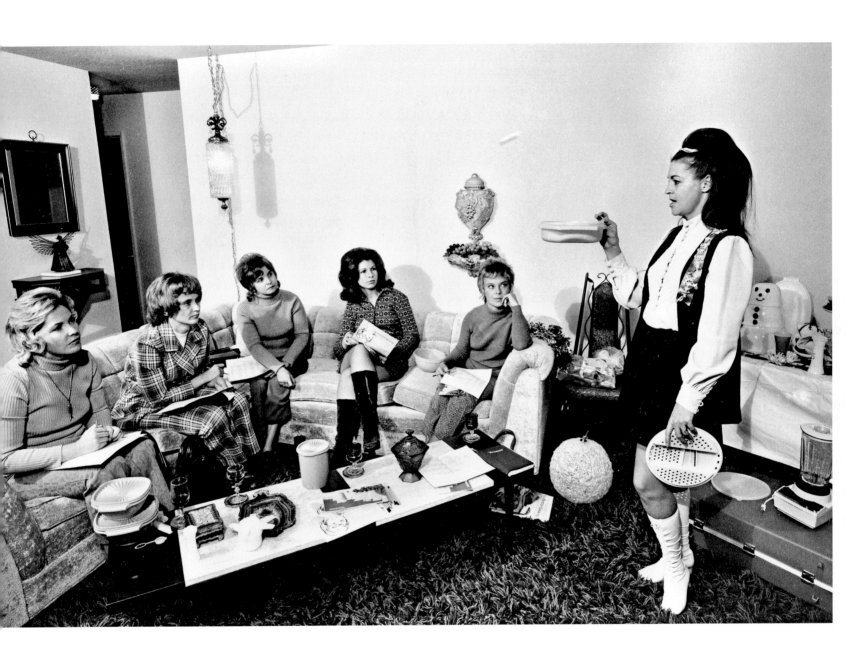

Bill Owens
*Tupperware Party*, 1971

In 1975, an exhibition and book attempted to "clean" the American photographic landscape of its subjectivity and chronic metaphorical aesthetic. The idea was to promote a new, more critical reading through the photography of a handful of artists familiar with each other's work. Curator William Jenkins brought the group together under the generic name of *New Topographics*; the term *topographic* seemed more rigorously objective than *landscape artist*. The exhibition was subtitled *Photographs of a Man-Altered Landscape*. [91] Some of the artists, such as Nicholas Nixon and Lewis Baltz, had met at the Light Gallery in Boston. The New Topographics shared the "essentially stylistic" characteristics of neutrality and anonymity. [92] Jenkins commented on these stylistic traits in his preface to the catalogue accompanying the exhibition at the International Museum of Photography at the George Eastman House in Rochester: "The stylistic concept within which all the work of the exhibition has been made is so coherent and so apparent that it appears to be the most significant aspect of the photographs." [93] Making a stunning historical leap, Jenkins ignored Walker Evans's work on the notion of stylistic anonymity, claiming that the idea had originated with the artist's books Ed Ruscha began publishing in 1962, including the aforementioned *Twentysix Gasoline Stations*. When considered closely, the argument elaborated in the preface to the exhibition catalogue displays blatant weaknesses. Jenkins rehashes the long-established idea that it is impossible to achieve a pure state of photographic neutrality. At the very least, he goes on to say, a landscape can be observed objectively, as the artists in the show do, in a manner that is "anthropological rather than critical, scientific rather than artistic." [94] In other words, photographic neutrality could be imitated, even approached, but never attained.

The iconic *New Topographics* exhibition will be remembered for promoting a style characterized by frontal composition (all the artists in the exhibition shot frontally); working in series (which Hilla and Bernd Becher, the only Europeans in the show, combined with typological classification); massive promotion of vernacular, especially architectural, subjects; and, among the more complex artists, such as Robert Adams or Lewis Baltz, a frequently nuanced critical reflection on the boundaries between the natural and cultural in the landscape, already initiated by a few predecessors, although in a less systematic fashion. These elements added up to a method of photography anticipated by the work of Walker Evans or the German New Objectivity between the

---

NEW TOPOGRAPHICS
Photographs of a Man-altered Landscape

Robert Adams · Lewis Baltz · Bernd and Hilla Becher · Joe Deal · Frank Gohlke · Nicholas Nixon John Schott · Stephen Shore · Henry Wessel, Jr.

International Museum of Photography
at George Eastman House, Rochester, New York.

ABOVE:
Cover of exhibition catalogue
*New Topographics*
(Rochester, NY: George
Eastman House, 1975)

OPPOSITE:
Pages 8 and 9 from the
exhibition catalogue
*New Topographics*

world wars. Followers of the New Topographics eventually turned the method into a stereotypical brand of documentary photography, which was strangely restrictive in its choice of a single point of view and a frontal style, rejecting as questionable or unwelcome any other approach to the real. Typical of that trend is the Düsseldorf School, a German movement that emerged from the Düsseldorf art school where Hilla and Bernd Becher began teaching in 1976, and whose most prominent proponents include Thomas Ruff, Axel Hutte, and Andreas Gursky.

With the exception of Nicholas Nixon, the Bechers, Frank Gohlke, and Stephen Shore, the New Topographics dedicated themselves to describing the transformations of the American West. They took apart the myth of its environmental purity, revealing the irreversible damages done by the rapid industrialization and urbanization that had reached right into the heart of the myth, into the deserts as well as the Rocky Mountains around Denver. Paradoxically, these images of visual material bordering on the banal are often aesthetically beautiful, particularly in the case of Baltz and of Adams.

In 1977, Mark Klett (b. 1952), Ellen Manchester, and JoAnn Verburg undertook to rephotograph twenty-seven sites in Colorado from the same vantage point that William Henry Jackson had photographed them in 1873. Aside from underlining the tremendous environmental stakes at play, the Rephotographic Survey Project [95] launched a fascinating, popular approach to examining the evolution of a single place over time.

## ROBERT ADAMS

Born 1937 in Orange, New Jersey; currently living and working in Colorado.

BACKGROUND

B.A., English, University of Redlands, California, 1959; Ph.D., English, University of Southern California, 1965.

SELECTED GROUP EXHIBITIONS

1975
"14 American Photographers," Baltimore Museum of Art

1974
"Photography 1/Recent Photographs by Seven Artists," Jack Glenn Gallery, Corona del Mar, California

1973
"New Acquisitions," Museum of Modern Art, New York
"Contemporary Photographs," Princeton University Art Museum
"Landscape/Cityscape," Metropolitan Museum of Art

1970
"New Acquisitions," Museum of Modern Art, New York

SELECTED ONE MAN EXHIBITIONS

1972
"Photographs by Robert Adams," Colorado Springs Fine Arts Center

1971-72
"Photographs by Robert Adams and Emmet Gowin," Museum of Modern Art, New York

SELECTED PUBLICATIONS AND REFERENCES

Adams, Robert. "Nature Photography Can Include Us." Sierra Club Bulletin, forthcoming.
Adams, Robert. The New West: Landscapes Along the Colorado Front Range. Introduction by John Szarkowski. Boulder: Colorado University Press, 1974.
Adams, Robert. "Pictures and the Survival of Literature."

Western Humanities Review (Winter 1971).
Adams, Robert. Review of Wisconsin Death Trip by Michael Lesy in The Colorado Magazine (Fall 1974).
Baltimore. Baltimore Museum of Art. 14 American Photographers. Introduction by Renato Danese. January 21-March 2, 1975.
Baltz, Lewis. Review of The New West by Robert Adams in Art in America, vol. 63, no. 2 (March-April 1975), pp. 41-2.
Trachtenberg, Alan; Peter Neill; and Peter C. Bunnell, eds. The City: American Experience. New York: Oxford University Press, 1971.

MAJOR AWARDS

National Endowment for the Arts Photography Fellowship, 1972-73
Guggenheim Fellowship, 1973-74

PUBLIC COLLECTIONS

Colorado State Museum, Denver
Polaroid Collection, Cambridge, Massachusetts
Princeton University Art Museum
Metropolitan Museum of Art, New York
Museum of Modern Art, New York

Robert Adams' photographs appear courtesy of Castelli Graphics, New York.

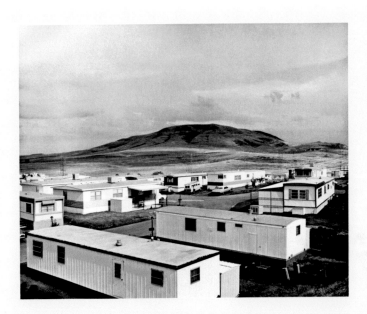

*Mobile homes, Jefferson County, Colorado, 1973.*

9

6    8

## NICHOLAS NIXON (B. 1947)

It's almost surprising to find Nicholas Nixon among the New Topographics. Yet his first pictures taken in Boston, in familiar urban surroundings, display the stylistic characteristics of the landscape artists brought together by William Jenkins. Among the works in the show, only Nixon's made a direct attempt at representing a big city. Taken with a large-format camera, often from above, Nixon's photos are reminiscent of Charles Sheeler's views of New York in the 1930s. Yet Nixon can also produce far more subjective urban images (see p. 145). Most important, he would soon extend his work to include human subjects, particularly the portrait, a genre he practices in the classic tradition, while always emphasizing the temporal aspect; Marcel Proust is one of his essential references. His emblematic series, *The Brown Sisters,* begun in 1975 and still in process, consists of annual photos of his wife Bebe with her three sisters, facing the photographer in a frontal pose and arranged in exactly the same order year after year.

Nicholas Nixon
*View North from the
Prudential Building, Boston,* 1975

## ROBERT ADAMS (B. 1937)

An expert in the work of pioneering landscape
photographers of the West, such as Timothy H. O'Sullivan,
as well as the photography of Dorothea Lange, Adams
is an advocate of photography as a vehicle for beauty, a
theory he defined in his remarkable essay "Beauty in
Photography."[1] This view almost made him pass for a
reactionary compared to the other artists selected by
William Jenkins for the *New Topographics* show at the
George Eastman House in Rochester in 1975. Adams's
attempt to uncover harmony in the architectural or
environmental disasters he photographed in the
American Far West or in the fragile boundaries between
the natural and cultural was accompanied by an elegant
aesthetic that he attributed to his ambition to make
"pictures . . . look like they were not easily taken.
Otherwise beauty in the world is made to seem elusive
and rare, which it is not."[2]

1. *Beauty in Photography: Essays in Defense of Traditional Values*
(New York: Aperture, 1981).
2. *New Topographics: Photographs of a Man-Altered Landscape* (Rochester,
NY: International Museum of Photography at George Eastman House,
1975), p. 7.

Robert Adams
*Longmont, Colorado,* 1980

# HENRY WESSEL JR. (B. 1942)

Wessel is undoubtedly the photographer
to have most extensively photographed
California, his home turf since 1970. He
works like an archivist, photographing
homes, motels, and gas stations as if he
were a real estate agent with the task
of erasing signs of human life from his
catalogue of property listings. Then,
suddenly, chills shoot up the viewer's
spine, as an unusual image reminds us
of a famous Hitchcock film that just
happens to take place in California: a
man in a dreamy pose looks up at a flock
of birds that would certainly be menacing
in Hitchcock's world.

Reviewing the 2007 exhibition
*Henry Wessel: Photographs,* which he
calls "a revelation," Michael Kimmelman
remarks about Wessel's first show, at
MoMA in 1972: "Mr. Wessel's humor was
laconic, and he had a knack for seeing
compositional order where it didn't
obviously present itself—making pictures
like visual haikus."[1]

1. Michael Kimmelman, "Celebrating the Views
That Others Looked Past," *The New York Times,*
March 6, 2007.

Henry Wessel Jr.
*Santa Barbara, California,* 1977

## LEWIS BALTZ (B. 1945)

Baltz combines a striking photographic intelligence—refined by his admiration for the work of Walker Evans and Ed Ruscha, whose profound irony he inherited, with an authentic concern for social issues. He has taken a passionate interest in the role that perception of the photographic image can play in transforming mindsets in the contemporary world. As with Ralph Gibson, Baltz's intellectual approach contributed to his success on the European art scene in the 1980s and 1990s; he now lives in Paris. Baltz's attempts to serially classify chaos, his reflection on points of rupture and convergence between the human and the natural, and the extreme rigor and unity of his pictures taken during the 1970s[1] set him apart as something of the moralist among the New Topographers.

1. These qualities are perfectly illustrated in Baltz's two major works from the period: *The New Industrial Park Near Irvine, California* (New York: Castelli Graphics, 1974) and *Park City*, with an essay by Gus Blaisdell (New York: Castelli Graphics, 1980).

Lewis Baltz
*West Wall, Rohm-Milliken Corporation, Irvine, California*, 1974

## JOE DEAL (B. 1947)

In the early seventies, Joe Deal's photographs of New Mexico landscapes—taken at slightly low angles and shown in the *New Topographics* exhibition—announced a sense of abstraction and visual austerity that could easily be associated with certain Arizona landscapes taken by Frederick Sommer some twenty years earlier. The compression of planes and the suppression of horizontal lines in Deal's compositions make his images seem to bear down on the viewer. His pictures are sometimes reminiscent of cadastral maps that indicate boundaries between properties, and his interweaving of cultural and natural elements of civilization with natural elements is graphically very complex. His *Fault Zone* series (1976–86) devoted to California land along the San Andreas Fault records the transformations spurred by an unexpected demographic boom in a region basically unsuited to it because of the constant threat of earthquake activity.

Joe Deal
*Glendale, California*, 1970

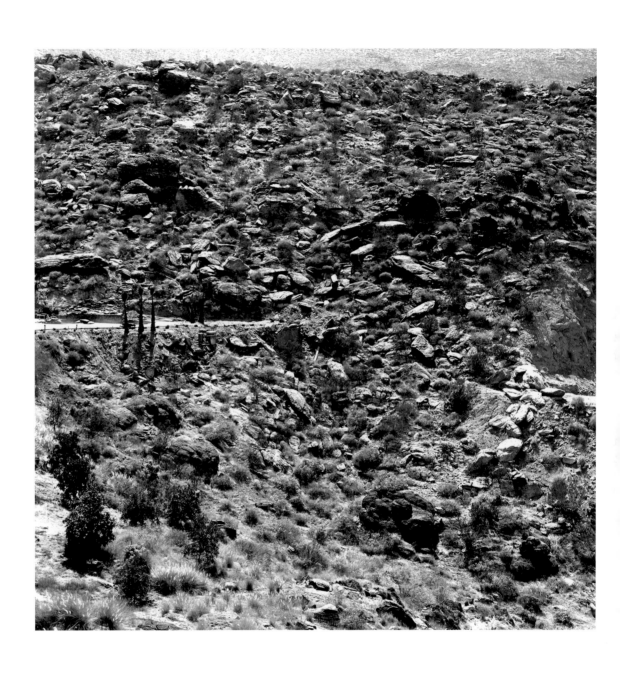

Joe Deal
*Palm Springs, California*, 1979

COLOR AND PHOTOGRAPHY:
THE AMERICAN LUMINISTS

**T**he great controversy that tore through the American photo scene in the late 1970s concerned color in photography. Once again, John Szarkowski was the instigator. His May 1976 MoMA exhibition dedicated to the young Southern photographer William Eggleston—at the time, almost totally unknown on the photo scene—served as one of those manifestos he so enjoyed letting loose upon the world. Szarkowski also played the provocateur in the exhibition catalogue, *William Eggleston's Guide,* [96] by lavishing praise on a young artist without a track record and, especially, by declaring that color photography, which had previously been banished from the museums, had become a reliable tool, just as apt to facilitate creative expression as black-and-white photography had been for a century.

To fully grasp the surprise with which the art world reacted to a museum of MoMA's stature deciding to take a chance on color photography, one must recall how suspicious most institutions were of the medium at the time. In February 1976, *Exposure* magazine took stock of the status of color photography and reported the responses to a questionnaire it had sent to the curators of the principal American museums with thriving photo collections. Of the twenty-five museums polled, only six included color photos in their acquisition policy for photographic works. [97] Most curators explained their reluctance to collect color by the lack of a reliable method for preserving standard color prints, despite Kodak's recent introduction, in 1970, of positive film using dye-transfer, which allowed for highly stable prints. This was the very process William Eggleston was using for his color pictures. Was the success of his controversial exhibition due to the recognition of a technical process or of an innovative body of photography? Contemporary commentators were hard pressed to say. *Afterimage* opted for the former theory. [98] *American Photographer,* whose readership consisted largely of amateur

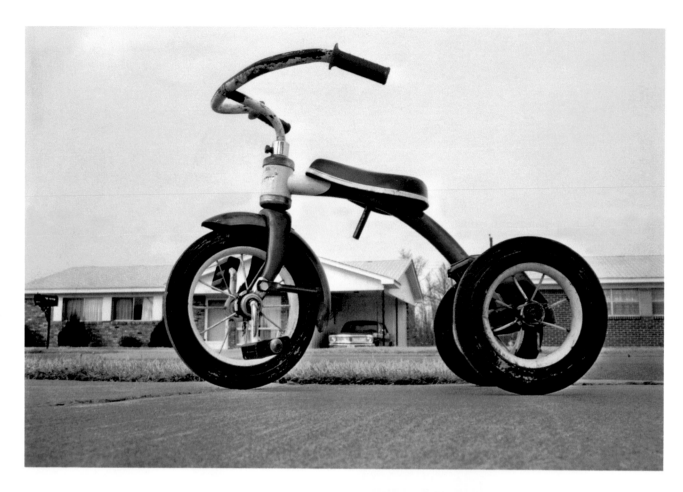

## Photographs by William Eggleston

**May 24-August 1, Northwest Galleries.** Eggleston is one of a group of young photographers who have in the last decade, according to John Szarkowski, director of the exhibition, "begun to work in color in a more confident, more natural, and yet more ambitious spirit, working not as though color were a separate issue, a problem to be solved in isolation (not thinking of color as photographers 70 years ago thought of composition), but rather as though the world itself existed in color, as though the blue and the sky *were* one thing."

*Memphis,* 1970 (above), is one of 80 color photographs by Eggleston in the current exhibition. "At this writing I have not yet visited Memphis, or northern Mississippi," notes Mr. Szarkowski in *William Eggleston's Guide,* published on the occasion of the exhibition, "and thus have no basis for judging how closely the photographs . . . might seem to resemble that part of the world and the life that is lived there. I have, however, visited other places described by works of art, and have observed that the poem or picture is likely to seem a faithful document if we get to know it first and . . . reality afterwards."

*William Eggleston's Guide* reproduces 48 color photographs

following the introductory essay by Mr. Szarkowski, who is the Director of the Department of Photography. Both exhibition and book are produced with the generous assistance of Vivitar, Inc., and the National Endowment for the Arts. *The book is to be distributed to Sustaining and Patron Members.*

## Narrative Prints

**May 14-August 8, Sachs Gallery.** The Japanese artist Ay-O's *Event for Prints/Very Popular Story. (Rainbow Glass) Then, Mr. Ay-O Got Drunk by the Rainbow* (1973, 3M color-in-color magnetic process, 11 1/2 x 8"; The Museum of Modern Art, Mrs. John D. Rockefeller 3rd Fund) may be seen in a show of 95 works invoking the storyteller's art. Among the suites of prints by eight artists are Edvard Munch's *Alpha and Omega* and Peter Blake's *Alice Through the Looking Glass.* The exhibition was directed by Howardena Pindell, Assistant Curator, Prints and Illustrated Books.

In conjunction with the exhibition, poet and storyteller Joyce Timpanelli will read from Lewis Carroll's *Through the Looking Glass* and tell stories based on other series in the show. The readings will take place in the Sachs Gallery at 12:15 and 3:15 on July 22, 23, 29, and 30, and August 5 and 6.

photographers, considered Eggleston an uninspired follower of black-and-white street photography of the 1950s and 1960s. [99] Janet Malcolm of the *New Yorker* was merciless. In her eyes, Eggleston was a poor imitator of the pictorial photorealist movement then at the height of its currency, an artist of limited stature, and a fashionable flash in the pan, brought to the fore through John Szarkowski's will alone. [100] One of the rare positive responses to the photographer from Mississippi's work came from the *Village Voice* that, despite some reservations regarding the essence of the photos, traced the similarities between Eggleston's aesthetic and that of television, [101] both of which were considered elusive and "cold," to use Marshall McLuhan's then fashionable terminology.

Posterity would prove Szarkowski right over nearly everyone else. Today, William Eggleston is widely recognized as an artist of the first importance. His 1976 show served as a catalyst. It delivered photographers, institutions, and the public from their doubts about color photography, triggering a creative explosion in the use of color that coincided with the advent of the Polaroid SX-70 process previously explored to great effect by

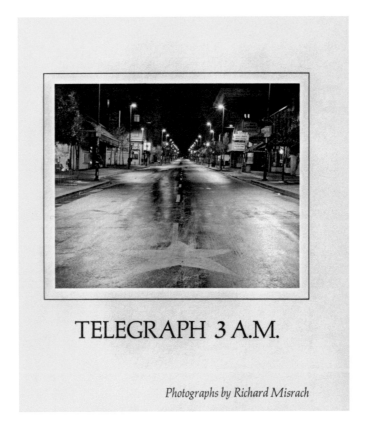

TELEGRAPH *3 A.M.*

*Photographs by Richard Misrach*

Walker Evans in 1972–73 and by Lucas Samaras in his "photo-transformations." In just a few months, what can be referred to as a "colorist" movement, and has even been called "luminism," sprang up in the United States. By the next year, color photographers had become the darlings of the private galleries and the market. In June 1977, Castelli Uptown brought together all the photographers now regularly working in color under the rather vague title of *Some Color Photographs*. The show included conceptual artists (John Baldessari and Ed Ruscha), Pop artists (David Hockney and Andy Warhol), new converts

PAGE 167:
Cover of catalogue for the exhibition *William Eggleston's Guide* (New York: Museum of Modern Art, 1976)

OPPOSITE:
Page of MoMA bulletin (July/August 1976) announcing the exhibition of photographs by William Eggleston

LEFT:
Cover of book by Richard Misrach, *Telegraph 3 A.M.* (Berkeley, CA: Cornucopia Press, 1974)

to color (Ralph Gibson and Mark Cohen), and early practitioners with a well-developed body of work (William Eggleston, Jan Groover, Stephen Shore, Joel Meyerowitz, and Neal Slavin).

Suddenly, long after cinema had taken the leap, it was as if a veil had been torn away and America appeared in color.[102] No longer a mere curiosity that, following the viewer's initial surprise, left them longing for the abstraction of black-and-white prints, color was more a new, perfectly obvious fact of life accompanied by a galloping visual hyperrealism that made monochrome photography look dated or obsolete. Thanks to advances in increasingly polyvalent emulsions, no subject, from the most banal to the most quotidian, was beyond the reach of recording in color. This can be seen, for better and for worse, in some of the road photos Stephen Shore shot during his 1972 American journey. In the "road movie," or visual journal of that trip, color shooting amplifies the radical vulgarity of "shooting everything," even the garbage.[103]

In the 1980s, the triumph of polychromatic imagery would edge out declining black-and-white, to the point that few new artists would take a chance on building a body of work in the older medium, now seemingly tainted with retrograde classicism. Only Lee Friedlander, Ralph Gibson, and Robert Mapplethorpe, operating in very different registers with disparate goals, had the courage to stay faithful to black-and-white. The career of Richard Misrach (b. 1949) serves as a perfect illustration of the trend. Having begun with traditional photography close to Bruce Davidson's aesthetic— *Telegraph 3 A.M.*, his first mature work, published in 1974—Misrach permanently abandoned black-and-white, first via a transition period using selenium-toned prints (a series on the deserts of Baja California), then once and for all, with full-fledged color in his photos of Louisiana, Greece, and Rome taken in 1978–79. From then on, and to the present day, the photographic document's descriptive approach could not do without color and, in an almost systematically related way, with the use of large format, as it was lastingly defined by the American luminists of the 1970s.

n October 1983, *The New York Times* dedicated a long article to Cindy Sherman, the new star of the American art scene.[1] Soon after she got her official start as a photographer in 1980, Sherman's work was shown at The Museum of Modern Art and the Whitney Museum, while her reputation abroad was made by exhibitions at Documenta in Kassel, the Venice Biennial, and Amsterdam's Stedelijk Museum. The black-and-white images of her *Untitled Film Stills* series of 1977–81, which are as grainy as a 1950s movie, show her playing stereotypical roles in staged representations of the American woman. In 1980, she switched to color, working in an even more emphatically kitsch tone, which she shared with her friend, the painter David Salle. Both artists plundered the popular visual languages of television, advertising, and pornography in a manner reminiscent of their predecessors Robert Heinecken and Robert Rauschenberg. Postmodernism had found its first heroine and elevated her to rock-star heights. In the interview she gave to Vicky Goldberg of *The New York Times*, Sherman declared, "I think of myself as an artist, not as a photographer."[2] Her public denial was not an intentional slight of photography, but an accurate expression of the way a new generation of artists considered the medium, using it more for its convenience than its creative potential. Sherman went on to say that "photography is faster than painting." In the 1980s and the decades that followed, photographic heroism was no longer in fashion.

1. Vicki Goldberg, "Portrait of a Photographer as a Young Artist," *The New York Times,* October 23, 1983.
2. Ibid.

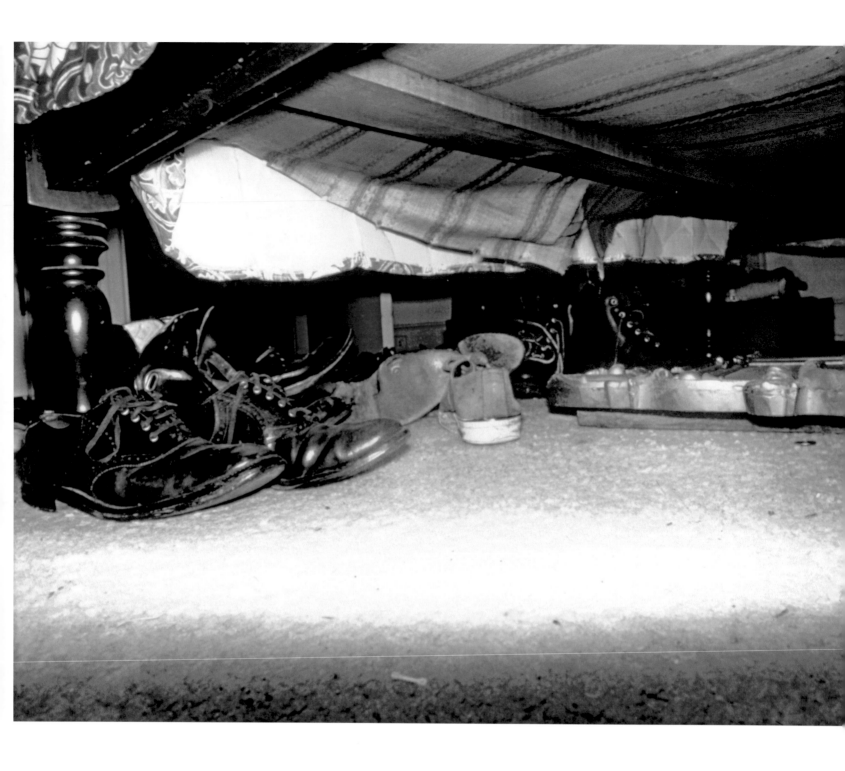

LEFT:
William Eggleston
*Pictures*, 1974

FOLLOWING PAGES:
William Eggleston
*Untitled*, 1974

**Bill EGGLESTON**

Height: 6'
Weight: 140
Born: South
Home: South
Throws: Don't throw
Bats: Don't bat     FP: Don't know
FC: Don't know      FF: Don't know
FD: Don't know      FPh: Don't know

126

**Bill Eggleston**

No comment

Gum by Topps Chewing Gum, Brooklyn / Litho by Mike Roberts, Berkeley
©1975  Mike Mandel

## WILLIAM EGGLESTON (B. 1939)

Eggleston is a Southern photographer, something of an elegant, aristocratic confederate. He was born in the Mississippi of great writers (William Faulkner, Eudora Welty) and lost causes. Lost causes hang over Eggleston's South like an unbroken curse, embodied in the region's refusal to embrace Northern culture and to allow racial diversity to flourish. For an artist like Eggleston, being a Southerner means relating to the subject of his pictures through the culture of the South. The contents of Eggleston's photographs may be immediately identified as part of a world that exists nowhere but the American South. In no other place do dogs cross wastelands with the same lazy gait. Nowhere else do cars decay with such painstaking dedication, as if the fate of Southern reality hinged on the burial and decay of objects by the excessive heat and humidity and by the natural chaos of their position in space; this world is best described in Eggleston's series *The Louisiana Project,* 1980. Nowhere else do you find the acid greens and washed-out pinks that Elvis chose to surround himself at Graceland, and that Eggleston photographed in 1984. You could call it Southern kitsch. As in Faulkner's work, Southern kitsch's most immediate quality is that it narrowly avoids the grotesque, only to sometimes fall into the tragic. Simply put, down South it is a way of life rather than a ridiculous idiosyncrasy.

As a long-time resident of Memphis, Tennessee, the unrivaled capital of Southern kitsch, Eggleston had no choice but to be its champion, perilously balancing irony and conviction. Hence his choice to shoot in color after a few early experiments with black-and-white. John Szarkowski was absolutely right to refute the photographer's claim that he used his environment as a pretext to explore the possibilities of color. Szarkowski tells us that Eggleston's images could only be in color for they
are the "irreducible surrogates for the experience they pretend to record, visual analogues for the quality of one life."[1]

William Eggleston tirelessly proclaims his debt to Cartier-Bresson. He may do so to underline their shared use of 35 mm, but also to legitimize his style by identifying it with European sources. Yet his images are more akin to the amateur snapshot—only externally, of course—in their obvious simplicity and avoidance of framing the essential in a uselessly aesthetic or foolishly distinctive fashion. Firmly dedicated to going beyond the frontal approach espoused by Walker Evans—who is curiously not one of his models[2]—Eggleston was the first of his generation to use color so freely, not restricting it to the static quality of the large-format camera, but conserving large-format's eagle-eyed gaze and carrying it over to the most unexpected vernacular subjects. The essence of Eggleston's art, which hovers somewhere between a game and deceptive simplicity, has been clearly discernible since the first square color photographs he took at the start of his career, between 1966 and 1971. Every one of Eggleston's images expresses a powerful nostalgia and a desire for time to come to a stop.

1. John Szarkowski, introduction to *William Eggleston's Guide* (New York: Museum of Modern Art, 1976), p. 14.
2. "If there was anything about Walker Evans's work that I disliked, it was his determination always to use that same, square, frontal view." Mark Holborn, introduction to *Eggleston: Ancient and Modern* (New York: Random House, 1992), p. 13.

# WILLIAM CHRISTENBERRY (B. 1936)

Another Southerner, William Christenberry comes from Selma, Alabama, near Hale County, where Walker Evans and the writer James Agee spent three weeks in the summer of 1936, staying with poor sharecroppers to document their hardscrabble lives in the classic volume *Let Us Now Praise Famous Men*.[1] The memory of Evans and Agee's presence would haunt Christenberry's work for many years. In 1958, he began revisiting the places Evans photographed, employing an amateur Brownie Flash—which he used until 1977—to take square color photographs of the buildings that Walker Evans had photographed more than twenty years earlier. This process became systematic over the years and led to his use of a large format starting in 1977.

Christenberry's friendship with his colleague William Eggleston does not imply that the two photographers take identical pictures of a shared territory. Christenberry's photographs are meditations on the passage of time and a photographic record of time's effect on signs, homes, and landscapes. Like Evans, Christenberry is attracted to Hale County's vernacular architecture, to the point that he eventually began making three-dimensional models of the buildings he photographed. In 1961, this remarkable storyteller, connoisseur of Southern culture, and multi-media artist, created a room in his home devoted to the Ku Klux Klan. His "Klan Room" contains dolls wearing the traditional garb of this malevolent secret society of the Old South. Though largely shaped by regional influences, Christenberry's work found a large international audience during the color-photography boom of the mid-1970s.

1. James Agee and Walker Evans, *Let Us Now Praise Famous Men* (Boston: Houghton Mifflin, 1941).

OPPOSITE, TOP:
William Christenberry
*Church, Sprott, Alabama,* 1971

OPPOSITE, BOTTOM:
William Christenberry
*Sprott Church,* 1974–75
Mixed media

## STEPHEN SHORE (B. 1947)

Bernd Becher's description of Stephen Shore's art could apply to many of his colleagues working in color photography, including Joel Meyerowitz and Joel Sternfeld: "His photos have something that I see as being an ideal in photography: that one actually enters into the object, that one looks at it in such a way that afterward one has a genuine love for it. . . . It seems to me that what is exemplary in Shore's photography is his respect for the visibility of things. . . . The image is a kind of documentation, but at the same time, one recognizes that it has been constructed."[1]

Walker Evans described his "documentary style" of factual recording and aesthetic construction in nearly the same terms. I have already mentioned Shore's precocious attraction to Evans's work and to photography in general. At sixteen, two years after MoMA had purchased two of his pictures for its collection, Shore began spending time with Andy Warhol. From then on, his interest in photography was combined with a genuine enthusiasm for Pop Art. These rather complementary influences—Isn't Walker Evans's work sometimes considered a forerunner of Pop Art?— encouraged Shore to set out on his 1972 road trip to record American culture. By this time, he was already shooting in color.

Shore's ability to illustrate an American scene largely explored by his contemporaries with the scrupulous realist objectivity described by the Bechers linked him to the New Topographics group. Yet he soon began producing less austere, more seductive photographs that echoed hyperrealist painting as well as the work of Edward Hopper. Shore's work is a perfect example of the descriptive clarity and immediacy with which American photography regularly flirts, at the constant risk of becoming superficial.

1. Conversation between Heinz Liesbruck and Hilla and Bernd Becher, in *Stephen Shore Photographs 1973–1993* (London: Schirmer Art Books, 1994), pp. 27–33.

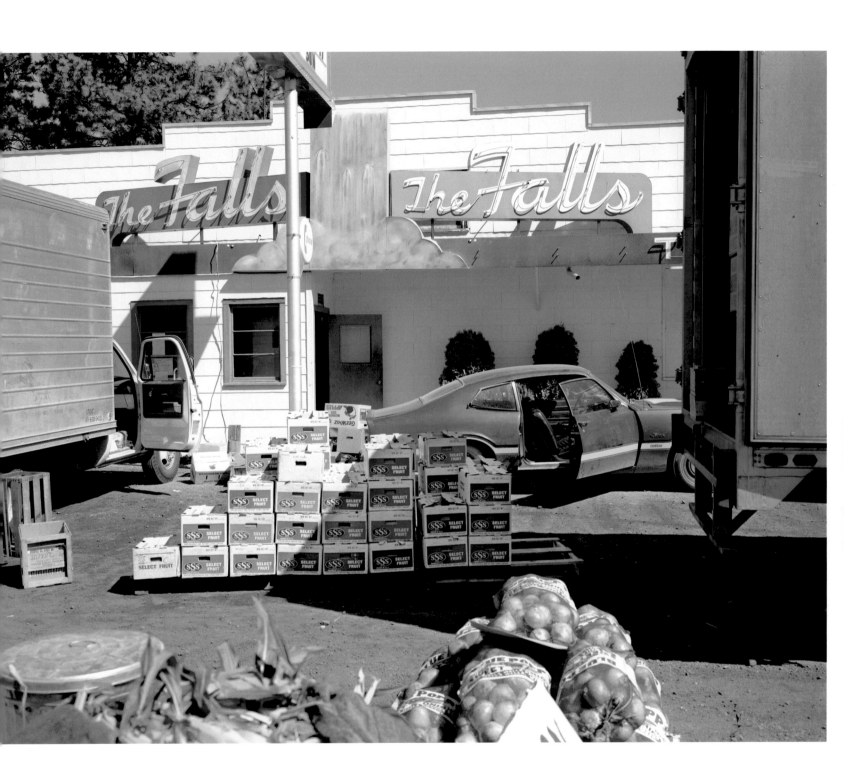

OPPOSITE:
Stephen Shore
*Presidio, Texas,* 1975

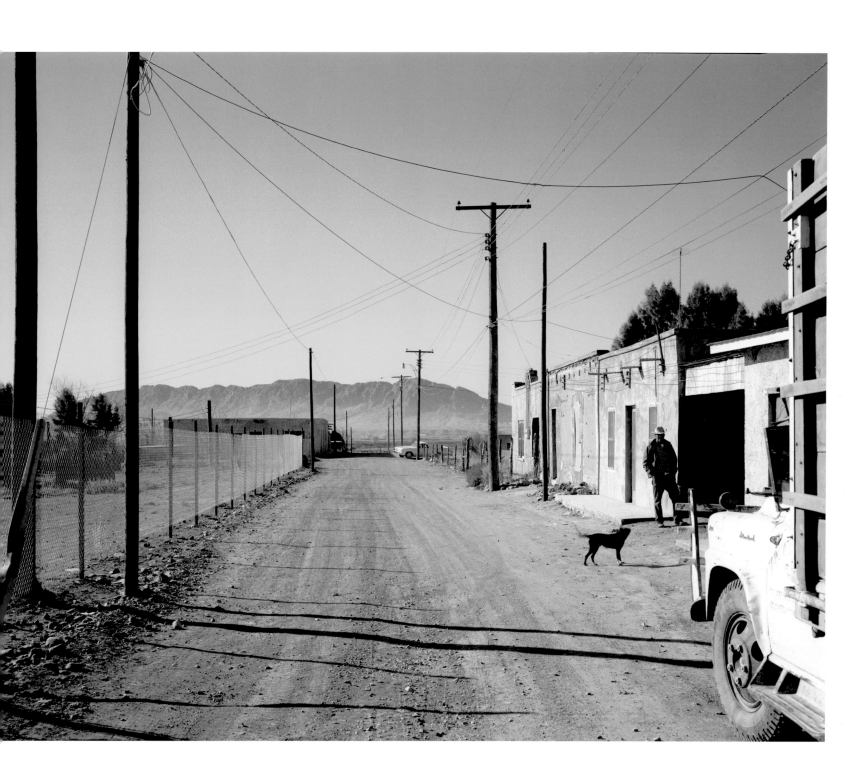

## JOEL MEYEROWITZ (B. 1938)

A close friend of Garry Winogrand's, Joel Meyerowitz
began his career in the 1960s as a street photographer
who recognized his debt to the Cartier-Bresson aesthetic.
Like Helen Levitt (b. 1918) and Winogrand, Meyerowitz
started off by alternating between black-and-white and
color photographs. In 1972, he permanently adopted color,
simultaneously switching to large format in order to enjoy
its greater descriptive value. Nonetheless, many of his
images, such as a beautiful 1978 series on Saint Louis and
the Gateway Arch, continued to bear the dynamic
characteristics of 35 mm street photography.

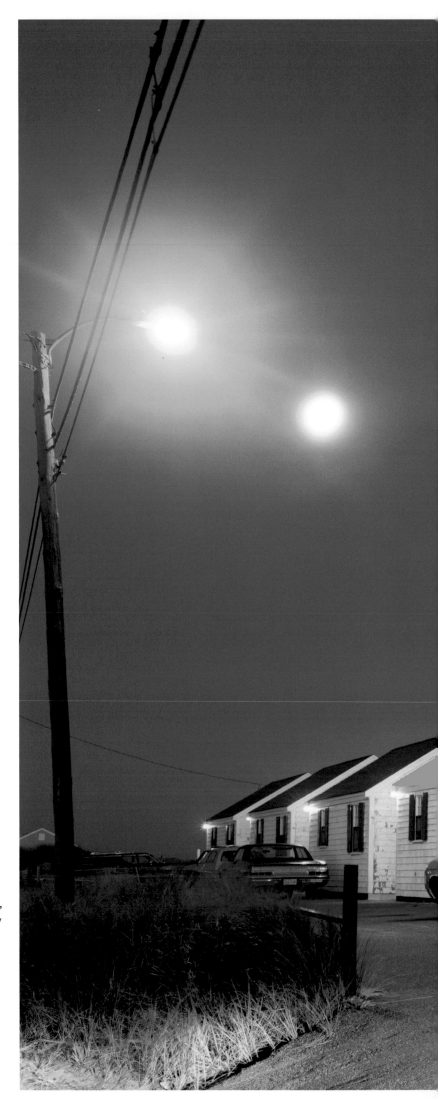

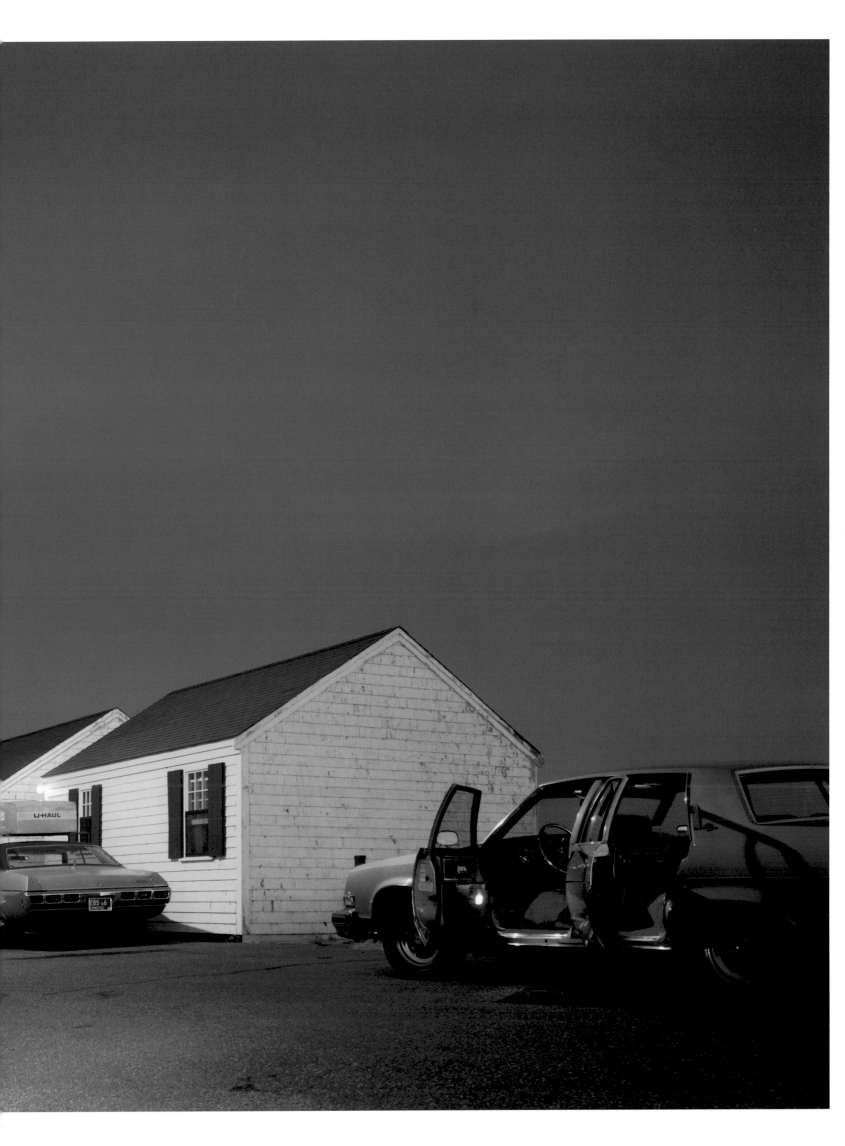

Richard Misrach
*Sounion, Greece*, 1979

# NOTES

1. *Popular Photography*, May 1958, p. 63.

2. A few figures provide a better understanding of the changes that took place over the course of a decade: in 1969, for instance, 131 venues (museums and galleries) exhibiting photography were listed in New York. In 1977, there were 592 galleries. Regarding the teaching of photography, the figures are just as eloquent: between 1964 and 1967, the number of establishments offering postgraduate courses in photography leapt from 268 to 440. See Jessica Lyn Mackta, "The Witkin Gallery, 1969–1976: A Critical Reading of the Paradigm of Photographic Display" (M.A. thesis, The University of Arizona, 1997).

3. Carl Sandburg, prologue to *The Family of Man* (New York: The Museum of Modern Art, 1955), p. 5.

4. Ibid., book-jacket flap.

5. See semiologist Roland Barthes's sharp analysis in an article written for the exhibition's opening in France and published in his *Mythologies* (Paris: Seuil, 1957), p. 196: "Everything here, from the content to the photogenic nature of the pictures, aims to suppress the determining weight of History."

6. The work, first published in France by Robert Delpire, appeared in 1959 in the United States.

7. "R. Frank, the Photographer as a Poet," *US Camera*, September 1954.

8. Review of *The Americans* by James M. Zanutto, *Popular Photography*, May 1960, p. 150.

9. See, in particular, his photo essay on Pittsburgh (1955–56); see also Gilles Mora and John T. Hill, *W. Eugene Smith: Photographs 1934–1975* (New York: Harry N. Abrams, 1998); and Sam Stephenson, ed., *Dream Street: W. E. Smith's Pittsburgh Project* (New York: W. W. Norton, 2001).

10. An organization founded in 1936 in New York to promote a politicized documentary photography that recorded the living conditions of the working class.

11. Regarding Frank's precursors and contemporaries, see Jane Livingston's *The New York School Photographs 1936-1963* (New York: Stewart, Tabori & Chang, 1992).

12. Peter C. Bunnell (b. 1937) was a MoMA curator from 1966 to 1972, then professor of the history of photography at Princeton University. After having taught at the University of New Mexico until 1979, Van Deren Coke (1921–2004) served as director of the San Francisco Museum of Modern Art's department of photography from 1979 to 1987. Nathan Lyons (b. 1930) has held several positions, among them director of the Rochester Visual Studies Workshop since 1972.

13. See Jacob Deschin, *The New York Times*, July 15, 1962, p. 17.

14. "Steichen's Successor: John Szarkowski, An Interview by Nat Hertz," *Infinity*, September 1962, p. 6.

15. Ibid., p. 6.

16. On the question of photographic modernity, see Gilles Mora and Theodore Stebbins Jr., *The Photography of Charles Sheeler: American Modernist* (New York: Bulfinch, 2002).

17. "The whole project points up the way in which museums tend to have a devitalizing effect on photography," Downes wrote. See Bruce Downes, *Popular Photography*, August 1965, p. 36.

18. Jonathan Green, *American Photography* (New York: Harry N. Abrams, 1984), p. 55.

19. See Catherine Lord, "Minor White: The Making of the Myth," *Afterimage* (Summer 1979): 4–5.

20. See, in particular, the monograph by Gilles Mora and John T. Hill, *Walker Evans: The Hungry Eye* (New York: Harry N. Abrams, 1993).

21. This was the case with Stephen Shore: "I first became aware of Evans's work when a neighbor of mine in New York gave me a copy of *American Photographs* for my 10th or 11th birthday (1957 or '58). It was the first photographic book I owned. I've learned much from studying this book." Stephen Shore, letter to Gilles Mora, December 12, 2006.

22. In Louis Kronenberger, *Quality: Its Image in the Arts*, (New York: Atheneum, 1969), pp. 169–71.

23. Evans's distaste for Winogrand's photography, which made the latter despair, is recalled by photographer Leo Rubinfien. See Charles Traub et al., eds., *The Education of a Photographer* (New York: Allworth Press, 2006), p. 115.

24. See Evans's article on Dan Wiener, *Print* 12, no. 2 (March–April 1959).

25. Notes typewritten by Garry Winogrand, n.d., Winogrand Archives, Center for Creative Photography (CCP), Tucson, Arizona, p. 1.

26. In *Creative Camera*.

27. "Those Little Screens," *Harper's Bazaar*, February 1963, pp. 126–29.

28. Lee Friedlander, letter to Gilles Mora, November 10, 2006.

29. Tod Papageorge, *Walker Evans and Robert Frank: An Essay on Influence* (New Haven, CT: Yale University Art Gallery, 1981).

30. Lyons wrote: "It was in my part my researches into the snapshot as an authentic picture form which led me to develop the exhibition from which this book and exhibition are derived." Nathan Lyons, ed., *Contemporary Photographers Toward a Social Landscape* (New York: Horizon Press, in collaboration with the George Eastman House, Rochester, N.Y., 1966), p. 7.

31. *Afterimage* (January 1978): 14–15.

32. "Neither snapshot, document, still-life, etc, are descriptions of separate photographic esthetics. There is only still-photography, with its own unique esthetic. Still-photography is the distinction term." Garry Winogrand, letter to Minor White, April 28, 1973, in response to a questionnaire for *Aperture*'s special issue on the snapshot, Winogrand Archives, CCP, Tucson, Arizona.

33. John Szarkowski, introduction in the pamphlet-catalogue accompanying the *New Documents* exhibition, 1967.

34. Written in her Ingram Merrill Grant application published in *Diane Arbus Revelations* (New York: Random House, 2003), p. 218.

35. *Artforum* (May 1971).

36. A. D. Coleman, "Bruce Davidson: East 100th Street," *The New York Times*, October 11, 1970.

37. See Patricia Bosworth's account of this day in *Diane Arbus: A Biography*, pp. 230-31.

38. Quoted by Helen Gee in an extract from her book *Limelight* published in *The Education of a Photographer*, ed. Charles H. Traub, Steven Heller, and Adam B. Bell (New York: Allworth Press, 2006), p. 140.

39. Larry Clark, *Tulsa* (New York: Lustrum Press, 1971).

40. Introduction by Nathan Lyons to the exhibition catalogue *Vision and Expression: An International Survey of Contemporary Photography* (New York: Horizon Press, 1969).

41. Ibid.

42. The Museum of Fine Arts in Boston was one of the first American museums to collect photography, beginning with its acquisition of twenty-four photos by Stieglitz in 1924. In 1967, it made its first contemporary American photography purchases. The 1971 exhibition was the first dedicated to that period of photography. Clifford Ackley, its young curator, organized every aspect of the show, which was an innovation in itself, given that the museum had previously limited itself to renting exhibitions.

43. Excerpt from Clifford Ackley's introduction in the exhibition catalogue *Private Realities: Recent American Photography* (Boston: Museum of Fine Arts, Boston; distributed by New York Graphics, 1971).

44. Minor White, ed., *Frederick Sommer, 1939-1962: Photographs* (Millerton, NY: Aperture, 1962).

45. Jonathan Williams, "The Eyes of Three Phantasts: Laughlin, Sommer, Bullock," *Aperture* 9, no. 3 (1961): 96-123.

46. Van Deren Coke (1921-2004) was a photography historian—author of the imposing *The Painter and the Photograph from Delacroix to Warhol* (1974)—and a photographer in the surrealist vein. A professor at the University of New Mexico, where he founded that institution's photo department in 1962, he went on to direct George Eastman House in Rochester, New York (1971-72) and the San Francisco Museum of Art's photography department (1979-87).

47. Guy Davenport (1927-2005) was a fascinating intellectual figure: a poet, draftsman, translator, and professor of American literature, he wrote an important thesis about Ezra Pound. A citizen of Lexington, Kentucky, he was one of Meatyard's best friends and models.

48. See the excellent brief catalogue by Robert C. May, *The Lexington Camera Club, 1936-1972* (Lexington: University of Kentucky Art Museum, 1974).

49. In A. D. Coleman, "The Directorial Mode: Notes toward a Definition," *Artforum* (September 1976).

50. See www.journalism.indiana.edu/syllabi/ccookman/j462/pages/lec22_grotesque.pdf.

51. In a review in the October 1980 issue of *Afterimage*, pp. 7-9, Hal Fisher emphasized the strengths of Les Krims, John Pfahl, and Robert Cummings' work, but accused the exhibition of being lax and having unfounded intellectual pretensions, relying on easy visual formulas, or "a method, a formula approach."

52. Harold Jones, director of the Light Gallery, which represented a few of the show's artists, declared: "These photographers demonstrate how technical virtuosity and investigation of viewpoint can produce images as expressive, as personal and as profound as in any medium." Exhibition press release, January 4, 1973.

53. In *Afterimage* (October 1978): 14-16, Martha Chahroudi's harsh criticism of the exhibition pointed out the flaws in Szarkowski's concept and the resulting confusion: "It does not advance our understanding of what is taking place in contemporary photography," she wrote.

54. See note 60.

55. See, in particular, "Contemporary California Photography," an article by *Artforum* critic Hal Fisher, published in *Afterimage* (November 1978): 4-6, describing the innovative and anti-establishment values put forth by John Szarkowski as characteristic of contemporary California artists. Fisher points out that only 17 percent of the photographs MoMA showed in *Mirrors and Windows* were by California artists, a percentage that seriously underestimated the significance of contemporary California photography.

56. Ed Ruscha, interview with John Coplans, in *Artforum* 25 (February 1965).

57. Cited in Coosje Van Bruggen, *John Baldessari* (Los Angeles: The Museum of Contemporary Art), p. 30.

58. Szarkowski isolates five characteristics intrinsic to the medium: "the Thing Itself," "the Detail," "the Frame," "Time," and "the Vantage Point." See John Szarkowski, preface to *The Photographer's Eye* (New York: The Museum of Modern Art, 1966).

59. The director of MoMA's photography department from 1940 to 1948, Beaumont Newhall (1908-1993) played an essential role as the first authentic photo historian. His book *The History of Photography 1839-1937* (New York: The Museum of Modern Art, 1937), was reprinted several times.

60. The photographs Szarkowski selected to support his theory were all—with the exception of works by Paul Caponigro and Shomei Tomatsu—culled from the period prior to the 1960s. The only contemporary photographer mentioned in the article (but without any reproduction of his work) was Garry Winogrand.

61. See Andy Grundberg, "Legacy from Photography's Mount Olympus," *The New York Times*, February 11, 1990.

62. According to Szarkowski, Winogrand was "the central photographer of his generation." In Mike Johnston, "Photography's Quiet Giant," *Camera & Darkroom* (April 1992): 41.

63. "This show is bound to wield considerable influence" wrote Kramer, "and to astonish, even offend, a public avid for photographs." In "The New American Photography," *The New York Times Magazine*, July 23, 1978, p. 8.

64. On this subject, see the remarkable thesis by Jessica Lyn Mackta, "The Witkin Gallery, 1969-1976" (M.A. thesis, Graduate College, The University of Arizona, 1997). I owe a great deal to Mackta's work, which is devoted in part to the photo galleries of the era and, in particular, the Witkin Gallery.

65. "Although the Witkin Gallery's standards were high, it could hardly be said to have an aesthetic position," Szarkowski wrote in the exhibition catalogue for *Photography Until Now* (New York: Museum of Modern Art, 1990), p. 75.

66. Jane A. Mull's article, "Investors in the Camera Masterpieces," *Fortune*, June 1976, provided a few striking examples: between 1967 and 1976, the value of a Julia Margaret Cameron print increased from $600 to $5,000 on the American auction block; the value of a Paul Strand print increased from $1,200 to $25,000.

67. These figures are drawn from the Witkin Gallery Archives at the Center for Creative Photography (CCP) in Tucson.

68. For these figures, see Jane A. Mull, "Investors in the Camera Masterpieces," *Fortune*, June 1976.

69. Pierre Apraxine justified this commercial investment in the following terms: "I think photography has been in everybody's mind for a few years now. . . . We will be showing the work of photographic artists just as we would a painter or sculptor." See Apraxine,

"Marlborough Gallery Steps into Photography," *Afterimage* (October 1975): 17.

70. "Price low, buyers cautious, at New York auction," stated the article in *Afterimage* (October 1975): 17.

71. In *Décor: The Magazine of Fine and Decorative Arts*, August 1982, p. 81.

72. Ibid., p. 115.

73. See, for instance, the exhibition review in *Afterimage* (April 1979): 6-7. The review's author notes: "Galleries, in fact, were the major force in the 1970s show. . . . It is, by its very origins, composed of pictures that sell well."

74. This collection was shown at the Norton Simon Museum in Pasadena (the Pasadena Art Museum's name since 1974) in the exhibition *The Collectible Moment: Photographs in the Norton Simon Museum*, Oct. 13, 2006–Feb. 26, 2007. The catalogue published to accompany the exhibition confirms the collection's radical eclecticism.

75. Statistic from C. William Horrell, *A Survey of Photographic Instruction* (Rochester, NY: Eastman Kodak Co., n.d.), p. 3.

76. These workshops included the Visual Studies Workshops in Rochester, headed by Nathan Lyons, or the Friends of Photography in Carmel, California, founded by Ansel Adams in 1967. The Friends of Photography was an organization with broad educational goals, responsible for a variety of activities (publishing, exhibiting) and, most important, for the celebrated Friends' Workshops where, for nearly thirty years, the great photographers of the moment came to lead brief educational sessions. The workshop trend swept across the United States during the 1970s and eventually reached Europe through Les Rencontres internationales de la photographie d'Arles, founded in 1969, and the efforts of French photographer Lucien Clergue. By inviting all of the period's great photographers to teach, the festival became an incredible launching pad for American photography. For many years, American photographers invited to Arles had a formative effect on young French and European photographers.

77. Jack Somer, "Gurus of the Visual Generation," *New York*, May 28, 1973, pp. 45–48.

78. Ibid., p. 45.

79. Ibid., p. 47.

80. "The illiterates of the future will be ignorant of the use of camera and pen alike," wrote Moholy-Nagy.

81. Andy Grundberg, "Toward a Critical Pluralism," reprinted in *Afterimage* (October 1980).

82. Max Kozloff, *Photography and Fascination* (Danbury, NH: Addison House, 1979).

83. See *National Endowment for the Arts 1965-1995: A Brief Chronology of Federal Involvement in the Arts* (Washington, DC: Office of Communications, 1995), pp. 18, 22.

84. Michael Lonier, "Summing Up the 70's," *Afterimage* (March 1979): 14.

85. The second page of the first issue of *Afterimage* (March 1972) stated the magazine was rooted in a theory of the modes of communication: "We are working toward more projects involving . . . modes of communication . . . in the field of visual studies." By producing traveling exhibitions and providing courses reflecting the history and sociology of photography, as well as the semiotic approach then dominant in Europe, *Afterimage* embodied the essence of the Visual Studies Workshop. Peter Galassi, John Szarkowski's eventual successor at MoMA in New York, served as a book reviewer for *Afterimage*, as did future *New York Times* columnist Charles Hagen.

86. A. D. Coleman regularly covered photography for the *Village Voice*, then for *The New York Times* from 1968 to 1978.

87. See Weston J. Naef, *Era of Exploration: The Rise of Landscape Photography in the American West, 1860-1885* (New York: The Museum of Modern Art, 1975).

88. These photographs are collected in the book *Photos IN + OUT City Limits Boston* (New York: ULAE Inc., 1981).

89. Rauschenberg's introduction to *In + Out City Limits Boston*.

90. See, for instance, the catalogue for the *Los Angeles 1955-1985* exhibition curated by Catherine Grenier (Paris: Centre Georges Pompidou, March–July 2006).

91. *New Topographics: Photographs of a Man-Altered Landscape*, Rochester, New York, International Museum of Photography at George Eastman House, 1975.

92. "There is little doubt that the problem at the center of this exhibition is one of style," William Jenkins wrote in the preface to the exhibition catalogue *New Topographics: Photographs of a Man-Altered Landscape* (Rochester, NY: International Museum of Photography at George Eastman House, 1975), p. 5.

93. Ibid., p. 5.

94. Ibid., p. 7: "As individuals these photographers take great pains to prevent the slightest trace of judgment or opinion from entering their work. . . . This viewpoint, which extends throughout the exhibition, is anthropological rather than critical, scientific rather than artistic."

95. See the account and review of this project in "Rephotographing Jackson," *Afterimage* (Summer 1978): 7–8. Also see the remarkable Web site "Third View, A Rephotographic Survey of the American West," www.thirdview.org.

96. Jon Szarkowski, introduction to *William Eggleston's Guide* (New York: Museum of Modern Art, 1976).

97. Linda Troeller, "Current Museum Attitudes in the Collection of Color Photographs," *Exposure* 14, no.1 (February 1976): 23–24.

98. Dan Meinwald, "Color me MoMA," *Afterimage* (September 1976): 18.

99. "Exhibitions, W. Eggleston," *American Photographer* (July 1978): 22–24.

100. "Color," *New Yorker* review reprinted in Janet Malcolm, *Diana and Nikon* (Boston: Godine, 1980), pp. 87–95.

101. Roberta Hellman and Marvin Hoshino, "What Television Has Brought," *Village Voice*, August 1976, p. 52: "Eggleston may be one of the first photographers to understand the lesson of TV," they wrote. "He holds back, leaving some color and content unresolved."

102. We should not overlook the first attempts at photographic documents in color undertaken by a few photographers for the Farm Security Administration (FSA) in 1940 and 1941; most of the pictures were taken on 35 mm Kodachrome slides, a process invented in the United States in 1936. See Paul Hendrickson, *Bound for Glory: America in Color 1936-1943* (New York: Harry N. Abrams, 2004).

103. The entire, uncut road journal was recently published; see Stephen Shore, *American Surfaces*, with text by Bob Nickas (London: Phaidon, 2005).

## ACKNOWLEDGEMENTS

Gilles Mora thanks all those who have helped in the making of this book, and in particular:

Leslie Calmes, Amy Rule, and the whole team at the Center for Creative Photography in Tucson, Arizona
James Enyeart
Peter Galassi, at MoMA in New York
Anne Biroleau, at the French National Library, Paris
the Fraenkel Gallery, San Francisco
the Yancey Richardson Gallery in Washington, D.C.
Lee and Maria Friedlander
Bernard Plossu

And the photographers for their generosity, advice, and help:

William Christenberry
Charles Harbutt
Les Krims
Mike Mandel
Nicholas Nixon
Charles Traub
Arthur Tress
Bill Owens
Tod Papageorge
Stephen Shore
Not forgetting everyone who is present in the book.

And finally, the whole team at Seuil Images, at the Éditions du Seuil, Paris.

TRANSLATED FROM THE FRENCH BY NICHOLAS ELLIOTT

PROJECT MANAGER, ENGLISH-LANGUAGE EDITION: MAGALI VEILLON
EDITOR, ENGLISH-LANGUAGE EDITION: SHEILA FRIEDLING
DESIGNER, ENGLISH-LANGUAGE EDITION: SHAWN DAHL
JACKET DESIGN, ENGLISH-LANGUAGE EDITION: SARAH GIFFORD
PRODUCTION MANAGER, ENGLISH-LANGUAGE EDITION: TINA CAMERON

LIBRARY OF CONGRESS CATALOGING-IN-PUBLICATION DATA

MORA, GILLES 1945–
   THE LAST PHOTOGRAPHIC HEROES : AMERICAN PHOTOGRAPHERS OF
THE SIXTIES AND SEVENTIES / BY GILLES MORA.
      P. CM.
   INCLUDES BIBLIOGRAPHICAL REFERENCES.
   ISBN 13: 978-0-8109-9374-7 (HARDCOVER WITH JACKET)
   ISBN 10: 0-8109-9374-0 (HARDCOVER WITH JACKET)
   1. PHOTOGRAPHERS—UNITED STATES—BIOGRAPHY. I. TITLE.

   TR139.M57 2007
   770.92—DC22

               2007020052

PUBLISHED SIMULTANEOUSLY IN FRENCH UNDER THE TITLE
*LA PHOTOGRAPHIE AMÉRICAINE DE 1958 À 1981: THE LAST PHOTOGRAPHIC
HEROES* BY ÉDITIONS DU SEUIL, PARIS, 2007.

COPYRIGHT © 2007 ÉDITIONS DU SEUIL, PARIS
ENGLISH TRANSLATION COPYRIGHT © 2007 ABRAMS, NEW YORK

PRINTED AND BOUND IN CHINA
10 9 8 7 6 5 4 3 2 1

**HNA** ■■■■■
harry n. abrams, inc.
a subsidiary of La Martinière Groupe

115 WEST 18TH STREET
NEW YORK, NY 10011
WWW.HNABOOKS.COM